robose ~~~~ Photo-
graphy will soon make
this book useless.

love

Ned.

YOUR GUIDE TO

Photography

YOUR GUIDE TO

Photography

SECOND EDITION

Helen Finn Bruce

BARNES & NOBLE BOOKS

A DIVISION OF HARPER & ROW, PUBLISHERS

New York, Hagerstown, San Francisco, London

YOUR GUIDE TO PHOTOGRAPHY. SECOND EDITION. Copyright © 1965 by
Barnes & Noble, Inc. Copyright © 1974 by Helen Finn Bruce. All rights
reserved. Printed in the United States of America. No part of this book
may be used or reproduced in any manner without written permission
except in the case of brief quotations embodied in critical articles and
reviews. For information address Harper & Row, Publishers, Inc., 10 East
53d Street, New York, N.Y. 10022. Published simultaneously in Canada by
Fitzhenry & Whiteside Limited, Toronto.

First BARNES & NOBLE BOOKS edition published 1965.

Second BARNES & NOBLE BOOKS edition published 1974.

LIBRARY OF CONGRESS CATALOG CARD NUMBER: 73–19475

HARDBOUND EDITION ISBN: 0-06-480104-7
PAPERBACK EDITION ISBN: 0-06-463342-X
78 10 9 8 7 6 5

PREFACE

When the original text of this book was written, it seemed as if advances in photography were occurring too fast to be captured in printed pages. Advances are still occurring at an ever faster rate and undoubtedly will continue to do so. Nevertheless, despite ongoing changes in equipment and techniques, some fundamentals of picture-making remain steadfast and can be explained and clarified.

It is gratifying to realize that this new edition owes its existence to the large number of photographers who have apparently found the book helpful, and also to the many teachers in classrooms all over the country who have chosen it as a textbook for their photography courses. I hope this revised version will prove even more helpful.

For his aid in updating this text, my thanks go to Casey Allen, well-known photography instructor, who was familiar with the original book and had recommended it to his students. His extensive suggestions have been invaluable in revising this work.

H.F.B.

PREFACE TO FIRST EDITION

A decade ago it was possible to ask someone "who knows about photography" a simple question or two and obtain some clear-cut answers. Now the acceleration of photographic products and relevant data has developed "specialists" rather than "family doctors"; and seldom do the opinions or even the "facts" of the experts agree. Nor should they: for one who is glibly certain he has all the answers has ceased to look at the questions. This text, consequently, represents not an unarguable consensus but my understanding of the information it includes, reinforced wherever practicable by firsthand trials and errors.

This guidebook is intended for beginners, or even more proficient photographers, who are interested in learning or review-

ing some of the principles and basic techniques that underlie the taking and making of photographs; it is not a course in professional photography, nor is it addressed to those advanced "amateurs" who are so often more "expert" than many professionals. Recently I had occasion to show a young student how a handful of snapshots could be improved by handling the camera thus and so. A few minutes later he turned to me with a gratifying smile and said, "You know, you explained that so well, I'm never going to forget how to do it." I hope I have done as well with the explanations in these pages.

My foremost indebtedness is to George L. Cantzlaar not only for his helpful starter suggestions about organizing the material but most of all for the illustrations. Since they are such an important part of this book, and since he is responsible for obtaining all of the illustrations and permission for their inclusion, I consider him a kind of "co-author." My personal thanks go with his to Miss Betty Wolcott of Eastman Kodak's editorial service for her invaluable assistance in supplying so many excellent prints on a wide variety of subjects, most of them derived from prizewinning photographs in national competitions. Our special gratitude is due also to Wayne Waters, head of the Training Publications Branch, Bureau of Naval Personnel, for the use of numerous technical illustrations; and to the Pictorial Branch, Office of Information, Department of the Air Force, for supplying additional art work.

I am appreciative, too, of the time and talent shared with amateurs generally by more camera-club judges and lecturers than I can name here. And I would like to thank William J. Daly of Sekonic for being one of my most obliging informants. Finally, I wish especially to thank Frank Ericson, not only for his high opinion of this book but also for his unstinting contribution of time and experience on behalf of amateurs; particularly in his training classes for the Volunteer Service Photographers, it is pleasantly apparent that, after twenty years as a successful professional, he has not forgotten how it feels to be a beginner.

<div align="right">H.F.B.</div>

Table of Contents

1

A Look at Photography

Beginning with a pinhole peek at a finite world, the science of photography has progressed to such an extent that it is now probing other planets and the wonders of an infinite universe. Present-day astronomers use complex photographic instruments to study the stars, discovering new ones visible only on photographic plates. Outer-space travelers send back enlightening photographs of unexplored celestial bodies and extraordinary views of our own planet. Inner space, too, has been researched with the aid of special equipment such as that of Kirlian photography, which has produced astonishing color pictures of human energy patterns.

For the everyday photographer, beginner or expert, there is a stream of new developments in camera designs and accessories, and new improvements in film emulsions and processing procedures. However, you should not feel that you have to keep up with every development. There is no necessity to delve into the realm of optics or learn about film manufacture or absorb the scientific data of the laboratory unless these subjects are of particular concern to you. You need consider only the information pertaining to your camera, your goals, and your personal interests. You may wish to study all of this text, or just parts of it, or you may be satisfied with only a casual reading.

GENERAL CONSIDERATIONS

Photographic Incentives. What starts people taking pictures? Photographers themselves often don't know. It may be a new baby on the premises, or a playful pet. It may be a rare visit

from friends or relatives living far away. It may be spectacular scenery, or the quiet beauty of a summer day, or the winter wonder of a brook carving a course through banks of snow. Travel frequently triggers the camera urge, and sometimes a business need sets one to taking pictures. Photography can be contagious, too: it's an enthusiasm you might catch from seeing the intriguing pictures taken by friends, or the enticing cameras and other equipment which keep appearing in stores and ads, as well as in the hands of friends and fellow vacationers.

Owning a camera has long been a fundamental desire, for the wish to preserve precious moments is universal. Photography is one way to help retain and relive the big and little events that mark a personal progression through life. Pictures of such events might be classified as "record" shots, but they can also be interesting photographs in their own right.

You CAN Take It with You. Another common-denominator reason for the popularity of photography is that it provides a ready and convenient outlet for creative energy—with no palette to scrape or brushes to clean. Photography is certainly no substitute for painting, but it does have its own physical as well as creative advantages: a camera can be transported more conveniently than a sketchbox and easel, and unlike a painting which requires a certain "showcase," a photograph can be looked at anywhere—it can be held in the hand, hung on a wall, projected on a screen, or carried in a wallet.

In addition to being a communicative and sociable hobby in itself, photography complements other hobbies or studies. The sports fan or coin collector, the fisherman or flower fancier, the bird watcher or boatman adds an extra thrill to his favorite projects by taking pictures of them and sharing his interest with others.

Developing the ability to see picture possibilities is essential in making photography an art as well as a pastime. One of the deep delights of exploring with your camera is the discovery of new visual patterns, waiting to be noticed, in familiar surroundings. As you become interested in the creation of your own pictures, you will find fresh material and new photographic opportunities all around you. And one of the great advantages of modern lenses and faster films is freedom from the whims of weather. Direct sunlight, once a must for acceptable exposures,

is now not only unnecessary but frequently quite undesirable. Pictures can be taken in rain or shine, day or night, indoors or out, on trips or at home.

So learn to look with discernment and master your equipment, whether you have a very inexpensive, simple camera or the costliest reflex model. A camera can be as individual as a pet: it should belong to someone who understands it, cares for it properly, and makes a close friend of it.

A FEW FUNDAMENTALS

There can be no hard and fast rules for taking pictures; rules are general guides to which the photographer must bring observation and judgment. All the points mentioned here will come up in later chapters dealing with different kinds of pictures. However, they are so basic that they should become part of your photographic thinking from the very beginning.

Closing In. First of all, as you get on closer terms with your camera, learn to get close to your pictures, too. When a photograph seems to lack interest, it is quite probable that the photographer was too far from his subject and that too much distracting background (or foreground) got into the act. An expressive face with a plain background will make a better picture than a figure competing with trees, houses, and clouds for attention. A kitten playing with a ball of yarn on a minimum of carpet will be much more interesting than a lot of carpet and chair legs with a minimum of kitty.

Guide Lines. Your outdoor scenes can have various curves and angles, but it is important to keep the horizon line straight; otherwise, the whole picture will be off balance. In architectural shots, such as of buildings and monuments, learn to align some straight perpendicular line of the subject with the vertical edge of your viewfinder—unless you are after a deliberate angle shot or a Leaning Tower. Avoid a too even distribution of the elements of your picture, either horizontally or vertically, as this will seem to cut the picture in two and destroy its unity; for example, try to keep at least two-thirds of a landscape view below the horizon line, or two-thirds of a sky scene above the horizon line. Also, endeavor to keep your main subject—your

center of interest—out of dead center, as this usually results in a weak composition.

Framing. A photograph, like any other picture, can be greatly enhanced by its frame, by an impression that your subject is contained within appropriate boundaries. Experiment with ways to frame your pictures and give them depth; sometimes a foreground figure will do it, sometimes a doorway, a shadow, or an overhead branch. Then see that you fill the frame—not with unrelated elements, but by an avoidance of blank areas.

Most still cameras can be held to take either horizontal or vertical views, so don't get into the habit of holding yours only one way. For example, a reclining figure generally belongs in a horizontal frame and a tall, standing figure in a vertical frame.

Haste Makes Waste. Some pictures must be snapped in a hurry or missed completely. On the whole, however, you will find it worthwhile to take time to study carefully your prospective picture before you click the shutter. Have a really good look at what you see in your viewfinder, from several angles, before you decide where you and your camera should be positioned. Then, equally important, study your finished photographs, both good and bad; mistakes frequently furnish the most persuasive instruction.

Basic Precepts. Make it a habit also to analyze photographs in newspapers and magazines; try to discover why it is that some of them capture and hold your attention more than others. You will find that for most of the interesting ones the photographer has followed these three rules:

> *Keep it simple.* A direct, uncomplicated statement is, visually as well as orally, the most effective.

> *Use contrast backgrounds.* Keep a light object against a dark background, or a dark object against a light background, so that it can be seen easily by anyone looking at the photograph.

> *Give it a personal viewpoint.* Your pictures express you as surely as your speech or your handwriting. Try to convey in them your interest in what you see.

Practice does not necessarily make perfect. Experienced camera fans as well as beginners find that photography, like life, is

full of ups and downs, trials and errors, elation and consternation. An "expert" may appear to produce only good pictures, but this may be so because he shows only the ones that make him look good. He has taken many that you never see and has wisely learned to discard more than he keeps. So don't envy him: go ahead and take your own pictures. And remember that pictures —like paintings, music, and words—have different meanings for different people; seldom are two opinions identical. If a picture really pleases you, you are entitled to consider it a good picture.

2

Cameras: Selection and Handling

"Which camera should I buy?" is undoubtedly the number one question asked by newcomers to the country's number one hobby. These beginners, and even those who have been taking pictures for some time and want to buy a better or more versatile camera, soon find out that the question rarely has one answer.

Not many years ago cameras could be classified under a few basic types with some subdivisions. Now the once stable categories have widened and shifted and overlapped to an extent that defies any practical pigeonholing. Longtime favorites, such as box cameras and folding cameras, have become extinct, and a number of intermediate favorites have gradually slipped from popularity toward a possible vanishing point. Also, quite often the esoteric nomenclature of individual manufacturers contributes to the confusion.

SOME CAMERA BASICS

Despite their endless variations, standard cameras have a few characteristics in common. Every camera starts out as a light-tight housing for a lens, shutter, and diaphragm at the front, and a support to hold and transport the film at the back. Every camera has some kind of mechanism to advance the film and a counter to indicate how many pictures have been taken. Every camera can take black-and-white or color pictures, unless film in a particular size and type is not available. But from there on, individualism reigns, with cameras seemingly having as many differences as the people who use them.

If you already own a camera and plan to replace or supplement it, you probably know what features are most important to you. If you are buying your first camera, it's a good idea to assess your photographic intentions. Until you know more or less what your preferences and goals are, you can't very well make the right inquiries to elicit helpful answers. Even with appropriate questions, you may still find that every "expert" will have a different recommendation. Here are a few questions you might try asking yourself:

Do I intend to take pictures just for pleasure or as a career possibility? Or for specific business uses?

Will I want many accessories, especially extra lenses?

Do I expect to take extreme close-ups?

Will I be shooting a lot of very fast action?

Am I likely to be taking many pictures of buildings and other architectural subjects?

Do I plan to photograph mostly outdoors or mostly indoors?

Am I interested primarily (or exclusively) in color?

If so, do I want color slides for projection or color prints for albums?

Do I intend to become a darkroom do-it-yourselfer?

Will my photographic economy be based on a strict-budget, a shoot-the-works, or an in-between program?

Just how much time and study and serious attention am I prepared to give to photography?

Add some questions of your own and see how your answers shape up. Sometimes pertinent information comes through knowledgeable salesclerks, photographic periodicals, camera clubs, informal workshop groups, or evening classes in local high schools. But regardless of the data obtained, no one can tell you for sure which camera you should have. That should be your decision. In making it, one of the important points to keep in mind is that, whether it costs under twenty dollars or over two hundred, no one camera is best for every kind of photography.

TYPES OF CAMERAS

The basic differences among cameras are in (1) shutter speed, from a fixed time of approximately 1/40 second to an adjustable 1/1000 second, and even higher; (2) lens aperture, from one or a few *f*/stops (lens openings) in mid-scale to a full scale of *f*/stops; (3) degree of automation; and (4) size of film used. This last was, and still is, the designation by which some cameras are known, so it may be helpful to preview camera types by film format.

Film-Format Designations and Backgrounds. The following list of cameras by film sizes is from small to large. (More details about films can be found in chapter 6.)

SUBMINIATURE CAMERAS. First to use double drop-in cartridges, these are not standardized as to film widths, which have varied from 9.5mm to 16mm. The "sub" prefix came about because they appeared after the 35mm "miniatures." The Minox, first to be adopted to any extent by amateur photographers, was originally developed as a precise instrument for undercover work. With steady handling, accurate focusing, and company-controlled processing, many users have been able to get surprisingly good pictures from the tiny negative. However, this type has been eclipsed by the newer "pocket" cameras and has limited appeal now.

110-FILM CAMERAS. These are the Pocket Instamatics introduced by Kodak in 1972. The new film comes in a drop-in cartridge, which can be used in any camera specifically designed to accept the Kodak 110 cartridge. The rectangular negative size of 13mm x 17mm is about one-third that of the square 126 format.

126 CAMERAS. These were the first instant-loading types with a negative size large enough for a standard print and projectable color slides in standard two-inch cardboard mounts. For a fairly long time the square 28mm x 28mm film could be used only by the original Kodak Instamatics. Later, Contaflex and other name cameras came out with a variety of models, from ultrasimple to highly sophisticated, designed to accept the 126 drop-in film cartridge.

"Instamatic" is not a generic term but a registered trademark

of the Eastman Kodak Company. The first Instamatic made its surprise debut in 1963, and for quite a while it was the only camera to use the new 126 Kodapak cartridge. Then other instant-loading Kodak models appeared until, in 1965, the first flashcube ushered in a whole new family of Instamatics. Still another group, the Instamatic-X cameras, flash-powered by Sylvania's no-batteries Magicube, arrived in 1970.

35MM CAMERAS. These were the early "miniatures," small indeed compared with the roll-film sizes of box and folding cameras, and capable of shooting a longer series of pictures on a short strip of film previously used only in motion-picture cameras. For years 35mm cameras have been the most widely preferred cameras, with the widest choice of film emulsions and the widest availability of generally dependable processing. They are available as rangefinder cameras, single-lens reflexes, stereo cameras, and a diversity of simpler, automatic types.

The first miniature cameras, made in Europe by Leitz, were introduced just prior to 1930 and promptly attracted hundreds of fans by the novelty of their being able to snap unsuspecting subjects with such a small yet precise instrument. For the first time, amateur photographers, without tripods and without time exposures, could take "candids" even under adverse light conditions. Furthermore, they could utilize many fascinating extras, so many in fact that it became quite usual to see an eager photographer so intent on his satchel-load of accessories that his camera was no longer very miniature nor his pictures very candid. Since all this initial enthusiasm was expressed in black and white, it carried over into many improvised darkrooms.

As more and more of the accessories were built into ever bulkier cameras, catching subjects off-guard ceased to be a factor in the 35mm's popularity. But in 1935 Kodak's introduction of color to 35mm film supplied even greater momentum. The original Kodachrome (ASA10) was *the* color film for many years, but eventually bowed out as its successors became established and offered greater speed and variety.

HALF-FRAME 35MM CAMERAS. The appearance of this type and its temporary flurry of favor seemed to indicate a reaction to the increased bulk of 35mm cameras, particularly the single-lens reflex, and a desire for a more compact camera that could still use 35mm film. Actually, back in those early "candid camera"

days, there were cameras that took the same size picture as this half-frame, but then it was called "single frame" and today's standard 35mm was called "double frame."

STEREO 35MM CAMERAS. These made a big hit when they first came on the photographic stage, but problems of handling, and especially the paraphernalia required for viewing, limited their popularity. They have become practically unavailable except where used cameras are sold.

Just as stereo systems in music aim at greater sound fidelity, stereo photography aims at three-dimensional visual realism. So, quite naturally, a stereo camera has two identical lenses in horizontal alignment, like a pair of eyes. It takes two pictures simultaneously on a single 35mm frame: one corresponds to what the left eye alone sees, the other to what the right eye sees with the left closed. A stereo camera must be held absolutely level as well as steady to avoid weird and dizzying effects. The mounted twin transparencies can produce some spectacular scenes, but they require a special two-lens holder for hand viewing, and a special projector, special mounts, and polarizing glasses for screen viewing—just too much trouble for these days of convenient, drop-in cartridges and electronic automation.

$2\frac{1}{4}$ x $2\frac{1}{4}$ CAMERAS. These larger square-format roll-film types include the twin-lens reflex and single-lens reflexes. The latter vary a great deal: some accept special magazines and backs for larger film sizes, some have waist-level viewing, others eye-level viewing, and some have unique individual features. Pioneer in this type was the Hasselblad, once regarded by some professionals as a "portable studio"; it now has several group-mates not sufficiently standard to classify.

4 x 5 CAMERAS. This format applies to press and view cameras, which use sheet film, roll film, and film packs.

INSTANT-PICTURE CAMERAS. These are mainly the very extensive Polaroid group. They are not listed here according to film size since they do not use standard films, and print sizes vary from a square print under 2 inches to a $3\frac{1}{4}$ x $4\frac{1}{4}$ print. This category has changed and diversified considerably since the first Polaroid Land camera introduced the novelty of "a picture in a minute." The earliest models were for black and white only, and development took place inside the camera. The resulting one-of-a-kind

prints required prompt coating with a protective liquid. Development time was later reduced to fifteen seconds for black and white and sixty seconds for color.

Pocket Cameras. The ultraslim Pocket Instamatics, engineered by Kodak to fit handily into pocket or purse, make it easy for anyone to take advantage of snapshot opportunities. There are several models: the simplest one has a preset lens aperture and two shutter speeds (for daylight and flash). Another has a faster lens with coupled rangefinder focusing. Pocket Instamatics accept the batteryless Magicubes for flash.

Especially welcome to those who use a camera mostly for prints of people and places is the new Kodacolor II emulsion developed particularly for the 110 drop-in cartridge (which was designed for these cameras): its finer grain and improved quality can produce surprisingly sharp color prints from the 13mm x 17mm negative. For color slides the 110 film is available also with Kodachrome-X and Ektachrome-X; for black and white there is an improved Verichrome film.

The tiny color slides are returned from the processor in square plastic mounts which can be slipped into a plastic "stick" for previewing and editing. For projection, a special small slide projector is required.

126 Cameras. As noted, these include the many standard-size Instamatics and a number of other cameras which accept the same size film cartridge. All of them also accept standard flash-

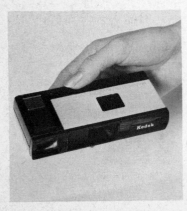
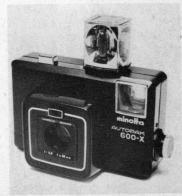

Fig. 2.1. A Pocket Instamatic camera Fig. 2.2. One of the 126 cameras

cubes and Magicubes. Since the 28mm x 28mm square format, although somewhat smaller than 35mm film, produces a satisfactory print and color slides mounted in two-inch cardboards to fit standard projectors, many photographers were won over by the quick and easy drop-in loading.

As the choice of cameras in this category increased to include simpler and more complex models—even rangefinders and single-lens reflexes with features once confined to the 35mm format—so too did the numbers of those who preferred to skip the much slower steps of manually loading the film and rewinding it after exposure.

Rangefinder Cameras. Regardless of size, this type has an optical mechanism for measuring the distance between lens and subject for correct focusing. This may be a system coupled to the lens or it may be of the focusing-screen type. With either rangefinder system there are small windows at the top of the camera. By adjusting a knob as he looks through the viewfinder, the photographer can frame and focus his subject. Because of the separation of viewing system and lens, parallax can be a problem at close-up distances. (See chapter 5.) Some rangefinder cameras have between-the-lens shutters. Others have focal-plane or behind-the-lens shutters, either of which permits lens interchangeability.

For many years the rangefinder camera, with top performance and prestige synonymous with the name Leica, was the favorite type in the populous 35mm field. But after the introduction of the single-lens reflex and that camera's ever wider acceptance,

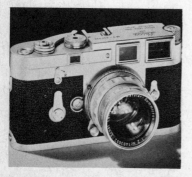

Fig. 2.3. A 35mm rangefinder

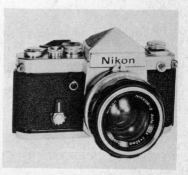

Fig. 2.4. A 35mm single-lens reflex

there has been a proportionate decline in the rangefinder's popularity. Still, the "quiet little camera," as it has been called, continues to keep many friends and to find some new ones, especially photographers who want an extra camera.

Coupled rangefinder cameras include the 126 and 35mm sizes. Rangefinder systems are also incorporated in a number of larger, multiformat cameras with backs which accept a wide and complex variety of films and accessories, but these are not known primarily as rangefinder cameras.

Single-Lens Reflex (SLR) Cameras (35mm). Because focusing is through the camera's one lens, single-lens reflexes are free of parallax problems: what you see is what you will get, including depth-of-field changes as the lens is stopped down or opened up. The eye-level prism finder of a 35mm SLR lets you look straight ahead at a right-side-up, normal left-to-right image—the way you would view a subject with other eye-level viewers. But instead of seeing it beyond the camera, you view a mirror image reflected from a ground-glass focusing screen within the camera.

As the shutter is clicked, the mirror that relays the picture preview must instantly fly out of the way so that the lens will take the actual subject and not the reflected image. A problem of early SLR cameras was blackout, or the case of the vanishing image: when the mirror flew up it stayed up until the shutter was wound for the next exposure, leaving the photographer sans mirror and sans image during the interval. But practically all SLRs now have an instantaneous mirror-return mechanism which sends the mirror up for the brief instant of exposure, then promptly drops it back into viewing position. This movement is what makes an SLR noisier than a rangefinder type.

Another basic feature of the SLR is the fully automatic diaphragm. The lens opens to maximum aperture after each exposure to provide a bright image during focusing, then automatically closes down to the selected f/stop when the shutter is released.

Its great versatility has made the SLR, especially the 35mm size, first choice of many amateur and professional photographers. Supplementary lenses, matched extension tubes, and bellows enable this camera to get within a few inches of a small subject, so it is particularly well adapted for close-up studies—of flowers and insects, seashells and snowflakes, and still-life compositions.

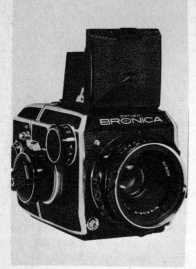

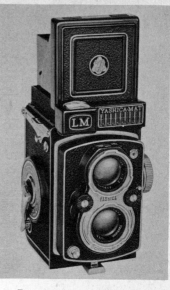

Fig. 2.5. A 2¼ single-lens reflex Fig. 2.6. A twin-lens reflex

2¼ Single-Lens Reflex (SLR) Cameras. The large-format cameras in this distinctive classification use roll films and have an image-reflecting mirror mechanism (as does the twin-lens reflex), and they have the SLR advantage of viewing and focusing through the taking lens. Different film backs permit the use of larger film sizes, but this is not uniform with all the cameras.

The forerunner in the 2¼ SLR category was the Hasselblad, later followed by the Bronica. Then came Rollei and other famous photographic names, expanding and diversifying this elite group. Concurrently, increasing numbers of serious photographers were becoming interested in these and other more specialized cameras. In addition to the 2¼ SLRs with the usual waist-level viewing, there are others, with eye-level viewing, which sometimes resemble an oversized 35mm SLR.

Other individual features of this category vary—in types of shutters, for instance, in film backs, and in extras such as a built-in bellows. Because of their individuality these cameras are generally known by their individual names, but all have in common the superior picture quality inherent in a larger negative and the great versatility of a single-lens reflex.

Twin-lens Reflex Cameras. This camera also uses 2¼ x 2¼ roll films and has waist-level viewing. Unlike the 2¼ SLR, however, the twin-lens camera has two lenses in vertical alignment, and its hooded focusing screen shows the subject right side up but reversed from right to left. When the image in the ground glass looks sharp, the subject is in focus.

Twin-lens cameras have a *finding* lens and a *taking* lens, which are not always identical; the top lens is the finder and may not be quite as well corrected as the bottom lens, which takes the picture. The aperture of the top lens is wide open, to give as bright an image as possible on the ground glass, and both lenses are focus-controlled simultaneously.

Because the two lenses are on different levels, parallax can be a problem in close-ups. (See chapter 5.) Obviously, if the taking lens is below the finding lens, it will see a tiny fraction less at the top of the picture than the finding lens sees. Most cameras have parallax-correction indicators; otherwise, the photographer learns through practice to tilt the camera very slightly upward for subjects closer than six or seven feet.

Besides the advantages of larger negative size and waist-level viewing that it shares with its single-lens counterpart, the twin-lens reflex is less complex and less expensive. It enjoyed a lengthy popularity for journalism and illustration, and it has been a great favorite for taking pictures of children because it lets the photographer focus down at the child's level without becoming a contortionist and without hiding his face behind the camera.

Press and View Cameras. In this category the trend has been toward smaller cameras with greater flexibility. In fact, the press-camera prototype, the old 4 x 5 Graflex, would hardly recognize its diversified descendants. Features such as sheet, roll, pack and Polaroid backs, coupled built-in rangefinders, and fully synchronized shutters are part of the modern versions of the Speed Graphic.

The designation "press camera" has become something of a misnomer: the 4 x 5 format is still much in demand but principally in areas outside of journalism. Photojournalists in general prefer the smaller and more flexible 35mm single-lens reflex or the 2¼ SLR, depending on the assignment.

View cameras are mounted on tripods and are slower to oper-

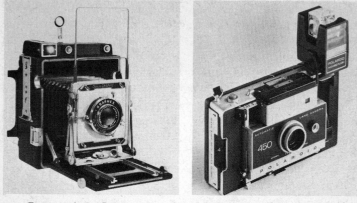

Fig. 2.7. A Graflex 4 × 5 Fig. 2.8. A Polaroid camera

ate. This 4 x 5 type is used primarily for technical photography in such areas as architecture, industry, and advertising.

Polaroid Instant-Picture Cameras. Polaroid continues to invent technological delights for photographers. The cameras, often reminiscent of the "folding camera," include a wide choice of models and individual capabilities, and an even wider price range, from under twenty dollars to almost two hundred. One is preset for a single close-up distance and takes only color pictures. Some have a built-in flash system to control the light of the flashcube. Others have a built-in timer to signal when the print is fully developed.

Development time at present is fifteen seconds for black and white and sixty seconds for a color print. As noted in the preceding section, print sizes and shapes vary. Copies and enlargements of original prints can be ordered from the company's copy service. Film comes in film packs of eight, with quite a bit of wrapping and gooey chemicals.

A newer Polaroid with a reflex viewfinder system is designed not only to eliminate the paper and chemical debris but also to fold into a much more compact camera. Seconds after it takes a picture, the camera ejects a dry film protected from light by a chemical shield, and automatic processing starts in the film itself. As one watches the emerging faint and foggy image, it gradually becomes a bright and clear finished print.

Polaroid also manufactures backs for many other types of

cameras and a special PN (professional) film which produces a reusable black-and-white negative. Although Polaroid is not the sole maker of instant-picture cameras, its competition is negligible.

Special Wide-Angle Cameras. These cameras include sizes ranging from 35mm to 4 x 5 and are designed for limited use. They have fixed lenses intended for special situations not likely to be encountered by most photographers. However, they are sometimes used in ordinary photographic situations to create extraordinary effects. Prices go from about four hundred dollars to more than twice that amount.

Home-Movie Cameras. While home movies and still photography have some fundamentals in common, they are really on opposite sides of a very high fence. Above that separation merge the basic principles of composition, lighting, and correct exposure. The fundamentals of home movies are discussed in chapter 21.

LEARNING TO USE A CAMERA

Once you have decided on your camera, get to know it intimately. The instruction manual or booklet that comes with a camera is vital to its efficient and trouble-free use, since cameras differ so much.

Camera Parts. The camera and booklet should be studied together to determine what each letter, each number, each arrow, each lever, each knob stands for and how it operates. Consult your camera dealer if necessary, and *keep the booklet* even when you think you no longer need to refer to it. If the booklet for your camera has been lost, write the manufacturer for a duplicate, and get into the habit of keeping it where you keep the camera and accessories.

Examine the camera systematically, either from front to back or in the order in which the parts are listed in the booklet. Figure 2.9 indicates most of the parts of one 35mm single-lens reflex camera. Although typical, these may be quite different from the design of your camera; also, some of the features may be called by other names in other cameras.

Handle the camera as you study it, and put it through several dry runs before you load any film into it. Aim it at different

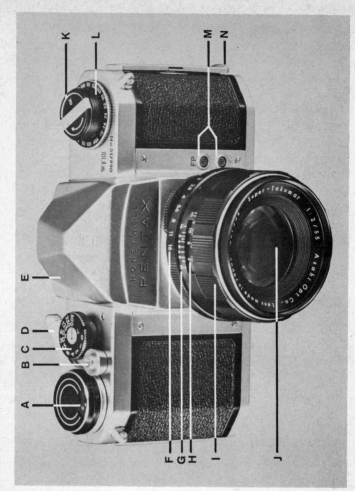

A Film exposure counter
B Shutter release
C Shutter-speed dial
D Film advance lever
E Prism/Mirror housing (SLR only)
F Diaphragm ring (f/stops)
G Depth-of-field scale
H Distance scale
I Focusing ring
J Lens
K Rewind knob
L Type-of-film reminder
M Flash terminals
N Back lock

O Viewfinder
P Focal plane shutter
Q Film cassette chamber
R Tripod head attached to tripod socket
S Film pressure plate
T Film perforation sprockets
U Film takeup spool
V Film-rewind release button

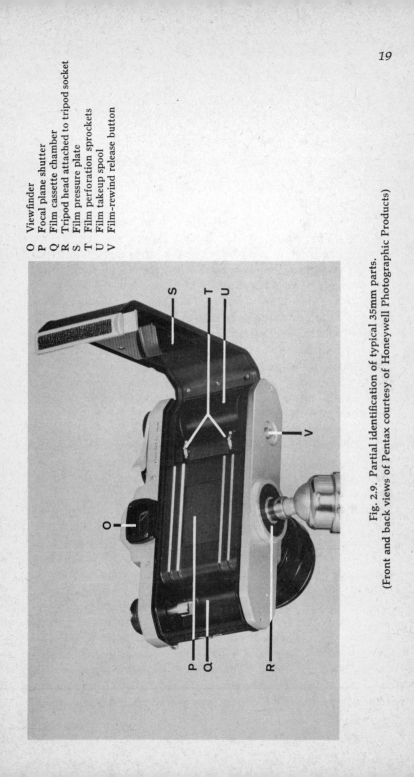

Fig. 2.9. Partial identification of typical 35mm parts.
(Front and back views of Pentax courtesy of Honeywell Photographic Products)

subjects to see how steady you can hold it and what you can see in the viewfinder from different angles. Click the shutter a number of times as if you were taking pictures to lessen the risk of losing pictures by fumbling later.

Common Errors in Camera Handling. Blur is the most common photographic error. When a picture turns out blurred all over, it is usually because the camera moved during exposure. If there is only a partial blur, it is generally the result of motion by the subject. One way to improve camera steadiness is to keep your arms in close to your body and to hold a deep breath when you release the shutter. If you have an eye-level viewfinder, try pressing the camera against your cheek. If eyeglasses interfere, try pressing your thumb against the back of the camera and against the side of your nose. If you have a waist-level viewfinder, hold the camera close to but not pressed against the body, and pull down slightly on the neck strap if you use one. Always press the shutter release gently.

A point frequently overlooked is the fact that a photographer's stance is as important to steadiness as his hands. If you place one foot well ahead of the other, you can not only have a tripod-like firmness but can also bend easily at the knees to lower and raise the camera position.

Faulty focusing is another cause of blur. Like camera steadiness, accurate focusing must be a matter of regular practice if you are to get consistently sharp pictures. If glasses are normally worn, they should be kept on for focusing and shooting; otherwise, vision defects can contribute to blur.

Unintentional double exposures caused by forgetting to advance the film after each exposure are far less common than formerly because so many cameras are designed to prevent this particular error. Still an occasional error, however, is the blackout caused by forgetting to remove a lens cap from a rangefinder or other camera type which does not have through-the-lens viewing. A partial blackout can be caused by inadvertently letting a finger, or a camera strap, or top of a camera case get in front of the lens during exposure.

Loading and Removing Film. Since specific instructions for your camera should be followed, only a few general ones need be observed here. First, open the camera according to directions and find out where the film is supposed to go and how it should

move inside the camera before trying to install any film. Look for helpful little arrows, but never force anything that does not turn or move easily. If something doesn't move, there is a reason; look again and refer to the instruction booklet. If you are loading 35mm or roll film, *be sure to get the film in straight*, or it will almost certainly cause trouble later. Note also that any film (except instant-load films) should be inserted or removed in subdued light.

INSTANT-LOADING CAMERAS. Subminiatures, Instamatics, and other 126 cameras need no loading instructions. Just open the camera and drop the lighttight cartridge into position where indicated. Cartridges are designed to fit only one way, so they can't be loaded the wrong way. No rewinding is required: simply remove the exposed film load from the camera.

35MM CAMERAS. These are characterized by a wind-and-rewind mechanism and, near the film-advance lever, a fixed take-up spool. There is usually an "A" for advance, and the rewind knob has an "R" and an arrow. The film comes in single, lightproof cassettes and is packaged with very useful and informative leaflets. It is a good habit to look at them regularly, not only to become familiar with the recommendations but also to note any unexpected changes in them. Another good habit is to slip the folded leaflet between the camera and its case as a reminder; it is easy to forget whether the camera is loaded with a slow color film or a fast black-and-white if the film is not used up right away.

To load, open the camera back, see that the winding mechanism is set for advance, and insert the film leader into the take-up spool. As you wind it onto the spool, be sure that the sprockets of the little wheels next to the spool engage the perforations along the edges of the film. When the film is correctly anchored, close the camera, advance two blank frames to get any light-struck film out of the way, and set the counter for the first picture. Advance the film after each exposure; if your camera has a single-stroke lever that simultaneously advances the film and cocks the shutter, see that the shutter is not left in the wound-up position for an indefinite length of time.

To remove 35mm film, set the mechanism at "R" and rewind the exposed film into its original cassette. Turn the knob gently, learning to look, feel, and listen; there will probably be a re-

volving dot to watch as you turn, and there will be a little click and a slight tug when the film goes off the take-up spool. If the entire film has been exposed, wind (or push) the leader all the way into the cassette so that it cannot be mistaken for a new film and reloaded into the camera.

However, if you are removing a partly exposed film, stop winding when you get the little click and slight tug in order to leave the leader outside the cassette for reloading. Make a notation of the number of frames already exposed and wrap it around the cassette. When reloading the partly used film it is important to keep the lens covered, either by a lens cap or by holding the camera face down on a dark surface while you advance the previously exposed film. Allow a loss of at least one frame (two to be on the safe side) in the transfer, and reset the counter for the number of frames still to be exposed.

Most photographers who plan to switch back and forth to different films have cameras with lens interchangeability. This lets them carry one set of lenses and two or three camera bodies loaded with different films and protected by lens and body caps.

ROLL-FILM CAMERAS. Cameras such as the 2¼ SLR and the twin-lens reflex have a removable spool near the winding knob (or lever). The films have a protective paper backing and a paper leader to guide them onto the spool. Roll films generally are not packaged with separate information leaflets but have the ASA index and exposure-count numbers printed compactly on the paper leader. It is a good idea to jot down the type and index of the film you are loading and either slip the notation inside the camera's carrying case or attach it to the back of the camera with a bit of masking tape until the roll is removed.

After noting the printed information, insert the leader into a slot of the take-up spool and start winding, keeping a finger lightly on the film so that it will not unroll. A method that usually works well with a twin-lens or similar type is to hold the camera in your lap, with the open back away from you. Try to use a smooth, almost continuous motion in turning the winding knob. Printed arrows on the paper backing indicate when to close the case. Then advance the film until number "1" appears in the small counter window to show that the film is in position for the first exposure.

Check to be sure if the camera has a double-exposure preven-

tion feature, which automatically advances the film after each exposure. If it does not, you must remember to advance it manually each time—unless you want to be surprised with some surreal effects. After the last exposure, follow the manufacturer's directions for winding the remaining film onto the take-up spool before removing it from the camera for processing.

A word about buying film. You should exercise care in ordering film for your camera. Types of film are discussed at length in chapter 6, but as an elementary step, you should ascertain what size your camera accepts and what types are available in that size. Know whether you want a slow or fast film, for example, whether you want color film for slides or prints, whether your film offers a choice as to number of exposures, and whether it comes with or without processing. Then ask clearly and correctly for the film you want.

Theory and Behavior of Light

The first and fundamental requirement for any photograph is light. Since the word itself is derived from a combination of a form of the Greek word *phos*, meaning "light," and the Greek word *graphos*, meaning "written," photographs are literally "written by light." This basic fact may seem obvious, yet it is sometimes overlooked or forgotten. And while it is true that with today's vastly improved photographic equipment, less and less light is needed to make a good picture, *some* light is still required and presumably always will be because of the nature of the photographic process.

So, just what *is* this all-important light? For centuries physicists have been striving to determine its exact nature and to reconcile such famous and contradictory findings of the late seventeenth century as Newton's theory that a beam of light consists of a stream of infinitely minute particles with Huygens's theory that all space is occupied by a substance he called *ether*, through which light travels in small waves.

NATURE OF LIGHT

Quantum Theory. At the beginning of this century the scientist Max Planck discovered that, under certain circumstances, light can knock electrons off various substances, transferring its energy to the electrons in measurable amounts. Assuming that light energy traveled in infinitesimal, particle-like packages, Planck named these packages *quanta;* hence, the quantum theory. This was corroborated by Einstein, who demonstrated with mathematical equations not only that quanta (or *photons*) have

a frequency comparable to waves, but also that they are actually particles of energy. Today all radiation, including light, is generally considered to be composed of electromagnetic particles with definite wave properties; when these particles are absorbed or emitted by an atom of material, their energy is measurable.

Light Wavelengths. Light radiates from its point of origin in waves that go out in all directions until they come into contact with some substance. To visualize such radial waves, imagine dropping a pebble into a pool of still water: now watch the resulting waves move out from the point where the pebble was dropped to all the various edges of the pool. Next think of several straight lines drawn from the pebble-center (or from an actual light source) out through the curved lines of the waves. These imaginary straight lines indicate light rays and the *direction* of the light movement. The form of radiant energy that reaches our eyes as light can travel from the sun, from a distant star, or from the glow of a small candle a few feet away.

Radio transmission works in much the same way: vibrations in the air produce waves that reach our ears as *sound*, or audio impulses. But light and sound waves have very different wavelengths. Sound waves are long, but light waves are extremely short. If shown in magnified lines, light waves would somewhat resemble hairpin loops. As illustrated in figure 3.1, wavelengths are measured from the crest of one wave, or loop, to the crest of the next. To avoid decimals of unwieldy smallness, these measurements are usually stated in millimicrons. A meter is slightly more than three feet (39.37 inches), a millimeter is one-thousandth of a meter, and a micron is one-thousandth of a millimeter. A millimicron, therefore, is one-millionth of a millimeter.

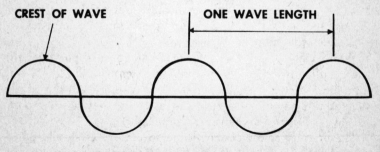

CREST OF WAVE **ONE WAVE LENGTH**

Fig. 3.1. Measurement of wavelength

Light wavelengths vary from about 400 to 700 millimicrons, the average being about one fifty-thousandth of an inch.

The Visible Spectrum. Of the entire electromagnetic spectrum, a relatively small part is occupied by visible light, as illustrated in figure 3.2. The reason for this is that neither comparatively

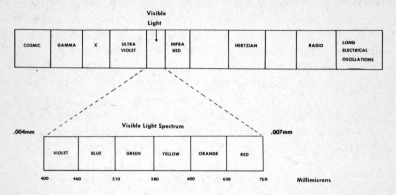

Fig. 3.2. Electromagnetic spectrum

long nor short light waves are visible to the human eye. As the wavelength shortens, the eyes gradually perceive the deepest reds at one end of the visible spectrum. As the wavelength decreases further, the eyes perceive respectively the orange, yellow, green, blue, and violet rays. Then the wavelengths become so short that they are again invisible.

These six colors are based on the classic Newtonian spectrum from which most of our conceptions of color derive. ("Indigo," a seventh color between blue and violet, is sometimes included in illustrations referring to the visible spectrum.) Each wavelength of light has its own typical color; but nearly every color that we see and call by an accepted color name is a combination of various wavelengths.

White Light and Primary Colors. Our most important light source, of course, is the sun. Sunlight is termed *white light* and is an ideal or equal blending of all the wavelengths of the visible spectrum. If any of these wavelengths are missing, even in part, we have another color instead of white light.

The primary colors of the visible spectrum, which add up to white light, are not the same as the *pigment primaries* used in

mixing paints. This is frequently a source of vast confusion, since most people learn the pigment primaries at nursery-school level. As a photographer, you should know that the *primary colors of photographic light* are red, green, and blue. (These fundamental colors and their complementaries are discussed in detail in chapter 9.)

Natural and Artificial Light. In general, the light used in photography is either *natural* or *artificial*. For a time it was standard practice to refer to these two broad classifications as *daylight* and *tungsten* (the latter name deriving from the material used in the filaments of electric light bulbs). However, with the increasing use of fluorescent lighting, mercury-vapor lamps, and other sources of artificial illumination, the present trend is back to the basic designation of light sources as either *daylight* (i.e., natural) or *artificial*.

TRANSMISSION, REFLECTION, AND ABSORPTION

When light rays traveling in straight lines encounter any substance, they are either transmitted through it, reflected from it, or absorbed by it. What happens is dependent to a considerable degree on whether the medium is transparent, translucent, or opaque—as shown in figure 3.3.

Transmission. Light can be transmitted, or passed through, transparent and translucent substances. A clear window glass through which an object can be seen distinctly is an example of a *transparent* medium; it permits maximum transmission of light. A frosted glass pane, through which light is visible but through which objects are seen indistinctly, is an example of a *translucent* medium; it transmits diffused light. A wooden door or a brick wall is an *opaque* medium and transmits no light.

Reflection. Reflected light describes rays that are bounced back from the surface of the object encountered instead of being transmitted through it or absorbed by it. Light rays that strike the surface of an object are termed *incident* (literally, "falling upon") rays, and their point of contact is called the *point of incidence*. Reflected light falls into two categories: specular and diffused.

Specular light travels in one direction. When the incident light strikes a perfectly smooth surface, it rebounds from the point of

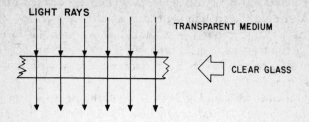

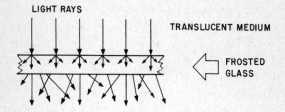

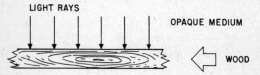

Fig. 3.3. Effect of media on light rays

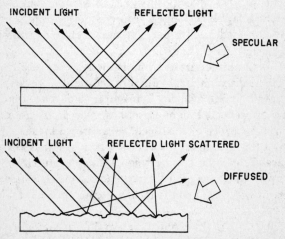

Fig. 3.4. Reflected light

impact at exactly the same angle as the incident ray. Figure 3.4 illustrates this cherished principle of elementary physics: *the angle of incidence equals the angle of reflection*.

Diffused light travels in more than one direction. If light rays strike an uneven surface, the light obviously cannot be reflected at an even angle; the incident rays will be tossed back at various angles, making the light diffused. Once again look at figure 3.4. Since absolutely smooth, polished surfaces are rather a rarity in ordinary encounters, most of the light you will use in photography will be diffused.

Absorption. Light is absorbed by different substances much as water is taken up by a sponge. There is always some degree of absorption whenever light rays encounter any surface. Furthermore, the way in which a given object absorbs incident light determines its color to a great extent. Dull-finish black fabrics and deep woodlands, for example, absorb far more light than a white cloth or a snowy landscape. The colors we think of as neutral—such as black, white, and some grays—absorb the primary colors of the light rays in almost equal amounts. It is the difference in the reflective properties of these so-called neutrals that affects our perception of their colors. A totally black surface refuses to reflect any appreciable amount of light and can be filmed only by contrast with other colors. White is just the opposite in its highly reflective character and needs the contrast of darker tones to be recorded properly in a photograph.

When you see red—in something such as a dress or tie—the reason is that the object is absorbing the blue and green rays of the incident white light and reflecting the red rays. In the same way, grass looks green because it tends to absorb all the red and blue rays, sending back to your eyes mostly the green rays. Because different objects absorb different kinds and amounts of incident light, you can use filters to exercise considerable control over the color values of your pictures, especially over the gray tones of your black and whites. (The subject of filters is covered in chapter 10.)

REFRACTION

The rays of light striking the clear glass head-on in figure 3.3 are called *normal* rays. Their air-travel speed of 186,000 miles

per second is reduced when they go through the glass, which has a greater density than that of air, but they are being transmitted straight through the heavier substance in a line *perpendicular to the surface.*

Law of Refraction. When light rays strike the glass at an angle, however, we have a more interesting phenomenon. The glass then *bends* the rays of light, forcing on them a change in direction. When light obliquely enters a transparent substance of different density from the one in which it is traveling, the resultant change in direction is known as *refraction.* Knowledge of the effects of refraction underlies the design and manufacture of optical and photographic lenses. Refraction follows a fixed law: *when a ray of light obliquely enters a medium of greater density, refraction is toward the normal; when a ray of light obliquely enters a medium of lesser density, refraction is away from the normal.* This rule is shown diagrammatically in figure 3.5. (The "sheet glass" is seen as though from the side, i.e., edge-on, with its front and back surfaces parallel to our line of vision.)

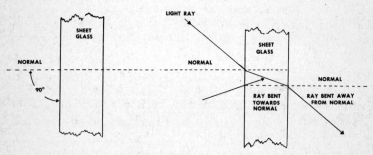

Fig. 3.5. Law of refraction

Index of Refraction. The speeds at which light travels through substances of varying degrees of transparency are measurable and determine the light-bending capacity of the substance. The measure of this ability, a sort of local speed limit, is termed the *index of refraction.* If light travels one-and-a-half times as fast in air as in a specific piece of glass, for instance, the refractive index of that glass is 1.5. By shaping the surfaces of a piece of glass, as in making a prism, it is possible to control the *degree* to which the light will be bent.

OTHER CHARACTERISTICS OF LIGHT

Besides refraction and the other properties already described, light has several other interesting behavioral characteristics which affect the design and use of lenses. Sometimes these properties can be helpful; at other times one or another of them can be a real headache. A brief look at three common characteristics follows.

Dispersion. The component colors of white light do not all refract equally; this is because of their different wavelengths. When a ray of light enters a prism, its colors disperse according to length. As you know from the illustration of the electromagnetic spectrum earlier in this chapter, red has the longest (700 millimicrons) and violet the shortest (400 millimicrons) wavelength. The shorter the wavelength, the greater will be its refraction—i.e., its deviation from the normal. The longest wavelength will be bent least. This separation of white-light components is known as *dispersion*, and it is illustrated in figure 3.6. You

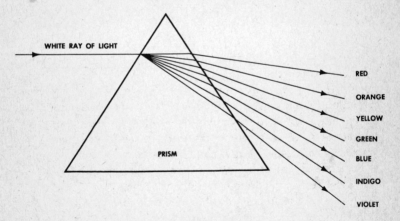

Fig. 3.6. Dispersion of light

can imagine that if you were trying to construct a lens to bend many visible color rays to one precise point, dispersion could be quite a tricky problem.

Diffraction. When light strikes the edge of an opaque medium, it has a tendency to scatter slightly. As the rays go past

some opaque object, such as a ball, a deep shadow forms, ringed by a lighter area with a blurred edge. (See figure 3.7.) The outermost rim of the lighter, blurry edge darkens toward the inner part and merges with the black center, thus evidencing that some light has scattered into the shadow. This scattering of light is called *diffraction*.

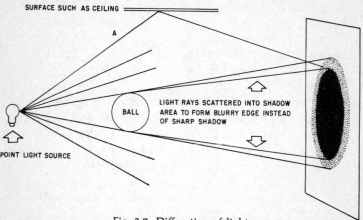

SURFACE SUCH AS CEILING

A

LIGHT RAYS SCATTERED INTO SHADOW AREA TO FORM BLURRY EDGE INSTEAD OF SHARP SHADOW

BALL

POINT LIGHT SOURCE

Fig. 3.7. Diffraction of light

Diffraction is readily discernible in a pinhole type of camera. With this primitive photographic instrument, images are pretty much in focus without being sharply defined. The sharpness of definition, or lack of it, depends on the pinhole size: too small an opening will scatter some light, while too large an opening will admit more than one ray from the same object point. Light scattering can result from various causes in any camera.

Polarization. In ordinary light waves the vibrations are supposed to be in all possible directions perpendicular to the ray. *Polarization* is a process of affecting the light so that the vibrations assume a definite direction, such as straight lines, circles, or ellipses.

Filters or screens designed to polarize light are very useful in certain kinds of photography, especially when it is necessary to minimize glare. Light-wave vibrations can be restricted to one plane, as shown in figure 3.8. This diagram indicates how ordinary light, reflected in one (specular) direction from a nonmetallic object at an angle of 30 to 35 degrees, is polarized so

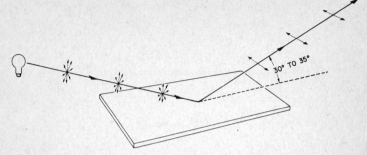

Fig. 3.8. Light plane polarized by reflection

that the vibrations are parallel to the reflecting surface. Other angles can also effect some polarization, but not at zero or 90-degree extremes.

THE PINHOLE PRINCIPLE

You can't put an image on film without light, but you can produce a picture without a lens. The *camera obscura* (Latin for "dark chamber") preceded our modern photographic mechanisms by several centuries. A dark box or a dark room—any lighttight compartment—can be used to form an image on film placed inside the box at the wall opposite a small hole which admits a beam of light. There is no focusing problem, no reshaping of the object as sometimes occurs with corrected lenses, and you can have as large an image as your box size allows.

But while such an image will be more or less "in focus," you should not expect it to be really sharp. If the pinhole is very tiny, light rays will strike the edges, causing diffraction and a fuzzily edged image. If the hole is too large, it will admit multiple rays and make the entire image blurred. If the pinhole manages to be exactly the right size for the box and object, the image will be reasonably sharp. This is illustrated by the three diagrams in figure 3.9.

Inverted Image. Another pinhole illustration, figure 3.10, shows why images on film are always upside down, whether they are formed by pinholes or by a modern camera lens. Notice that the line representing a ray of light from the top of the

Fig. 3.9. Characteristics of images formed by different size pinholes: (*top*) pinhole too small; (*middle*) pinhole too large; (*bottom*) pinhole correct size

tree slants downward to the pinhole. As it enters the opening, the ray continues in the same direction, thus putting the top of the tree on the bottom of the film or of the box wall. The ray from the base of the tree travels upward through the pinhole to the top of the image area. Hence the *inverted image* that is characteristic of photography.

Suppose we see what happens if the dark box acquires more than one pinhole. Assume that it has two holes. Two images would appear. Right? If the twin images could be superimposed, of course, the resulting image would have a double portion of light and so would be twice as bright as either separate image. Now apply the refraction principle and place a precisely angled prismatic glass at each pinhole. Imagine here that both beams of light are refracted to the same point and imprismed, as it were,

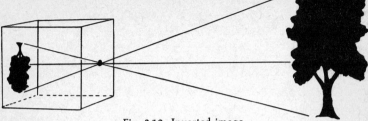

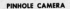

Fig. 3.10. Inverted image

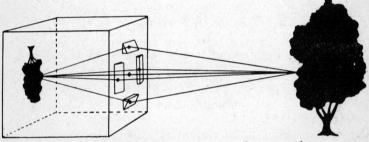

Fig. 3.11. Multiple pinhole images made to coincide

in a single image. All right, how about trying four pinholes with four prisms around the original center pinhole? If the holes are the correct size and the surfaces of the refracting prisms at the correct angles, the result should be one image five times as bright as the single-pinhole tree we started with. This hypothetical tree is illustrated in figure 3.11.

The foregoing facts about prisms and control of *direction* of light and about apertures and control of *amount* of light bring us directly to the subject of lenses.

Theory and Characteristics of Lenses

The lens element is the camera's eye, recording the image it sees on a light-sensitive film which remembers the image and repeats it on a print or slide. A camera is, in fact, merely a light-gathering mechanism whose parts correspond quite remarkably to those of the human eye: *lens* = pupil, *diaphragm* = iris, *shutter* = eyelid, and *film* = retina.

To understand more clearly how a photographic lens works, recall the law of refraction, explained in the preceding chapter. This fundamental law of physics concerns the change in direction of light rays: in passing from one transparent medium into a more dense one, refraction is toward the normal; into a less dense one, refraction is away from the normal. Because light travels faster or slower in different substances, it can be controlled by varying the substance, such as optical glass, and imparting to it a high or low refractive index. (X-rays, on the other hand, although of the same nature as light rays, are extremely short and travel right through a substance; they allow no control of their direction, which is why they make shadow patterns instead of photographs.)

POSITIVE AND NEGATIVE LENSES

Positive, convergent lenses act essentially like base-to-base prisms. Figure 4.1 shows triangular prisms having only four refracting surfaces. You will observe that although the refracted light rays intersect, they do not do so at a single point. Now imagine the prisms with their surfaces rounded into convex curves possessing many more refracting possibilities. The *bicon-*

Fig. 4.1. Convergent refraction of light rays by two base-to-base prisms

vex shape will be thickest at the center and thin out toward the edges. These curvatures will form an image by pulling light rays to a definite point of convergence, the top half of the convex lens bending the rays upward, as shown in figure 4.2.

Fig. 4.2. Refraction of parallel light rays by a positive lens

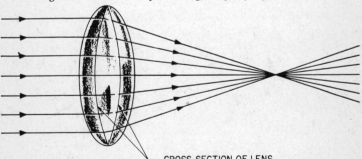

CROSS SECTION OF LENS

Simple positive lenses can have other shapes than the biconvex. One is a half-convex, as if a double-convex lens had been cut down the center to give it one flat plane opposite a convex curve—like half a football. The third most common simple lens shape is a concave-convex curve—like a quarter moon—which is known most often as the *positive meniscus*.

The meniscus is a single piece of glass tapering from center

thickness to thin edges and is frequently used alone in low-cost cameras of simple construction. Such a lens, like a box camera, can perform quite satisfactorily within its limitations, which usually restrict the feasible apertures to $f/11$, or smaller, and limit the color of light in which really sharp images can be obtained on modern panchromatic films. A simple meniscus lens, not corrected for chromatic aberration, will focus images of light rays from different zones of the spectrum on different planes, thus decreasing the potential sharpness of the photograph.

Negative, divergent lenses are concave in shape, as if two prisms were joined apex to apex (figure 4.3). A negative lens

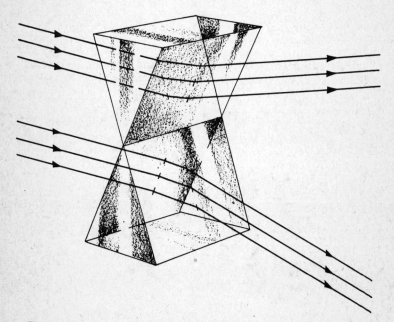

Fig. 4.3. Divergent refraction of light rays by two apex-to-apex prisms

cannot focus light rays passing through it but causes them to diverge from the center, as illustrated in figure 4.4. This type of lens is thickest at its edges, thinning toward its center. A negative lens can also be half of the biconcave shape with one flat plane opposite a concave curve, or it can be a convex-concave

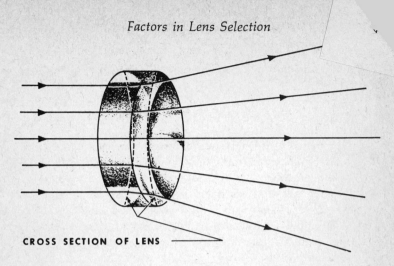

CROSS SECTION OF LENS

Fig. 4.4. Refraction of parallel light rays by a negative lens

curve. The three shapes are just the reverse of the most common positive lens shapes.

Simple negative lenses are never used alone but are combined with positive lenses to counteract specific aberrations and so help to produce more accurate images.

FACTORS IN LENS SELECTION

The lens with which a camera is equipped depends largely on the performance expected of that camera, much as an engine may be designed for a jet plane or a small car or something in-between. Once you have decided on the kind of camera you want, there are certain lens characteristics to look for, which may be grouped generally as follows: (1) focal length, (2) aperture, (3) lens quality, and (4) individual features, such as inter-changeability. First, a preview of these factors; later in this chapter they are discussed in greater detail.

Focal length, which is a fixed factor of lens design and cannot be varied by the camera user, represents the distance from the optical center of the lens to the film plane when the lens is focused at infinity. The focal length, therefore, is going to determine what size image appears on the film, a longer focal length producing a larger image in less area and a shorter focal length

producing a relatively smaller image with greater depth of field. All this, in turn, influences perspective by affecting the camera-to-subject distance required to fill the picture area.

The usual focal length of a lens is approximately the diagonal of the film size. For example, the popular 35mm type of camera has a 24 x 36mm (about 1 x 1½″) film size and generally has a 50mm, or two-inch, focal length. However, its lens may have a focal length as short as 44mm or as long as 58mm. Look for this information on the lens mount.

The *aperture* is the lens opening, and the *speed* of a lens is determined by the size of its largest possible opening, known as the "maximum effective aperture." A series of f/numbers shown on the lens mount designates the different amounts of light the lens is capable of transmitting at a given setting. The lowest number, such as f/2, indicates the largest opening and, therefore, the speed of the lens. This may appear as f/2 or f-2 or 1:2. A typical series may range from f/2, the largest aperture, to f/22, the smallest aperture.

The "f" symbol is an abbreviation of "focal length" and the "/" after it denotes a fraction; the number after the slant line completes the fraction. Thus an f/4 lens is one whose maximum effective aperture has a diameter equal to ¼ of its focal length. If you will remind yourself occasionally that ½ is a larger fraction than ¼, and ¼ is considerably larger than $\frac{1}{16}$, it is easy to remember which f/numbers mean larger openings and more light and which mean smaller openings and less light.

The *quality* of a lens is judged by the sharpness of the picture it is capable of producing. This depends on the quality of the optical glass, the number of elements, and the extent to which the aberrations, or defects, of the lens components have been reduced or eliminated. The *aberrations* which an uncorrected lens may contain are (1) chromatic aberration, (2) spherical aberration, (3) coma, (4) astigmatism, (5) curvature of field, (6) curvilinear distortion, and (7) color magnification. All of these are explained later in this chapter.

By designing one component of a lens specifically to create opposing and equal aberrations that will offset those in another component, camera makers endeavor to cancel out these aberrations. The degree of correction is greater in the lenses of better cameras, and because these refinements are costly, they are re-

flected in the camera price. Price alone should never be the criterion of lens quality but, given the same speed and focal length, a more expensive lens can generally produce better photographic results.

After focal length, aperture, and lens quality, the final consideration in selecting a lens is the inclusion of any *individual features* which may be important for your particular purpose. Lens interchangeability, type of shutter, and flash synchronization and equipment are among the points you might be concerned with. Focusing adjustments vary, as do the markings of *f*/stops and shutter speeds. (These various features are discussed in the different sections of this book where they are more directly relevant.)

Focal Length. The distance between the optical center of a lens and the plane where parallel light rays from an object at infinity come to a sharp focus has been termed the *focal length* of the lens. *Infinity* is defined as the distant point at which parallel lines seem to converge, as in the vanishing end of a section of railroad tracks; with most small cameras it generally refers to distances over thirty feet.

Since focal length is controlled by the surface curvatures and thickness of the lens, an understanding of the basic principle of lens action can sometimes be helpful to the photographer in analyzing certain problems as they are encountered.

The *principal plane* of a compound lens is its vertical axis at the joining of the two flat lens planes, indicated by the dotted line through the center of the biconvex "football" in figure 4.5.

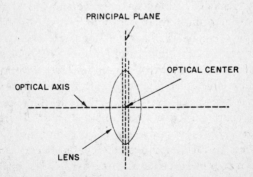

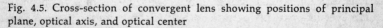

Fig. 4.5. Cross-section of convergent lens showing positions of principal plane, optical axis, and optical center

The broken line cutting horizontally through the center of the football, and normal to both surfaces, is the *optical axis*. The point at which these two lines cross is the *optical center* of the lens. Since the purpose of the lens design is to bend light rays up and down to a single focal point, it should be apparent from the diagram that only the rays traveling along the true optical axis can pass through the lens without bending.

Any light ray at an angle to the optical axis will be refracted at each lens surface in passing through the optical center. When these refractions are equal and in opposite directions—as in corrected lenses—the result will be as if the ray had gone through in a straight line. Look at figure 4.6: the broken line represents the path of a light ray through a biconvex lens, and the solid line shows how the ray starts and ends at the same points as the straight line.

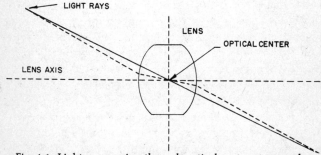

Fig. 4.6. Light ray passing through optical center at an angle

Aperture. The size of the lens aperture and the length of time it is opened determine how much light reaches the film during any one exposure. The *diaphragm* of a camera is the mechanical device that regulates the amount of light allowed to pass through the lens. It is controlled by the scale of f/stop settings and is part of every lens assembly. Most often this light-controlling mechanism is a series of overlapping thin metal leaves. One end of each leaf is attached to a mount inside the lens barrel and the other end to a movable circular ring on which the f/stops are marked. Rotating the ring moves the center of each leaf toward or away from the optical center of the lens.

Because of its close resemblance to the mechanics of the human eye, this part of the camera lens is sometimes known as the

iris diaphragm, as illustrated in figure 4.7. When you turn the control ring so that it enlarges the aperture, you are "opening up" the lens. When you turn the control ring in the opposite direction to reduce the size of the opening (the way the pupil of your eye contracts within the iris to shut out excessive light in bright sunshine), you are "stopping down" the lens.

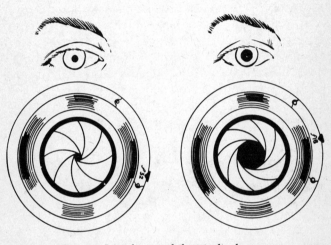

Fig. 4.7. Iris of eye and the iris diaphragm

RELATIVE-APERTURE RATIO. To get the best results from your lens it is important to have some understanding of the relationship between its aperture and its focal length. This relationship, or *relative aperture,* governs the brightness intensity at the focal plane where the image is recorded. Again, the *f/*number represents a ratio between the diameter of the aperture and the focal length of the lens when focused at infinity. (For example, a stop of *f/*4 means that the diameter of the aperture at that setting represents ¼ the focal length of the lens; if the diaphragm is set at *f/*11, the diameter of the aperture is $\frac{1}{11}$ the focal length of the lens.) The relative-aperture ratio can be written as a simple formula:

$$f/\text{number} = \frac{F \text{ (focal length of lens)}}{D \text{ (diameter of effective aperture)}}$$

This same relationship can be stated mathematically by the *inverse square law:* the intensity of light varies inversely with the square of the distance from the light source. The diagram in figure 4.8, with its accompanying explanation, visualizes clearly how this applies to photography.

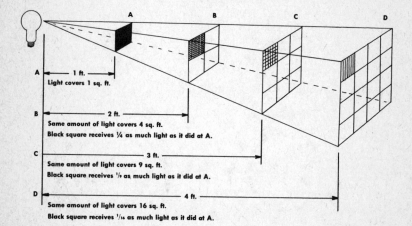

Fig. 4.8. Inverse square law. Example: If you place a card one foot from a light source, the light striking the card is of a certain intensity. If the card is moved two feet away, the intensity of the light decreases with the square of the distance (2^2 or 4 times) and is ¼ as bright. If the card is moved three feet away, the decrease is 3^2 or the light is ⅑ as intense. If the card is moved four feet away, the light is 1/16 as intense.

Applying this law to the *f*/number formula: if the focal length of a given lens is 8 inches and the diameter of the maximum effective aperture is 2 inches, the lens has a relative aperture of 4. The same *f*/4 rating would apply to a lens with a 4-inch focal length and a 1-inch aperture, or to a 6-inch focal length and a 1½-inch aperture. If the focal length is 8 inches but the effective aperture has a diameter of 4 inches, the lens has an *f*/2 rating. (Since inches are easier to visualize than millimeters, the foregoing examples are stated in focal lengths of large-camera lenses.)

From this you can see that if D (diameter of lens opening) is decreased, the ratio (*f*/numbers) will be increased. As the *f*/numbers increase, the relative apertures decrease. For exam-

ple, an $f/22$ stop on a lens will be one of the smallest openings with relatively less light-transmitting capacity. The lowest f/number on the lens will admit the greatest amount of light.

THE f/VALUE SYSTEM. The system of f/numbers used to calibrate diaphragm openings was devised to standardize the markings on a wide variety of cameras. It is found on most cameras today, although a comparatively new calibration, known as the *Exposure Value System* (EVS), is being used on some cameras with cross-coupled lenses and shutter dials. (EVS is discussed in chapter 7.) Cameras with EV numbers usually have the f/markings also.

Being a ratio of the lens's focal length and opening diameter, the same f/number can be expected to transmit the same amount of light on any camera, whatever its focal length, provided that other factors remain constant. Since the shutter speed determines the length of time the light will be in contact with the film, f/stops and shutter speeds are generally lined up in a series of equivalent exposures on the lens scale.

Standard Full Stops. The f/values on a scale of full stops are arranged so that each f/number, going up the scale, transmits half as much light as the next. Or looking at it from right to left, going down the scale, you will find that each opening doubles the amount of light. (Remember those fractions—$\frac{1}{4}$ is larger than $\frac{1}{16}$! If you are not mathematically minded, the figures may not *look* as if each represented half as much light as the next, but don't worry—it does; the scale has been figured out by experts.) The standard full stops are:

$f/1$ $f/1.4$ $f/2$ $f/2.8$ $f/4$ $f/5.6$ $f/8$ $f/11$ $f/16$ $f/22$ $f/32$ $f/45$ $f/64$

On most lenses, and on all American lenses, the lowest f/number represents the *correct value for the maximum aperture* and often does not correspond to a full stop. For example, many popular good cameras have an $f/3.5$ lens, with the next marking at $f/4$. Some cameras have markings for other intermediate or half-stops, such as $f/4.5$ and $f/6.3$. The aperture can be set anywhere between full stops whether marked or not. Most cameras do not go higher than $f/22$ on the scale. When a half-stop is the largest aperture, the half-as-much-light principle begins at the next f/number on that lens's scale. It is a good idea to memorize the full stops on the standard f/scale; in fact, their repeated use makes memorizing almost inevitable.

T-Stops. The *transmission stop system*, seldom employed now in photography, is based on the f/system. But instead of using only the focal length and effective diameter of the lens, the T-system takes into account the results of the scattering, absorption, and reflection of light, and the different effects of coated and uncoated lenses. By utilizing a photoelectric cell to measure light transmission, T-stops provide more precise calibration where extreme accuracy is required, as in some professional movie cameras. For T-stops to have any appreciable advantage over f/stops, other factors affecting exposure must have equally precise control.

Lens Quality. It is a recognized fact that there are no absolutely perfect lenses, although designers and technicians are making them better and better. Nevertheless, a moderately well-corrected lens of high-quality optical glass serves most photographic requirements very well indeed.

There are two general classifications of optical glass—*crown* and *flint*—and each can vary considerably. By combining different varieties of alkali-lime crown for low-dispersion characteristics with different types of heavier, more brilliant flint glass for high dispersion in different types of single lenses, it is possible to meet the specifications of almost any design in refractive and dispersive power.

Lens designs, figure 4.9, follow a variety of formulas, usually based on previous models, and may combine one to seven elements, or even more. Besides the types of optical glass for each element and the myriad surface curvatures, other considerations

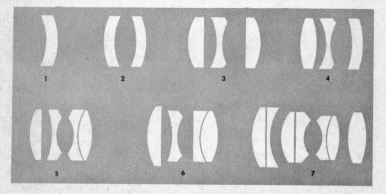

Fig. 4.9. Lens designs vary in number of elements and other details.

in the complicated process of designing a lens include the place-ment of the aperture, the positioning of the elements in relation to each other, and the air spaces. Before a new compound lens is manufactured in quantity, a prototype is subjected to a bar-rage of bench tests to ascertain how successfully the aberrations inherent in simple lenses have been corrected.

Computers have dramatically reduced the time required for designing complicated lenses, making possible an impressive variety of lenses having a far greater degree of accuracy than before; this fact has gradually made it unnecessary for a pho-tographer to test a new lens himself. Most modern lenses, with the exception of the lowest-priced ones, are so well corrected that only professional bench testing would be likely to detect any residual aberrations.

LENS TEST. For photographers who still wish to test their own lenses, there are a number of kits and charts available in most camera stores. The United States government and some specialty houses also offer test patterns for checking lenses and other photographic material.

For many photographers a satisfactory test of a new camera, or an accessory lens, is to put it through a trial run of black-and-white picture-making. Shoot a chosen subject at all the different settings on the f/stop scale, under the same conditions of light and steadiness. Make notes of exposure data, and be certain that no human error (such as hand-held shots that are not absolutely steady) invalidates your results. Bear in mind, too, that a high-speed lens on a small camera may at its largest apertures quite normally produce slightly less sharpness at the extreme edges of the picture than at the center. See that the film gets quality processing, then make a comparative study of the prints to decide whether they meet your own standards.

LENS ABERRATIONS. As previously noted, there are seven types of aberrations which a simple, uncorrected lens may contain. These should not really be considered defects, which might imply carelessness or lack of skill; rather, they are a normal condition caused by the behavior of light. Correction of these aberrations during the course of lens design and manufacture is essentially a matter of good balance, since total elimination of all errors all of the time is not possible. Only three of the seven aberrations defined here are affected by aperture size;

they are spherical aberration, coma, and astigmatism.

Chromatic Aberration. The failure of a lens to bring light rays of different lengths, or colors, to a focus on one plane is called *chromatic aberration.* The rays that make up white light will separate into their different wavelengths when passed through a prism or a single lens, as shown in figure 4.10.

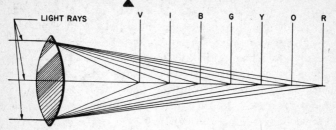

Fig. 4.10. Chromatic aberration in a convergent lens

A negative lens placed in optical contact with a simple positive lens causes sharper refraction of the longer wavelengths and less sharp refraction of the shorter wavelengths, thus pulling all of the colors nearer a common plane.

Spherical Aberration. The inability of a lens to focus parallel central and marginal light rays at the same plane along the optical axis is termed *spherical aberration.* This is a normal defect of a simple lens with curved surfaces and makes for lack of sharp definition: either the central area of the image will be sharp with softness in the edge areas, or vice versa, depending on the location of the focal plane.

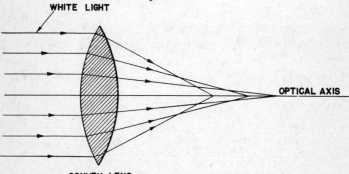

Fig. 4.11. Spherical aberration in a convergent lens

Spherical aberration, illustrated in figure 4.11, is inherent in divergent (negative) lenses also, but their concave surfaces will spread the rays up and down from the optical axis—just the opposite of the direction shown in the figure. A compound lens system equalizes these spherical errors by combining positive and negative lenses.

The design of a compound lens and its effectiveness must be looked at as a whole, however; it is not feasible to correct spherical aberration completely since that would adversely affect the chromatic correction. Additional reduction of spherical errors can be achieved by decreasing the aperture size of the lens, but this reduces image brightness as well.

Coma. The aberration labeled *coma* has a slight resemblance to a comet. It is produced by strong light rays passing through the lens edges at an angle and falling in much the same plane but at different distances from the optical axis. Because they are not accurately superimposed, such rays do not come to a true circular point but to a pear-shaped image, as illustrated in figure 4.12.

Image point is in the form of a coma

Fig. 4.12. Coma

Astigmatism. This aberration is the inability of a simple lens to project a sharp image of lines running at angles to each other —almost as if the lens had one focal length for horizontal and another for vertical projection. If you will look at figure 4.13, you will observe that when the horizontal line of the cross is in

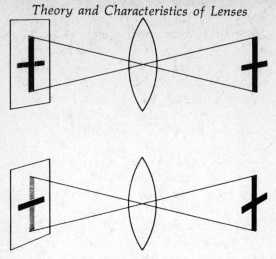

Fig. 4.13. Astigmatism

sharp focus, the vertical line is anything but sharp. By adjusting the focal plane to a greater distance from the lens, the vertical line can be focused sharply but the horizontal will be blurry. The most acceptable image of the cross will be formed by a midway focus between the horizontal and vertical focuses. Both lines will then be slightly and more evenly blurred. Whenever this error is present in a lens, it will be greatest at distances farthest from the lens axis.

Curvature of Field. When light passes through an uncorrected lens, an object with a flat surface is rendered at the film plane as a curved, saucer-shaped image (illustrated in figure 4.14). This *curvature of field*, which is closely related to astigmatism, increases with the distance from the axis of the lens, since a sim-

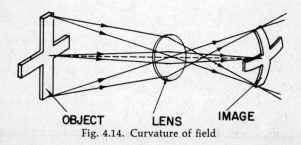

OBJECT LENS IMAGE
Fig. 4.14. Curvature of field

ple lens is not capable of producing sharpness at center and edges simultaneously. Lenses corrected for both astigmatism and curvature of field are designated "anastigmat," and are usually corrected for other aberrations as well.

Curvilinear Distortion. When a simple lens renders straight lines in a subject as curved lines in the image, the error is known as *curvilinear distortion.* This lens condition, which does not

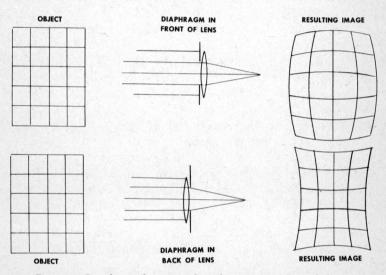

Fig. 4.15. Curvilinear distortion: barrel (*top*), pincushion (*below*)

affect the sharpness of the image, can be eliminated by placing the diaphragm in the center of a symmetrical lens—that is, a lens with duplicate elements in front of and in back of the diaphragm. Center placement of the diaphragm is often preferred in lens design because it also eliminates coma and transverse chromatic aberration (color-magnification error). In asymmetrical lenses, distortion can be controlled by the use of symmetrical lens elements.

There are two types of curvilinear distortion: when the image lines curve out toward the picture edges, it is *barrel distortion;* when the image lines curve in toward the center, it is *pincushion distortion.* In the case of a single lens, or elements cemented into a single unit, the diaphragm placement is generally in front

of the lens, because barrel distortion is considered the less objectionable of the two types.

Color Magnification, also called Transverse (Lateral) Chromatic Aberration. The error called *color magnification* is independent of the axial chromatic aberration already described and can exist separately from it. If color-magnification error is present, it can alter the apparent size of objects. The effect is not noticeable near the lens axis but increases toward the edges of the lens field, a typical result being color fringing along the image boundaries. Symmetrical lens design is used to overcome this aberration.

Flare. Besides the aberrations just explained, a lens may develop the problem of *flare*, caused by multiple reflections of light at the glass-air surfaces of the lens elements. In the course of correction, a good lens acquires a great number of these reflecting surfaces, which may result in internal reflections and double images. Whenever a definite secondary image is formed, whether out-of-focus or sharp, it is termed a *ghost image*. Such double images usually appear to have spots of light extraneous to the main image. When smaller apertures are used, the light spots may sometimes assume the shape of the diaphragm opening.

Under average photographic conditions, flare is generally not a problem. You should watch out for it, however, when there is a strong light away from the lens axis, such as a lamp or window reflection indoors, or a street lamp or chrome trim on cars outdoors. The through-the-lens viewing of SLR cameras will show a flare condition and permit a careful photographer to eliminate it by adjusting his camera position. Flare cannot be observed through other viewing systems.

Coatings on modern lenses are effective in subduing optical flare. Like many another invention, this one originated in a casual discovery—that old lenses with a blue tarnish had less flare and transmitted more light than untarnished lenses. Early tries at duplicating this result did not succeed very well: the synthetic tarnishes were so soft that they either became scratched or were wiped off easily. Today's low-reflection coatings are durable enough to withstand cleaning satisfactorily; furthermore, today's lenses are so designed that ghost images are not troublesome even without special coatings. Good design and good coat-

ings, while not eliminating ghosts completely, have reduced their haunting power to a minimum.

Individual Features. There are certain individual features to consider when selecting a camera, and one of the most important is the availability of optional equipment such as interchangeable lenses. For cameras which do not have fixed lenses, there is an abundant choice for general photographic purposes and for specialized work. Focal lengths can range from less than 8mm to 2000mm, or even longer; however, most photographers choose extra lenses which are well inward from the two extremes, usually a 20mm-to-200mm range. *Zoom lenses,* with continuously variable focal lengths within that approximate range, are also available for hand cameras with lens interchangeability.

As explained earlier in this chapter, the focal length of the lens governs the size of the image. It also governs *perspective,* which is the apparent relationship of objects at different distances, and *depth of field,* which is the near and far boundaries within which a scene is in acceptably sharp focus.

The angle of view of a lens varies in proportion to the focal length. Shorter lenses, because they are closer to the film, record a wider view of a given scene than does a normal lens. Longer lenses, being farther from the film, record a narrower view of the same scene. The angle of view of a normal lens is approximately 45 degrees.

The accessory lenses most in demand are wide-angle and telephoto, although zoom lenses for still cameras are becoming more numerous. The angle of view of wide-angle lenses can exceed 180 degrees. Telephoto lenses, on the other hand, have a much narrower angle of view, which can range from a normal down to an extreme of less than 4 degrees.

Such lenses are fully automatic, requiring no settings beyond those on the camera with which they are used. Some which are made for a specific brand of camera can be used on certain other cameras by means of a special adapter. Another difference is in mounts: they may be threaded to screw into the camera body or they may be a "bayonet" type, which clicks into position in the camera with only a partial turn.

Wide-angle lenses are used mainly for working in limited space. They permit inclusion of a larger picture area when it is not possible to move the camera far enough back from the sub-

ject to include all of it with a normal lens. With a wide-angle lens you can take in a wider portion of a room interior, for example, or a group of people in a restricted space. Outdoors it can be used to photograph such favorite subjects as a quaint house on a narrow foreign street or a scenic panorama such as the sailboats (which could be taken with a 35mm lens) in figure 4.16. When using a wide-angle lens, remember that the shorter focal lengths tend to exaggerate distances and to distort objects close to the lens.

Telephoto lenses are used to bring a subject closer to the photographer when it is impractical or undesirable to move a camera with a normal lens closer to the subject. Although all long lenses are generally referred to as "telephoto," a distinction should be noted between these and "long-focus" lenses. *Telephoto* properly designates a specific kind of construction that makes the distance from lens center to film plane shorter than the inscribed focal length. The shorter length of telephotos makes for greater facility in handling. *Long-focus* lenses, by comparison, are simpler in construction but physically longer than a telephoto lens of the same focal length. Also, long-focus lenses generally have smaller maximum apertures and are more easily corrected for aberrations than telephotos.

Both telephoto and long-focus lenses are designed for a long-focus and narrow-angle effect, and perform the same function. They are very useful when you cannot get as close as you would like to a subject—just as wide-angle lenses are useful when you cannot get far enough away. A telephoto lens can abstract a small area of a large landscape, or reach out to catch the expression of a child absorbed with a new toy, or photograph an animal on the far side of a zoo cage, like the lioness in figure 4.17.

Zoom lenses are lenses with a continuously variable focal length. Originally developed for movie cameras, zoom lenses have gradually become available for still cameras. Improvements in design have brought them increasingly into favor with photographers who use several telephoto sizes, especially the bulkier lenses like 200mm and 400mm. An average popular zoom lens may extend from an 80mm to a 200mm focal length, a range which includes the most frequently used telephoto lengths in one accessory. Besides lessening the bulk and weight of a camera bag, a zoom lens can also reduce the chance of losing a picture opportunity while changing lenses.

Fig. 4.16. *Above:* A wide-angle lens can include relatively broad views. (Courtesy of Scholastic High School Photo Awards)

Fig. 4.17. *Below:* Telephoto shot of lioness awaiting feeding time. (Courtesy of the Newspaper National Snapshot Awards)

Shutters. Another of a camera's individual features is its type of shutter. The shutter of a lens is the mechanical device governing the length of time that light is in contact with the film. After the diaphragm has been set to the f/stop desired and the shutter-speed indicator set for the *time* desired for the exposure (1/60 and 1/125 of a second are common exposure times), the shutter is first cocked by a lever which puts it at-the-ready, then tripped by a release lever to admit light for the set period. *The amount of light for any exposure, therefore, is controlled by the diameter of the diaphragm opening and the length of time it remains in open position.*

Although it is good practice to set the lens aperture anywhere you choose between full stops on the f/scale, it is not advisable to set the shutter between the speeds indicated on the lens mount. In the first place, most shutters will not work at an in-between timing but will trip at whichever time the indicator is nearer. In the second place, there is the possibility of damaging the shutter, which is not equipped to decide whether you want 1/60 or 1/125. Also, don't leave the shutter cocked for long periods. It is not good for the shutter, and you will probably trip it unintentionally and waste one picture anyway. All this having been said, it should be noted that with the continuing rapid development of electronic diaphragms and shutters, it seems highly probable that any discussion of manually adjusted exposure controls may soon become academic and applicable mainly to vintage cameras.

There are at present three types of lens shutters, each with its particular advantage for different photographic aims: between-the-lens, focal-plane, and the less familiar behind-the-lens.

BETWEEN-THE-LENS SHUTTERS. The most frequently used type is the between-the-lens shutter, and it is placed just where its name indicates: with the iris diaphragm between the front and rear elements of a compound lens. It consists of overlapping metal leaves which spring open when the shutter release is pressed, allow the light to pass through for the time specified, then spring shut. The midway placement is especially effective in correcting distortion, as explained above in the section about aberrations. These shutters (also referred to as "leaf shutters") usually have timings up to 1/500 of a second, although a few boast higher speeds. One advantage is that, unlike focal-plane

types (see below), which synchronize with flash at only a very limited number of shutter speeds, the leaf shutters generally synchronize at any setting up to 1/500 of a second.

Between-the-lens shutters are used primarily in fixed-lens cameras. An interchangeable-lens camera designed with a between-the-lens shutter requires an individual shutter for each lens, which becomes prohibitively expensive for many photographers. For this reason it is considered more practical to use a focal-plane shutter or the rarer behind-the-lens type when interchangeability of lenses is a prime consideration.

FOCAL-PLANE SHUTTERS. These consist of lightproof curtains, usually of rubberized black cloth but sometimes of extremely thin and flexible metal, mounted on spring-tension rollers; they move just in front of the film to admit a slit of light when the shutter is released. In 35mm cameras a focal-plane shutter consists of two curtains on opposite rollers; the curtains overlap at the center and may move horizontally or vertically as they open to admit a strip of light and quickly close. In larger cameras a standard single curtain has slits of varying widths which traverse the film plane.

The advantages of these shutters are that their position back at the focal plane permits easy interchangeability of lenses and that they have high speeds, usually to 1/1000 of a second. Their versatility and speed make them preferred for action photographs, especially in press cameras. However, they cannot be used with electronic flash at the highest shutter speeds. Also, the location and speed of focal-plane shutters do contribute to positional distortions. These distortions are quite apparent with cameras when the curtain slits admit light in successive strips; a fast-moving car, for instance, can take on a stretched, forward-straining appearance because the image was not recorded all at once. Other distortions of focal-plane shutters depend on the direction in which the curtain slit moves in relation to the image. When you are photographing action, distortion will be minimized if the movement of the shutter curtains corresponds to the movement of the action. If you know how your own shutter moves, you can hold the camera horizontally or vertically to match the shutter movement to the subject movement.

BEHIND-THE-LENS SHUTTERS. Developed primarily for lens interchangeability, behind-the-lens shutters have overlapping blades

and operate the same as between-the-lens shutters, with similar speeds, but they are placed at the back of the lens mount instead of in the lens itself. Behind-the-lens shutters provide easy inter-changeability but, of course, they offer less distortion correction.

SHUTTER MARKINGS. Some cameras have shutter speeds that include 1/25, 1/50, 1/100, and so on, in their markings. Corresponding markings on other cameras are 1/30, 1/60, and 1/125. The newer system of markings is 1 second, 1/2, 1/4, 1/8, 1/15, 1/30, 1/60, 1/250, and 1/500, designed to permit a more nearly exact doubling of shutter speeds. However, for all practical purposes the exposure values are the same for either series.

LENS CARE

As with any valued, delicate instrument, proper care is primarily common-sense care. Treat your lens with respect and appreciation, and a good lens will serve willingly and well. If a lens is in need of repair, take it to an expert for diagnosis and prescription.

Your lens should be protected from bumps and falls, from extremes of temperature and dampness, from fumes and salt spray, from dust and finger marks. You may sometimes prefer to use your camera without a case, but the leather protection does cushion a camera against minor encounters with the outside world.

Always store your camera carefully. Where you keep it when it's not in use depends, of course, on climatic conditions and available facilities. But if you live in a hot and humid area—or are traveling through a steamy jungle—try to find a dry cabinet or locker in which a moderate temperature can be maintained. If you do not have a case for it, keep the camera in an unsealed plastic bag.

Among the worst storage spots (for camera or film) are the temptingly convenient glove compartment of a car and the ledge inside the car's rear window. Almost as bad is a casual window-sill at home, since any lengthy exposure to the elements, especially direct sunlight, can weaken the lens structure as well as necessitate cleaning. By keeping the camera in its case or using a protective lens cap whenever you are not taking pictures, by handling it carefully and storing it sensibly, you can avoid most

of the dust and finger marks which might cause lens damage and beclouded images.

It should rarely be necessary to clean camera lenses if you abide by the simple rules of good camera care. But when obvious finger marks, dust particles, and moisture call for cleaning, do it *gently*. First, use a very fine camel's-hair or sable brush on the surface. If light brushing does the trick, go no further. But if smudges seem to cling, wipe the surface very gently with a soft lens tissue or fresh lint-free linen handkerchief. Ordinary paper tissues or silicone materials should not be used as they affect the porous lens coatings. If the surface has any greasiness, as might come from finger marks, you may need to moisten the tissue or linen slightly with a lens cleaner.

Never use acids, alcohol, or any other agents except a professionally recommended lens-cleaning fluid. Apply minimum pressure with a circular motion, and use the fluid very sparingly, since even an approved cleaner can be harmful if it seeps into the lens mount.

If the condition of your lens calls for more than superficial cleaning, do not attempt to take the camera apart or otherwise tamper with it. Rather, take it to a reputable photographic dealer, preferably to the store where you bought it or to a licensed representative of the manufacturer. If this is not possible, write the manufacturer for advice about sending your camera to the company for reconditioning.

Focusing the Lens

Focus in photography means just what it means outside photography. The eyes bring objects into focus by adjusting to different distances and to different degrees of darkness and light. Actually, the right eye sees a view slightly different from the one seen by the left eye, but in normal eyesight the views converge simultaneously into a single, distinct view.

The photographer focuses a lens on a given object at a given distance in order to control the light that reaches the focal plane and to assure the formation of a distinct image on the film. Some focusing aids and the factors affecting sharpness of focus are discussed in this chapter.

VIEWING SYSTEMS

Since the viewfinder in which you compose your picture is one of the most important points of camera differences, you should investigate various types to determine which one suits you best. Convenience and efficiency are matters of individual preference, and the choice is sometimes dependent on one's eyesight. For instance, if eyeglasses interfere with his getting close enough to an eye-level viewfinder to see the complete frame, the photographer may want to consider a waist-level type. Viewing systems allow for many refinements; there are even prescription eyepieces for photographers who wear glasses. The majority of viewfinders, however, may be broadly classified as two types: (1) direct-vision, including rangefinder mechanisms, and (2) reflex types, incorporating ground-glass focusing screens.

Direct-Vision Viewfinders. With the direct-vision finder, the

photographer looks through a small "window" at the top of the camera to frame his subject. In the less expensive cameras, this window has no provision for focusing and is generally referred to as a *simple viewfinder*—or, more often, the camera itself is called a *simple camera*.

Rangefinders. A simple camera becomes a rangefinder camera when the manufacturer incorporates an optical mechanism which measures the distance between the lens and the subject to indicate proper focus. This rangefinder is attached directly to the focusing mechanism, which is often referred to as a *coupled rangefinder system*, and which allows the photographer to frame and focus at the same time.

Either a superimposed- or a split-image technique is used for focusing. With a superimposed image, you would see an out-of-focus subject as a doubled image. By manipulating the focusing knob until the two images become single, you get the subject into correct focus. (See figure 5.1.) A split-image rangefinder

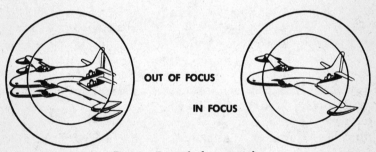

OUT OF FOCUS

IN FOCUS

Fig. 5.1. Rangefinder principle

works much the same way, except that instead of a doubled image, you would see the subject split laterally left and right. By focusing until the split or separated elements are brought together, you get the subject into correct single-image alignment.

Reflex Viewfinders. The two types of reflex viewing systems, single-lens and twin-lens, both utilize an image-reflecting mirror and a ground-glass focusing screen. The mirror is placed behind the lens at a 45° angle so that it reflects the image of the subject to a ground-glass screen near the top of the camera. When the focusing is done directly on the ground glass, as in twin-lens cameras, the image is reversed laterally left and right. In most

single-lens reflex cameras, this lateral reversal is corrected by a pentaprism (a five-sided glass prism) inserted between the focusing screen and the viewing eyepiece.

Single-Lens Viewing. Because of the advantages of its through-the-lens viewing and lens interchangeability, the single-lens reflex has during recent years supplanted the rangefinder camera in popularity. With any lens—normal, telephoto, or wide-angle—the single-lens viewing system shows the picture-taking field almost exactly as it is recorded on the film and as it will appear later in a slide or print (allowing a very slight margin for the overlap of slide mounts or trimming of prints). This eliminates the problem of parallax, which occurs when a camera has separate viewing and taking lenses (see below). The SLR advantages are especially important in normal close-ups, as well as in macrophotography and other highly specialized fields. For particular photographic problems, a few SLR cameras have interchangeable screens for greater focusing flexibility.

Twin-Lens Viewing. With a twin-lens viewfinder, the photographer looks down into a hooded ground-glass focusing screen which shows the image right side up but reversed left to right. This waist-level viewing is sometimes preferred by people who wear glasses and have difficulty getting close enough to an eye-level viewfinder to see the full frame for proper focusing. The two lenses of a twin-lens camera are connected and move together during focusing. The viewing (upper) lens is used only for focusing and usually has a fixed aperture, slightly larger than the taking lens. The taking lens, shutter, and diaphragm are all contained in a compartment in the lower part of the camera body. This separation allows the photographer to see a fully lighted image at all times.

Twin-lens reflex cameras, as well as simple and rangefinder types—in fact, all cameras except those with single-lens viewing—are subject to the problem of parallax.

PARALLAX

The apparent displacement of an object when seen from two different viewpoints is termed *parallax*. Photographically, it is not at all mysterious, since what you see on the ground glass of a twin-lens reflex or through the window of a rangefinder cam-

era is not quite the same as what the picture-taking lens sees. This is because the lens is slightly separated from the viewfinder, and this separation produces the minor discrepancy called parallax. Usually this problem does not exist beyond about six feet from the camera, but at closer distances correction of parallax must be considered.

Since any lens records an inverted image on the film (see chapter 3), uncorrected parallax results in cut-off tops of picture subjects. The closer the camera gets to the subject, the greater becomes the lens-viewfinder discrepancy. Parallax is especially disconcerting when one takes pictures of friends: all too frequently the tops of their heads are missing in the finished photographs.

Cameras with through-the-lens viewing have no parallax problem, and, of the non-SLR types, all except the most inexpensive have some kind of parallax-correction device. Often this consists of guidelines etched into the glass of the viewfinder. Under the ground-glass screen of some twin-lens reflexes, there is a movable frame which shifts automatically to compensate for parallax as the photographer changes camera position. If you have a non-SLR camera, be sure to read the instructions that come with it to see if the manufacturer has made any provisions for parallax correction. If there are none, you will have to determine your own parallax compensation by trial and error. For subjects closer than six feet, try tilting the camera almost imperceptibly *toward the viewfinder*: if the camera is held horizontally, tilt it up; if held vertically, with the viewfinder to the right, turn the camera very slightly in that direction. The closer the subject, the more tilt you will need. Practice and a comparative study of your prints or slides is the only way to learn the correct tilt for a particular camera.

FACTORS AFFECTING SHARPNESS

Circle of Confusion. In bending light rays to produce an image, the lens ideally projects cones of light to fine points on the focusing plane. But just as no lens is perfect, so the image points are not perfect points, but actually infinitesimal circles of measurable light. Hence, circle of confusion refers to the diameter of an image point as formed by a given lens. A lens has its

own fixed minimum circle of confusion; in high-grade lenses this is generally less than $\frac{1}{1000}$ of an inch. If the circles of confusion are extremely small, they have the sharp effect of true points unless other factors are contributing to a blurred result.

The fact that a good lens can bend subject light rays into cones and bring them to sharp points at a specific distance poses the problem of what happens at other distances. Absolutely sharp focus is possible only for a subject at a known distance. When objects nearer or farther than the in-focus subject form cones of light that strike planes in front of or in back of the critical focal plane, you get small circles instead of points, as shown in the diagram in figure 5.2. These circles are simply

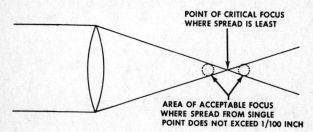

Fig. 5.2. Circle of confusion

cross sections of coming or going cones of light. When an image is made up of millions of true or nearly true points, you get sharpness; but when an image is composed of millions of over-lapping little circles, you get a dandy blur.

The acceptable circle of confusion is generally regarded as $\frac{1}{100}$ of an inch or less in prints held at a normal viewing distance of ten or twelve inches. If this is a contact print and you want to enlarge the negative, the allowable circle of confusion decreases proportionately to the blowup size. For example, if the final print is to be enlarged ten times, the picture should be made with a lens corrected to produce a circle of confusion no larger than $\frac{1}{1000}$ of an inch in order to assure the $\frac{1}{100}$-inch acceptability in the finished enlargement.

The *resolving power*, or *definition*, of a lens is its ability to form sharply defined images. The same term is applied to film to indicate the capacity of the emulsion to reproduce fine detail

in the image. The lens's minimum circle of confusion, which is dependent on the quality of the lens, controls the resolving power—that is, the maximum definition of which the lens is capable.

Perspective. Normal human eyes see things in three dimensions: length, width, and depth. A photographic lens "sees" only the first two of these dimensions. A skillful photographer therefore compensates for the missing third dimension with a suggestion of depth in the relative size and position of the different parts of the scene. This relationship of near and far objects as they appear to the eyes from a given viewpoint is termed *perspective*. Figure 5.3 is a classic example of perspective, with the receding lines of the landscape appearing as normally viewed.

Fig. 5.3. Perspective

The position of the camera and the focal length of its lens are important in controlling the apparent relation and position of objects in a picture. By a discerning selection of viewpoints the photographer can achieve a remarkable diversity of results, creating the illusion of space and distance in a flat two-dimensional plane.

Positioning the camera at a distance from the scene makes the background seem disproportionately large in relation to the foreground and makes the distance between foreground and background seem considerably less than it actually is. Bringing the camera up close to the scene produces the opposite effect: the size of the foreground seems exaggerated in proportion to the background, and the distance between the two seems greater. For an example, look at the illustrations in figure 5.4.

Fig. 5.4. *Above:*
Camera viewpoint at
a distance (negative
enlarged) *Right:*
camera viewpoint up
close

A lens with a longer focal length has a narrower field than the
area covered by one with a shorter focal length. (The normal
focal length, you remember, is approximately equal to the diag-
onal of one film frame.) However, you can obtain the same per-
spective with lenses of different focal lengths, although the
effects will not be exactly alike. For example, if a negative from
a lens of short focal length is enlarged and the view restricted to
the narrower one made by a longer focal length, the perspective
in both prints will seem about the same.

Size of image, therefore, is controlled by focal length, other
factors remaining the same. Briefly again, a longer focal length
will produce a larger image in less area and a shorter focal length
will produce a smaller image in a larger area.

Hyperfocal Distance. The nearest distance at which a lens can

be focused to produce a reasonably satisfactory sharpness in everything from half that distance to infinity is the *hyperfocal distance* of that lens. This varies with different lenses and with different apertures. Some manufacturers provide hyperfocal-distance tables (worked out from a mass of mathematical calculations based on the focal length, minimum circle of confusion, and the *f*/stop being used), but it is quite simple to get this information from a depth-of-field scale. Adjust the focusing mechanism so that the aperture you intend to use is opposite the scale's infinity mark and your lens will then be focused at its hyperfocal distance.

Depth of Field. The area between the nearest and farthest points in acceptably sharp focus is called the *depth of field*, and it is illustrated in figure 5.5. Depth of field is affected by (1) the distance of the subject from the lens, (2) the size of the aperture, and (3) the focal length of the lens. Depth-of-field computations are based on all the factors that make up the hyperfocal distance, including the focal length of the lens, circle of confusion, and the *f*/number being used.

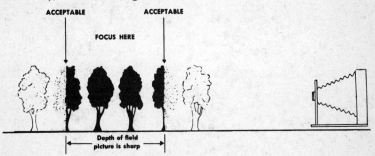

Fig. 5.5. Depth of field

Various depth-of-field indicators are found on many modern cameras, and the individual instruction booklets should be consulted. Or you can consult a separate depth-of-field card on which you can dial the distance to be focused upon, then read the near and far distances within which your subject will be in focus at different apertures. (See figure 5.6.) As an example, if you have focused a 50mm lens at a distance of 10 feet and wish to use an aperture of *f*/11, everything from just under 7 feet to approximately 20 feet will be in acceptably sharp focus. With an

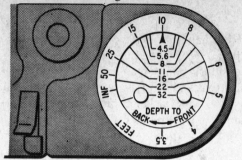

Fig. 5.6. A typical depth-of-field scale

aperture of $f/4.5$ at the same 10 feet, your picture will be in focus from about 9 feet to about 13 feet.

You will notice that *decreasing the lens aperture increases the depth of field* and that *lengthening the distance at which the lens is focused increases the depth of field*. Bringing your focus in to 3 or 4 feet for a close-up, with a wide aperture, will reduce the depth of field to a minimum. Figure 5.7 shows how opening up or closing down the lens affects depth of field. Observe now that the lines in the diagram take cone shapes, like the cones of light described under circles of confusion, a wide-open lens producing short, wide cones and a small aperture producing long, narrow ones.

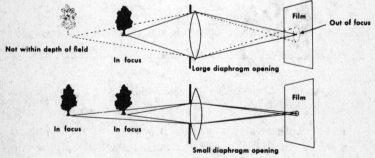

Fig. 5.7. Effect of aperture on depth of field

When maximum depth within a given scene is desired, use your depth-of-field scale to determine the most effective setting. Suppose you are using a 35mm camera with an average 50mm lens and find that you want the area between 6 feet and 20 feet

to be in focus; the depth-of-field scale will indicate a small, $f/16$ opening and a distance setting of almost 10 feet as your best bet.

Zone Focusing. If you are photographing a children's game, a group of dancers, or any activity confined to an approximate zone of predictable distances from your camera, focus on a distance about one-third into the area and check your depth-of-field scale. Suppose you estimate that the subject (or subjects) will move within a range of 8 to 20 feet. If you focus at 12 feet, you will find that a reasonably sharp image can be expected in a zone of 8 to 20 feet. Some simple cameras are preset for three focusing zones: a close area for a single subject, a medium zone for groups, and a distance zone for scenery.

In considering depth of field and other aspects of photography, it is necessary to be aware that "sharpness" is a relative term. Quite obviously, a lens cannot focus exactly on different objects at different distances simultaneously. Some compromise is inevitable, a fact which explains why a qualifying adjective such as "reasonable" or "satisfactory" or "acceptable" is generally used when discussing sharpness.

6

Structure and Types of Films

Films are the light-sensitive materials on which your camera lens records the pictures you elect to take. The term is no longer confined to the thin, transparent, emulsified medium that is used to register negative images and from which prints can be subsequently reproduced on positive material. *Film* is now the accepted designation for any negative-producing material, regardless of its flexibility or thickness and regardless of whether the negative is made on cellulose, glass, or paper. Most of us give little thought to a film's construction these days, nor is it necessary to do so; like the telephone and the jet airplane, it has become a taken-for-granted miracle.

The visible and invisible effects of light on everyday objects are all around you: a wall that darkens; a curtain that fades; substances that become insoluble under light; plants that absorb carbon and release oxygen by using the radiant energy of light. Photographic developing relies on the properties of compounds which are made to yield to specific reactions by exposing them to light. This principle applies photographically to metals, especially the halogen salts of silver.

STRUCTURE OF FILM

Light-sensitive materials comprise two main parts: an *emulsion*, which records images, and a *base*, or support, on which to spread the emulsion. This applies also to positive light-sensitive materials, or printing papers, which are discussed in chapter 19, but in this chapter we are considering only *negative materials*.

Emulsions. Fundamentally, a photographic emulsion is chemi-

cally pure gelatin holding in suspension microscopically fine salts of light-sensitive silver bromide. Since the complex process itself is of no vital concern to you as a photographer, only a brief description covering information of fairly general interest is included in this text. What is important, of course, is a working knowledge of the characteristics and performance of the finished product.

To begin with, pure gelatin is water-soaked to a swollen state (much like dried legumes before cooking) and then gradually heated to dissolve it completely. To the gelatin solution is added a quantity of halogen salts; then silver nitrate, which is obtained by dissolving bars of silver in nitric acid, is added under darkroom conditions to produce light-sensitive crystals of silver bromide. The silver bromide grains, insoluble in water, are held dispersed and suspended by the gelatin and can be seen (sort of cream-colored) all through it. At this point the gelatin mixture becomes an emulsion instead of a solution.

The emulsion is then "ripened" by repeated heating and chilling to recrystallize the silver bromide and to fix the size-frequency of the particles. After the ripening process, when the emulsion is in a jellied state, it is slivered into small strips, washed to remove the excess soluble salts, and reheated to receive the addition of hardeners, preservatives, and other special-purpose agents.

At various phases of the procedure, technicians control the built-in qualities of the finished film. For example, the longer the "cooking" period, the larger will be the silver bromide particles and the greater the emulsion *speed;* the larger particles account for the relatively coarse grain of very fast films. When all the various substances have been incorporated, the emulsion is ready for application to the supporting base.

Bases. Supporting bases for light-sensitive emulsions vary according to their intended use. Generally, you will find all *negative* materials (which we are discussing here) on transparent bases and all *positive* materials (such as printing papers) on opaque or translucent bases. But, like every other generalization, this one has its exceptions: color transparencies, lantern slides, and movie "films" are positives on transparent bases.

Pioneer photographers almost always rolled their own emulsions onto glass plates—a procedure that required steady hands,

stout hearts, and clumsy equipment. But glass was the only available material that was clear, chemically inert, and that would not swell or shrink in solutions. Glass plates are still in limited use as emulsion supports but, needless to say, photographers no longer have to construct their own. They are preferred for some portrait and commercial work, for some types of photogrammetry, for lantern slides, and for special situations where rigidity with no expansion-contraction is sufficiently important to outweigh the disadvantages of bulk and breakage.

Transparent film bases for light-sensitive emulsions have come a long way from the early postglass products and are still being continually improved. The first flexible transparent bases to prove satisfactory on many counts were so highly flammable that they constituted a storage danger as well as a handling hazard, and if ignited, their fumes were not only disagreeable but toxic.

It was not easy to find new materials to fill these rather exacting specifications; chemically, they had to be stable, moisture resistant, and capable of furnishing good adherence without reacting on the emulsion. Physically, they had to be light but tough, stiff but flexible, hard but not brittle, and resistant to curling and tearing. Optically, of course, they had to be perfectly and colorlessly transparent. The fact that they should also possess dimensional stability so they would not buckle when the edges became shorter than the center, or flute when the edges became longer than the center, made certain compromises inevitable.

Safety bases of cellulose acetate have been replacing cellulose nitrate films for many years. Because of their greatly reduced flammability, these modern products are called *safety films*. Although acetate will burn while in direct contact with a flame, it is easily discouraged and quits when the flame is withdrawn. And while you would never mistake its fumes for a rose garden, the rather acidy odor is nontoxic. To make these bases, cellulose or cotton derivatives are dissolved into a gooey solution to which "dope" (a textile term) has been applied. (When your acetate or rayon shirt is "dope-dyed," its color has been added to the synthetic fiber solution, or dope.) The volatile dope for film is fed onto enormous polished-metal drums where heat drives off the excess solvents until the solution acquires suffi-

cient body to be removed to other machines for drying and winding. The thickness—or thinness—of the safety bases depends on the kind of film. Roll films and film packs have very thin, flexible bases, while those for 35mm and movie films are a bit thicker; sheet films usually have still more body.

So, EMULSION + BASE = FILM. But manufacturers give you a few extras in the precise process of putting these two major components together. Between base and emulsion there is a special adhesive subcoating of cellulose and gelatin which assures better adhesion than the cellulose base alone provides. On top of the emulsion there is usually a very thin antiabrasion overcoating of clear gelatin to counteract scratches and friction before the film gets to the developing stage. Underneath all this, sometimes incorporated in an anticurl coating, is an antihalation backing to keep the halo of secondary light around a particularly bright object, like a street lamp, from spreading through the film. It is hard to believe that so many elements, so much scientific accomplishment, can be contained in the wonderful, almost weightless bit of material you insert so casually into your camera.

BLACK–AND–WHITE FILMS

If you read the following explanation of black-and-white film characteristics thoughtfully, you will realize that much of it applies also to color film. A basic difference is that color film has three layers of emulsion, while black-and-white has only one. A black-and-white film structure is layered like this:

> Protective overcoating
> Emulsion
> Adhesive subcoating
> Supporting base
> Antihalation backing

Some films are engineered to meet very precise requirements, while others can be expected to serve multiple photographic purposes very satisfactorily. There are several qualities to consider in choosing film and, as always, experience will prove to be the most effective guide. A study of the following points should help you decide which black-and-white film will give you best results

under certain conditions and will best fill your individual needs.

Film Characteristics. The most important characteristics to consider in choosing your film are: (1) color sensitivity, (2) speed, (3) contrast, (4) latitude, (5) grain, and (6) resolving power. In addition, one must consider the available packaging—whether a particular kind of film comes in a size to fit your camera.

COLOR SENSITIVITY. Although negative emulsions fall into four categories of color response, rendered in black and white as brightness differences, only panchromatic emulsions are of much interest to most photographers because of their great versatility, pleasingly normal values, and adaptability to a longer range of daylight hours. The different types of black-and-white film, in order of sensitivity to color, are: monochromatic, orthochromatic, panchromatic, and infrared.

Monochromatic, sometimes termed "blue-sensitive" or "color-blind," has a basic sensitivity only to the blue-violet end of the spectrum; all other colors reproduce as unlighted darks. These emulsions are mainly for specialized commercial uses, particularly photocopying.

Orthochromatic emulsions, which now have a very limited availability in commercial sheet film, gave way long ago to panchromatic. Once the old reliable of amateurs, ortho films responded to the blue-violet range and also to the green-yellow areas of the visible spectrum, with reds showing only as darks.

Panchromatic emulsions, as the name implies, are sensitive to all colors of the visible spectrum, including red, and offer a wide variety of speeds and tone ranges. In general, their sensitivity parallels that of the human eye, which makes these emulsions by far the most popular black-and-white film choice at present.

Infrared emulsions are highly sensitive to red rays beyond the humanly visible spectrum. They also have an ultraviolet-blue sensitivity band, with very little yellow-green sensitivity. Infrared films are used a great deal for aerial photography, particularly by the armed services; in medical research, astronomy, and other scientific areas; and sometimes just for dramatic pictorial effects.

SPEED. The emulsion speed, or rating, is quite likely to be an amateur's first concern in choosing film. A film's built-in sensi-

tivity to light has a direct bearing on the exposure required for correct negative density and a resulting satisfactory image. Ratings are assigned by the manufacturers according to a specific procedure set up in 1947 by the ASA (American Standards Association). In Europe the DIN (Deutsche Industrie Norm) rating system of Germany is usually used.

Film speeds have increased by leaps and bounds over the years, which is another way of saying that films need less and less light for satisfactory exposure. Films of high speeds—both black-and-white and color—offer freedom to photographers, making an $f/3.5$ or an $f/4.5$ lens as versatile as a much faster lens with a slow film. Seldom is it necessary nowadays to pass up a good shot for the old "not enough light" reason, and the opportunity to utilize higher shutter speeds permits action to be caught more sharply. This gain cannot be entirely one-sided, to be sure; something has to be sacrificed, such as grain and contrast.

Do not, therefore, let film speed run away with your judgment. Consider what pictures you are going to take and where and why before you decide what film to use. What will be the probable brightness range of the scenes? Will there be any fast action? Will you want enlargements? What is the maximum lens opening and shutter speed your camera permits? Trying out different films and carefully comparing the results should provide the wisest answers.

Since a safety margin for protection against underexposure is included in the ASA standard, it is possible to expose black-and-white film at a higher rating, sometimes twice the published one, and obtain sharper results with special processing. This is because the exposure nearest the correct minimum generally produces the best negative, whereas overexposure produces too much density for really good prints. Rerated films must be sent to a custom lab (or handled in your own darkroom), and the lab should be instructed to process the entire roll at your arbitrary index.

CONTRAST. The degree to which a film is capable of recording closely related tones in gradations of black and white is termed *contrast*. The darkest and densest areas on a negative are reverse images of the scene's brightest objects, which affect the greatest number of silver bromide particles and transform them into

metallic silver. Conversely, the lightest parts of the negative correspond to the deepest shadows in the picture.

Thus, the term *density* indicates the amount of metallic silver in different areas of the negative. If your negative is "too dense" you have probably overexposed it, allowing too much brightness to affect too many grains of the emulsion. Inexperienced photographers generally tend to overexpose film. A relatively "thin" negative can be expected to produce a better print, although to an unpracticed eye it may seem distressingly underexposed.

Contrast is another basic quality which is incorporated during the manufacture of film and also of the sensitized emulsions of printing papers. A film of *average contrast* will reproduce highlights, halftones, and shadows with a full range of densities; the highlights will reveal their own dark areas, and the shadows will show whatever brightness they encompass. A *high-contrast* film will record only highlights and shadows, giving you mostly blacks and whites without the in-between grays. A *low-contrast* film records little differentiation in negative densities, resulting in softer tones. Portraits and general snapshots, for instance, benefit from the softer effects of medium- or low-contrast films. High-contrast films are especially useful in copying line drawings, documents, and other printed matter.

Finally, remember that none of these qualities operates alone. The contrast built into a film is affected by the other qualities of the film and to a considerable degree by the exposure and development of the film.

LATITUDE. Latitude is the film characteristic most closely related to contrast and may be defined as the film's ability to record differences in brightness as differences in negative densities.

The range of brightness differences can extend from 1 to 128; that is, it is possible, with most general panchromatic films, for a highlight to be reproduced as much as 128 times as bright as a shadow without loss of tone gradations. An average scene has about one-fourth of that extreme range, thus utilizing only one-fourth of the emulsion capacity under normal conditions. Therefore, minor exposure variations above or below normal need not detract from the print quality of a negative. If a film is described as having "little latitude," it can produce a relatively shorter range of brightness differences.

There is seldom a single correct exposure; usually there is a

short range of acceptable exposures referred to as the *exposure latitude*. Black-and-white films have considerably more exposure latitude than color films. A point to bear in mind, however, is that latitude decreases when the brightness range of a scene increases. Also, the density of a negative will be increased by longer exposures.

GRAIN. The film characteristic most likely to be affected adversely by any appreciable increase in emulsion speed is the grain structure. The faster the film, the larger will be the silver bromide grains of the emulsion and the metallic silver particles into which they are developed. These are what compose the latent photographic image; so the size and distribution of the grains have a direct relation to the sharpness of the picture and to the capacity of the negative to impart fine detail. Since all the film characteristics are interdependent, there are a few "ifs" to consider.

If a very fine-grain emulsion is coated thinly on the film base, it will increase the potential sharpness of the picture over that of a thicker application. The reason for this is that, with a thin emulsion, there is less chance for the light to bounce about and scatter during the printing process. If the film base is comparatively thin, the diffusion will be cut down still further.

If a negative of coarser grain has good contrast quality, the finer details of a picture can sometimes be brought out more sharply than those of a fine-grain negative with insufficient contrast. How the negative is developed, as well as the kind of emulsion, affects the visible graininess of a finished picture.

Where grain assumes the greatest importance is in *enlargements*, especially in those blown up to more than seven or eight times the original size. Grain is rarely discernible in standard small prints such as those returned with your processed black-and-white film, regardless of the type of film. But it is possible for an individual grain to be magnified in reproduction from 2,500 to 25,000 times; an extralarge blowup of a negative can, therefore, literally put spots before your eyes. An enlargement can come out as smooth as a glass floor or as mottled as a weather-beaten sidewalk, and grain is a major factor in the result.

One cause of the granular look is the inclination of the grains to join in groups during development. Actually, the exposed emulsion particles develop as individual grains; however, when

grains are close or touching, one grain can touch off development in its neighbors and induce them to cluster. A fine-grain developer, as well as a fine-grain emulsion, will lessen this togetherness tendency. The price of thus disciplining the grain structure is usually a slight loss in contrast and speed, but there is a gain on the side of a good enlargement.

RESOLVING POWER. This term refers to the capacity of the film to resolve, or reproduce, distinctly fine lines for sharpness of detail. These lines, which are an integral part of the photographic image, are etched on the film by light and are affected by the proneness of a given emulsion to scatter the light. The less opportunity a film offers the light to spread, the sharper the lines will be. This is somewhat comparable to differences in pen-and-ink lines: on some hard-surface papers it is possible to draw extremely fine lines very close together, while the same lines on a paper towel would run into one big blur.

The scientific testing of a film's resolving power measures microscopically the number of reproducible lines per millimeter. Since light spreading is attributable to reflection, more of it usually occurs among the larger grains of high-speed films. Consequently, the power to resolve fine detail is generally greater in the slower films, which have small grains of a fairly uniform size.

No single factor is responsible to any appreciable extent for a film's resolving power because of the close relationship of all the emulsion properties. Higher contrast, such as black lines on a white ground, will also raise the resolving power if exposure and development conditions remain constant. Variations in such factors as length of exposure, color of light, and method of development will affect the resolving power as well as the picture image as a whole.

COLOR FILMS

The reason for separating color photography from black-and-white, in classrooms and in books, is that there are significant differences to note, digest, and keep in their proper places. Since there are also numerous likenesses in both categories, it is not possible to keep them completely separate. Color in photography, including the structure of color films, is covered in more detail in chapter 9.

Basically, the structure of color film is three color-sensitive emulsions on three layers of film, with a yellow filter between the top layers, supported on a single base—somewhat like a layer cake on a plate. The base is the kind used in black-and-white films and has an antihalation coating. The bottom layer of emulsion, applied directly to the base, is a specific panchromatic type which, with filtering, reacts to red only. The middle emulsion layer is orthochromatic, sensitive to green only. The top layer is colorblind, sensitive to blue only. Coatings of clear gelatin protect the emulsions from scratches before and during processing.

RAW FILM **COLOR POSITIVE**

Blue Sensitive Emulsion | YELLOW IMAGE

Green Sensitive Emulsion | MAGENTA IMAGE

Red Sensitive Emulsion | BLUE-GREEN IMAGE

 | Safety Film Support

ANTIHALATION BACKING

Fig. 6.1. Structure of color film

Contrast. In black-and-white photography, the contrasts in the negative are governed mainly by the difference between highlights and shadows and the angle of the light source. In color photography, the contrasts in the negative are produced by the different colors of the subject. As a rule, extremes of lights and darks are not desirable in color work.

Exposure Latitude. There is a much wider leeway in the exposure range within which you can get a perfectly good black-and-white print than there is in color films. The multilayer construction of color films results in lower ratings, and these, in turn, sharply curtail the exposure latitude. The latitude is further limited by the fact that variations in color are less acceptable to the eye than variations in black-and-white tones.

Relative Speeds. A major difference between black-and-white films and color films is in their emulsion speed. Furthermore, while it is possible to rate a color film higher than the printed index, it is not usually recommended, since the safety factor for under- and overexposure is generally less than for black and white. However, faster and faster color films have been narrowing the difference between black-and-white and color films.

For many years the original Kodachrome, at ASA 10, was the only color film as far as some photographers were concerned, even after a few faster films became popular. Color-film ratings remained constant for a long time, and it was possible to publish a short list of color-film speeds with some accuracy. Now, however, the ratings of various old and new brands range from ASA 25 to ASA 500, with changes too frequent to tabulate with any certainty. Even an old favorite, whether color or black and white, is subject to change in its ASA index. To be sure of the current rating, always look at the film's instruction leaflet or wrapping.

Chrome vs. Color. The brand names of domestic color films have an element of potential confusion in their suffixes. You should therefore remember that those ending in "chrome" produce *transparencies* for color slides. Those ending in "color" produce *negatives* for making color prints.

Although it is possible to obtain prints from color transparencies and slides from color negatives, this involves extra steps and extra expense. Thus, it is advisable to determine in advance whether you want to show most of your pictures by slide projection or by prints to be passed around and mounted in an album, and to choose your film accordingly.

The two main types of color film generally available for hand cameras are described as *reversal* and *negative* types.

Reversal-type color films are developed first as negatives and then, by re-exposing and redeveloping, are reversed to produce positive images directly on the film that was in your camera. That very same film eventually emerges, in small mounted pieces, as color transparencies or, more simply, slides. Agfa*chrome*, Ansco*chrome*, Ekta*chrome*, and Koda*chrome* are examples of color reversal film.

Negative-type color films record the opposites of the colors being photographed, which are later transferred in their true

values to appropriate sensitized paper as *color prints.* Koda*color* is a color negative film. It comes in daylight type only, for use outdoors or with clear (white) flashbulbs.

Color reversal films come in daylight or tungsten emulsions. While the tungsten type is for artificial light generally, fluorescent lighting usually requires daylight film and special filters for natural effects. Whether a film is a daylight or tungsten type and whether it is a reversal or negative film is printed on the package.

The "chrome" and "color" differentiation is not always true of the brand names of foreign films. When buying an unfamiliar color film in another country, look carefully to see whether the package is marked "For Slides" or "For Prints" and, if in doubt, ask the shop.

Color Variations. There are noticeable differences in the colors produced by different color films under similar or even identical conditions. One may give you blue skies that verge toward a purple tone, while another may give skies of bright ultramarine. Grass and other foliage may be reproduced in quite dissimilar greens. Yellows may be slightly orange or more golden. Reds can be dazzling or subtle. You will find softer pastel shades in some films and a more saturated color brilliance in others. White can vary a great deal and can be one of the most difficult colors for the photographer. It is up to you personally to decide which color film pleases you best. Not every gentleman prefers blondes, and not every photographer votes for the same color film.

A further difference in color films is that some can be processed in home darkrooms but others cannot. (For more on this subject, along with other topics relating to color, see chapter 9.)

FILM SIZES AND PACKAGING

The availability of films in the size your camera accepts is another factor in determining what to use. Films come in drop-in cartridges, 35mm cassettes, rolls, packs, and sheets. The sizes most in demand generally offer a wider choice of emulsion types and speeds than those which are less in demand. Color films have greatly outdistanced black-and-white in popularity as their speeds and other qualities reviewed here have continually im-

proved over the years. A broad classification of sizes follows.

110 Films. These very small drop-in cartridges were specifically developed by Kodak for their Pocket Instamatics. An improved emulsion for the color-print film allows the tiny 13mm x 17mm negative to be enlarged to a standard print. Films for color transparencies and black-and-white prints are also available in this size.

126 Films. These are the 28mm square-format films which fit standard Instamatic (including Instamatic-X) and other 126 cameras. These too are in drop-in cartridges with instant loading and unloading. Some have twelve exposures, and some twenty per cartridge.

35mm Films. Before the days of instant loading and unloading, the relative economy and convenience of shooting 20 or 36 frames without reloading advanced the acceptance of 35mm films and cameras. Despite the growing trend toward faster loading, 35mm films offer the widest variety of types.

Since a distinguishing feature of 35mm cameras is their wind-rewind mechanism, the film is packaged in single, lightproof metal cassettes. Standard perforations along the edges of the film strip, to engage the sprockets of the winding wheel, are a reminder of the movie origin of 35mm film. To reduce the chance of tearing at the sprocket holes, 35mm is slightly thicker than roll films or film packs. After the last exposure, the film must be rewound into its original cassette before it is removed from the camera.

Roll Films. These films, once standard for box and folding cameras, are used in the 2¼ SLR cameras and the twin-lens reflex cameras. They are identified by a number—for example, 120 for twelve exposures and 220 for twenty-four. Their square negatives are 2¼ x 2¼ inches.

The opaque paper backing that is characteristic of roll films has the vital statistics about exposure index and frame numbers printed on the leader and backing. Roll films have no perforations, but wind onto a removable spool which is removed from the camera after the last exposure.

A roll film for pictures 2¼ x 2¼ inches or larger costs more per frame than 35mm since it uses more emulsion, more protection, and more developing materials. On the other hand, it

offers a larger contact print and this, as a rule, cuts down on the cost of enlargements.

8mm and 16mm Films. These are basically movie films. They come in rolls and magazines for some camera types, and in drop-in double cartridges for others; the instant-loading home-movie cameras use the 8mm cartridges, and the 16mm cartridges have been used in larger subminiatures.

Film Packs. Film packs are thin, like roll film, and are used professionally in press and view cameras when it is not possible or convenient to use a large number of film holders, which are bulky, heavy, and expensive. The very thin and unprotected material of film packs makes them a bit tricky to handle and more vulnerable to damage than other films. Probably the most useful size is the 4 x 5, but there are several others commercially available.

Sheet and Cut Film. These have a sturdy base, less flexible than other films, and come in numerous emulsions, for general and some specialized purposes. They are for the larger cameras used mostly by professionals.

Polaroid Films. These are very specialized films for Polaroid Land cameras and cameras which can use Polaroid backs. Like the cameras themselves, they vary a great deal, from the fifteen-second print in black and white through the sixty-second color print to the newer "no pods and no garbage" self-developing type which produces a color print outside the camera in a few minutes. Print sizes and shapes vary also, depending on which camera is used.

It is important to know your film as well as your camera. Look at the information sheet each time you open a package of film: it is a good reminder even when it contains no surprises. Practice with a few rolls to find out which film you like best for certain purposes. If you ask a fellow picture-taker what film he is using and he answers vaguely, "Oh, I think it's Kodak-this, or maybe it's Ansco-that," you can be sure that he is not very interested in how his pictures turn out—and they probably won't.

Principles of Exposure

Exposure refers to the amount of light that reaches the film. In the uncomplicated days of the early box camera, exposing a film correctly was a relatively simple matter, and good results were largely dependent on luck. For one thing, there were far fewer kinds of film to expose; and because the old-time camera was preset to do its own focusing and to take pictures at one fixed speed through a fixed aperture, there were not too many mistakes you could make. You picked a nice sunny day, placed your subject in a nice bright spot, and click!—it was a snap, and most of the time a fairly good one.

This easygoing picture was gradually altered by an influx of improvements and refinements which first intrigued, then baffled and frustrated eager amateurs. Cameras suddenly seemed to shift all responsibility for exposure to the bewildered photographer. But as it became necessary to cope with more powerful lenses, multiple-speed shutters, new focusing mechanisms, and a growing complex of new film types, timely aids kept pace with the changes. Technical skills and cumulative experience came up with answers to problems, and now technology appears to have swung the pendulum back to a new ease of operation and a dramatic degree of automation.

Although some casual photographers like built-in mechanisms as automatic as possible, there is still much discretionary ground in which more thoughtful photographers must exercise trained observation and judgment. Printed instruction leaflets packaged with 35mm film, compact printed dials, and a great variety of exposure meters are some of the helpful guides for the users of not-so-automatic cameras. The factors to be considered in deter-

mining the setting for accurate exposure, all of which have been discussed in preceding chapters, are: light conditions, the reflectance of your subject, the kind of film being used, and the speed of your lens.

STEPS TO CONTROL EXPOSURE

Basic Exposure. To learn to estimate exposure, begin with a basic or key setting for an average outdoor scene. *Average* in a photograph means a nearly equal distribution of lights and darks in normal sunlight, with the subject front lighted. A generally accepted starting point is an $f/16$ stop and the index number of the film as the shutter speed. To illustrate: if you are using black-and-white film with an index of 125, your basic exposure for an average sunlight picture will be $1/125$ at $f/16$; if your film is rated at 60, your basic exposure will be $1/60$ at $f/16$ (or $1/50$ in case your camera has the alternative shutter markings explained in chapter 4).

The *index number*, or rating, of film is based on its emulsion speed and on other known factors affecting the amount of light the film records. The index is a standard measurement for which we can thank the American Standards Association. This association also developed another useful tool, the *ASA Computer*, at the request of the U.S. Navy during World War II. It was designed originally for setting cameras in combat conditions where it was not possible to read a meter successfully.

The ASA Computer and the Kodak Master Photoguides each merge so much researched data into compact, printed form that you can get off to a running start in your exposure calculations by using one of them. But it is still up to you to supplement this valuable information with your individual evaluation of light conditions and relevant factors. (Incidentally, if you are traveling in Europe and buy film with DIN ratings, just ask the shop for a card with a conversion table to ASA ratings.)

EV Numbers. In the Exposure Value System (EVS), mentioned in the chapter on lenses, each number from 2 to 18 represents the amount of light admitted to a lens by a given aperture and shutter speed. When these two controls are cross-coupled, changing one makes an automatic compensation in the other. EVS allows you to keep a shutter speed and $f/$stop combination

in mind as a single number. If you accustom yourself to the system, it is very useful in reading any light meters which include EV numbers. Table 1 shows how EV numbers compare to conventional shutter speed and f/stop combinations.

TABLE 1

EV SYSTEM NUMBERS

Conventional equivalents in shutter speeds shown below the corresponding f/stops

EV	Aperture	f/2	f/2.8	f/4	f/5.6	f/8	f/11	f/16	f/22
2	Shutter Settings (seconds)	1							
3		1/2	1						
4		1/4	1/2	1					
5		1/8	1/4	1/2	1				
6		1/15	1/8	1/4	1/2	1			
7		1/30	1/15	1/8	1/4	1/2	1		
8		1/60	1/30	1/15	1/8	1/4	1/2	1	
9		1/125	1/60	1/30	1/15	1/8	1/4	1/2	1
10		1/250	1/125	1/60	1/30	1/15	1/8	1/4	1/2
11		1/500	1/250	1/125	1/60	1/30	1/15	1/8	1/4
12			1/500	1/250	1/125	1/60	1/30	1/15	1/8
13				1/500	1/250	1/125	1/60	1/30	1/15
14					1/500	1/250	1/125	1/60	1/30
15						1/500	1/250	1/125	1/60
16							1/500	1/250	1/125
17								1/500	1/250
18									1/500

This EV System (originally called the "Light Value System") was introduced in 1954 when relatively few electronic devices were built into cameras. But although it was intended as an easier simplified method of determining exposure, the EVS has never really caught on.

CONDITIONS GOVERNING EXPOSURE

We have said that exposure refers to the amount of light that reaches the film; now let's look at what is meant by *correct exposure*. When you have chosen the right combination of f/stop and shutter speed to control the exposure correctly, you will be able to see distinct detail in both the light and the dark areas of

the negative. Regardless of weather, the highlights and shadows of your picture should show up clearly, with a good range of middle gray tones, so that your print will have proper contrast. The basic aim of correct exposure is to record accurately the widest possible gray scale commensurate with the range of tones in the scene.

Basic Light Conditions. The printed leaflet packaged with film includes a little chart, similar to that in figure 7.1, which applies

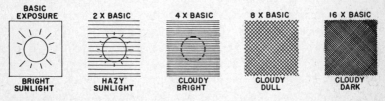

Fig. 7.1. Basic exposure must be increased or decreased according to sky conditions.

to all hand cameras. When you know your basic exposure, the next step is to look at the chart, look at the sky, and learn to interpret these light conditions.

Bright sunlight is, well, bright sunlight, with clear skies. So you set the camera at your basic exposure, which is, say, 1/125 at *f*/16.

Hazy sunlight is less intense, with the sun visible through a thin curtain of clouds or fog. There are shadows, but not as definite a contrast in lights and darks. This condition calls for *two times* basic exposure, which you get either by decreasing your shutter speed to 1/60 of a second or by opening up to *f*/11.

Cloudy bright has very little trace of shadows; you know the sun is up there but you can't find it because of the unbroken layer of fairly thin clouds. Contrast is so low the lighting seems flat, yet this lighting is fine for some subjects when you want maximum detail in all tones. *Four times* basic exposure should compensate for this lower intensity: either change your shutter speed to 1/30 or enlarge your lens aperture to *f*/8.

Cloudy dull is not very different from cloudy bright except for further weakening in the intensity of the illumination: there are quite thick clouds, with no sign of the sun. Now you may need as much as *eight times* basic exposure, which would bring

your setting to either $f/5.6$ at your original speed of $1/125$ or $f/16$ at $1/15$. Please note that it is almost impossible to hand-hold a camera steady for a quarter of a second.

Cloudy dark is when you will probably decide that you didn't want to take pictures anyway. This flat and dismal condition may be in very early or very late hours or when a storm is imminent. Such lack of intensity requires up to *sixteen times* basic exposure: open up to $f/4$ for $1/125$ of a second or change the shutter speed to $1/8$ of a second for your original $f/16$ aperture. The same negative density can be obtained with these equivalent combinations: $1/60$ at $f/5.6$, $1/30$ at $f/8$, and $1/15$ at $f/11$.

Any slight variation in exposure due to a different series of shutter markings—for instance, $1/25$ and $1/50$ instead of $1/30$ and $1/60$— is negligible. Whichever standard series of markings your camera carries, your exposure calculations can be made in the same way.

Color and Intensity of Light. When we refer to *normal sunlight* in arriving at a basic exposure, it is necessary to consider urban smog conditions and to remember that the *color* of light, as well as its *intensity*, varies at different times of the year and at different hours, especially toward the beginning and end of the day. The white light of the sun at midday blends about equal parts of all colors. During the hours near sunrise and sunset, however, the light not only decreases in the intensity of all wavelengths, but also loses proportionately more in the blue zone of the spectrum.

Because earlier films were most sensitive to this blue light, they generally required an increase in exposure during the hours farthest from the peak light of the day. But with today's truly panchromatic films, exposure is governed by whether there is less light or more light, regardless of the hour.

Extreme variations in the intensity of the sunlight, such as in midsummer in areas toward the tropics or winter in the far north, can alter basic exposure by one stop. For instance, if basic exposure is $1/125$ at $f/16$, then stopping down your lens to $f/22$ for more intense light, or opening up to $f/11$ for weaker light, may give you a more normal exposure even though, with the latitude of modern panchromatic films, $f/16$ would probably be satisfactory.

Direction of Light. In evaluating light conditions, you must also consider where the light comes from and the angle at which

it falls upon the subject. As already mentioned, frontlighting is the direction on which basic exposure is predicated.

In *frontlighting*, the sun, or other source of illumination, is more or less directly behind you and striking the subject head-on. Because the sun's direction is constantly changing, you get variations on the frontlighting theme, which apply also to illumination other than the sun: *45-degree frontlighting* is usually the most desirable and is what you get on a sunny day during most of the midmorning and midafternoon when the sun slants downward over your shoulder. *Top frontlighting* is the kind that makes dark shadows under noses and chins and objects because the sun is almost directly overhead. These shadows can be softened by a fill-in flash (see chapter 11) or reflector, and can be quite flattering if the sun, though very high, is not quite directly overhead.

Side lighting means that the illumination is coming pretty much at a right angle to the imaginary line between the lens and the subject. This, especially in bright sunlight, makes an interesting contrast by throwing half of your subject in shadow and keeping the other half well lighted. In bright sunlight the basic exposure should usually be increased by a half to a full stop for side lighting; but if the light is weak or diffused, no increase is needed.

Crosslighting refers to illumination falling on a subject from two directions. It may be fairly soft lighting from a main light and a fill-in reflector, or it may be two lights placed to lighten strong shadows or to accentuate texture details.

Backlighting means that you, rather than your subject, are facing the source of light. On a bright day, backlighting can produce pleasing highlights on a person's hair and shoulders and a soft, even lighting of the face, but don't allow the sun to shine directly into your lens or you will get a glare. Basic exposure should be increased by a full stop for backlighting; if the illumination is very intense, you may need an increase of two stops, but on a dull cloudy day no increase is required.

The reason no increase is needed for side lighting or backlighting in dull or diffused light is easy to understand if you stop to realize that your exposure estimate will already have been increased to compensate for the lessened light, whatever its direction.

Backlighting can also be used for dramatic silhouette effects,

for a tree or a building or a foreground figure, for instance. In this case you do not want detail in the dark areas, so instead of opening up your lens, you close down one *f*/stop below your basic exposure.

Subject Reflectance. The color and amount of light reflected into the lens from the subject being photographed is termed *subject reflectance*. This principle was covered in the chapter on light and is summarized here.

Light or bright-colored objects will reflect a considerable amount of the light striking them, sometimes more than 80 percent; a brilliant white surface will reflect nearly all of the light. A surface that is sufficiently smooth to be nondiffusing will reflect a larger percentage of light than a rough-textured surface which scatters the rays. *Exposure should be decreased*, usually by a full stop, *for lighter than average subjects:* for example, a sunlit snow scene, a beach with bright sky light striking the sand and water, a gleaming white steeple, or a brilliant blue sky with white clouds.

Darker surfaces, on the other hand, absorb much more of the light, often reflecting only a small percentage of it to the lens. When nearly equal wavelengths are absorbed, the object will appear to be a neutral gray, becoming a deeper gray tone as light absorption increases until it finally seems black. But if the surface absorbs one wavelength more than the others, it will take on the color tone of the least absorbed wavelengths; then it will no longer look neutral but will appear as a lighter or darker gray tone. *Exposure should be increased* by at least one stop *for darker than average subjects:* for example, a rainy landscape, a dark-skinned person, a dull bronze statue, a dark building, or people in dark clothes when the focus is on figures rather than on faces.

OTHER FACTORS AFFECTING EXPOSURE

Exposures through Glass. Taking a picture through glass is a common condition that nearly always calls for opening up one stop. Suppose you are shooting a street scene through a closed window, or a view from a train window, or a display in a shop window. Although a transparent medium such as glass will transmit almost all of the light reaching it (see chapter 3), and

although some glass will have more refraction than others, it is a fairly safe bet to increase the exposure by an additional f/stop. If a window has not been washed for some time, it's better not to consider it a transparent medium.

If you are taking a picture through an airplane window, the brightness of the aerial view generally makes it unnecessary to increase the basic exposure. If you are shooting through a car window, however, you will probably need to increase the exposure by one or possibly two stops, depending on the quality and thickness of the car's window glass.

Nearly all filters call for some increase in exposure. These variations, and others as they apply to different conditions and types of subjects, are discussed in subsequent chapters.

Brightness Range. Obviously, if you select a scene with extremes of bright and dark areas, it is not possible to expose the film evenly. The span of light values within a scene, from brightest to darkest tones, is called the *brightness range* of the scene. For satisfactory reproduction, exposure must be within the latitude of the emulsion you are using, as explained in the preceding chapter.

The brightness range is represented as a ratio, which takes into account the capacity of the film to convert silver halides into the metallic silver of the image. When an emulsion is asked to respond to an unreasonable range, it can do its best only for the highlights, the shadows, or the middle tones—not all three. It is as if you were to measure a wall with a yardstick: the yardstick can take in only three feet at one time, but those three feet can be at either end of the wall or in the center or anywhere in between.

The ratio expressing the maximum brightness range (of arbitrary light units) with which a film can cope adequately is 128:1; in other words, the lightest part of a scene to be reproduced acceptably must not be more than 128 times as bright as the darkest part, even when you are using a black-and-white film with great latitude. Color films, having far less latitude than black-and-white films, cannot be expected to reproduce satisfactorily all the detail in a scene with more than an 8:1 brightness range.

On an extremely bright day a scene with high contrast may have a brightness range of as much as 1600:1; for such a scene, no exposure could produce detail in both the highlights

and the shadows. On the other hand, on a dark day a scene with very little contrast may have a range of only 30:1; it could be exposed to produce a thin negative with faint detail in the dark areas and moderate density in the lighter areas.

Sensitometry. The measurement of an emulsion's response to light is known as *sensitometry* and is primarily the concern of manufacturers of films, printing materials, and developers. It is scarcely necessary for a photographer to go into the technicalities of the subject or to acquaint himself with the "characteristic curve" of the film he buys. The first scientific study of the relationship between exposure and development was made in 1890 by a team named Hurter and Driffield; hence the term *H & D curve*, which is still applied to the measurement of film sensitivity, as shown in figure 7.2.

Tone Scale. What *is* necessary, however, is for the photographer to develop an awareness of a black-and-white tone scale in what he sees. Curiously enough, this is very easy for a color-blind person; for one with normal color vision, more studious observation is often required. Start by giving your imaginary scale a specific number of gray values, such as those in the film strip in the center of figure 7.2, with a neutral gray having about equal parts of black and white in the middle of the scale. Then learn to evaluate colors and light in terms of these gray tones when making an exposure.

Overexposure and *underexposure* can be measured in this way for deliberate effects with predictable results. No photographer wants a neutral gray all the time, and frequently he must choose from an extreme brightness range which areas to emphasize or to sacrifice. You will notice in the illustration that, within the film latitude, there are three gray tones on either side of the middle gray. *Overexposing* one stop from this neutral gray will produce the slightly lighter gray of an average flesh tone or of flagstones; two stops will produce a very pale gray; an overexposure of three stops will produce an off-white. *Underexposing* by one stop will result in a slightly darkened gray comparable to open shade; two stops will result in a darker gray more like that of definite shadows; three stops will result in a very dark gray with little or no discernible detail.

How the brightness range of a scene affects the number of

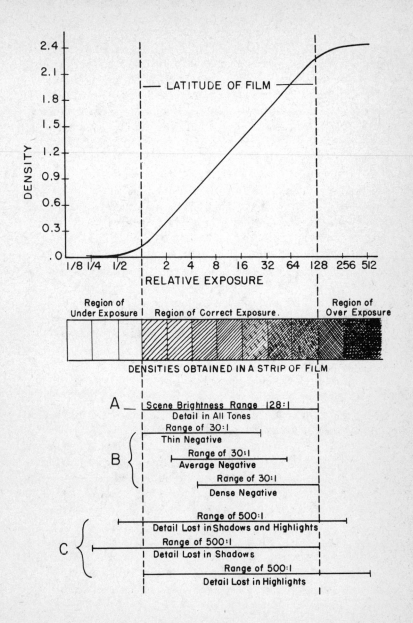

Fig. 7.2. A typical film characteristic curve (H & D)

gray tones that a film can encompass is shown in the lower half of figure 7.2. When the brightness range is 128:1 or less, an exposure for all values can be made within the film latitude; otherwise, you must decide whether to shoot for highlights, or shadow detail, or an average brightness. Sometimes an extreme brightness range can be compensated for in processing: for example, if the film is exposed for shadow detail, then developed less than normal time, the density of the overexposed areas will be reduced.

Kind of Film. Film was discussed at length in chapter 6 and was mentioned earlier in this chapter in connection with the exposure index, which is the numerical scale of the sensitivity of various films to light. When you buy a film rated 50, for example, you know it is approximately half as fast as one rated 100; in other words, a film rated 50 will require twice the exposure of one rated 100, other factors being equal, to produce the same degree of density in the negative. Any recommendation for different ASA ratings in daylight or tungsten will be printed on the leaflet that is packaged with panchromatic films.

If you switch from one brand or type of film to another having the same index number, there may be a slight variation in the density obtained by the same exposure setting. This small difference can safely be ignored in black-and-white films, but with color films, because of their more limited latitude, it is a good idea to make a few test shots and to note the most favorable basic exposure for using a particular film.

The very great latitude of black-and-white films for outdoor photography makes it possible to use them quite satisfactorily without a light meter. Under average light conditions and with some practice in estimating correct exposure, you can get a fair percentage of really good negatives. Color is another matter, however; there the latitude is much less and guesswork much riskier. Since color films are more expensive than black and white, and errors in exposing them more costly, it is worthwhile on all counts to use a reliable light meter for color materials. Light meters (described in the next chapter) are advisable also for poor or unusual light conditions.

Age and unsuitable storage can affect the speed of film, which is rated under controlled processing conditions. The manufacturer's instructions for care and handling should be observed, as

well as the printed advice about developing the negative, in
order to avoid a diminution in sensitivity. In fact, reading all
labels and directions of photographic materials is a wise precau-
tion and may prevent some picture failures; at the least, it helps
you to keep track of a few of the continual changes.

Speed of Lens. Your choice of exposure is defined, in the final
analysis, by the maximum effective aperture of your camera's
lens and by its range of shutter speeds. As an example, assume
that, for the film you are using, a meter reading of light condi-
tions gives you a choice of these equivalent exposures:

$f/2$	$f/2.8$	$f/4$	$f/5.6$	$f/8$	$f/11$	$f/16$	$f/22$
1/500	1/250	1/125	1/60	1/30	1/15	1/8	1/4

If the speed of your lens happens to be $f/3.5$ (a half stop), obvi-
ously you cannot use the first two exposures; or if the lens
closes down only to $f/16$, you cannot use the slowest shutter
speed in the series above. Similarly, you cannot use the first two
exposures if your lens has a maximum shutter speed of 1/200 of
a second. Which setting, when you have a wide choice, depends
on your subject and particularly on how much depth and action
it involves.

Speed vs. Depth. As you will recall from the study of lenses,
increasing the aperture to stop fast action in a picture decreases
the depth of field. Conversely, decreasing the aperture increases
the depth of field. You can't have it both ways, as a rule, so the
exposure must sometimes be a compromise.

When movement is of major importance to your picture, natu-
rally you choose a fast shutter speed and the corresponding
f/stop. When depth of field is essential, choose one of your
smallest aperture settings and a slower shutter speed. Remem-
ber, too, that it is difficult to hand-hold a camera steady for ex-
posures longer than 1/50 of a second; anything slower than
1/25 should have a tripod or other brace.

Presetting the exposure of an adjustable camera to give it box-
camera simplicity for casual outdoor shooting on sunny days is
a frequent practice of some amateurs. To do this with a standard
lens, select a film with a rating recommended for simple cam-
eras. Set your shutter speed at 1/60, for example, for most color
shooting and your aperture at $f/11$ or $f/16$—depending on the
speed of the film. Set the distance at about fifteen feet, and

everything in an average sunlit scene will be reasonably sharp from approximately nine feet to infinity.

If you are a newcomer to this great all-American game, you may feel at first that there is too much to remember just to get set for one picture, even with a simple camera. But it is like driving a car or a golf ball; once you get the hang of it and reinforce your knowing with some doing, taking pictures becomes a surprisingly easy and natural operation.

Exposure by Light Meter

Measurement of light for photography is by a small instrument which originally was referred to as a "light meter." Its purpose is to help determine correct exposure, and the term "exposure meter" has become more popular. Although the meter actually measures light rather than exposure, both terms are in use.

A reliable light meter can be a photographer's best friend. But a meter should serve only as a guide and should not be expected to carry the entire burden of decisions about the best exposure. That is the responsibility of the photographer. Even though many cameras now have built-in meters, many photographers like to use a hand meter also, as a check on the camera's reading.

An exposure meter is a must for color pictures generally and, by and large, will assure a more uniformly consistent density in all your negatives. With correctly exposed black-and-white negatives you can count on obtaining good prints with a full range of gray tones. Furthermore, a meter's ability to help you cut down on wasted film can justify its cost in a short time.

Selenium and CdS Meters. Photoelectric meters with a selenium cell have long been the standard method of measuring light intensity to determine correct exposure. In the early 1960s, a new type of meter with a cadmium sulfide (CdS) cell appeared on the market. The fundamental difference between the two types is that photoelectric (selenium) meters have an extremely delicate wire for transmitting the energy generated by light falling on the meter window; also, the size of the cell is comparatively large. CdS meters have a tiny hearing-aid type of battery in conjunction with a tiny photoresistive cell; they offer greater sensitivity, ruggedness, and compactness.

Built-in meters are a feature of many of today's cameras, with different designs to fit the camera makers' requirements. Some SLR cameras have the meter placement on the mirror to measure all the light reaching the lens. But there is still a wide and constantly changing selection of both selenium and CdS hand meters, and they are more in demand than ever, regardless of built-ins. The illustrations on the following pages show a few by Sekonic, one of the world's largest manufacturers of photographic meters.

Basic Meter Construction. Exposure meters, like individuals, have certain similarities despite their infinite variations in design, as you can see in the examples illustrated. Curving behind the cell is a calibrated scale with numbers representing light values and a needle indicator ready to point to a number. The circular calculator on the meter body is a kind of compact computer into which you feed the index number (speed) of your film and the light-value number of the subject which the meter has sized up for you. When you have wheeled this number to the spot indicated by the fluctuating needle, the calculator displays an orderly choice of equivalent combinations for f/stop and

Fig. 8.1. A relatively inexpensive meter for general use. Computer dial rotates, indicating easy-to-read settings.

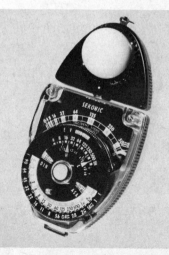

Fig. 8.2. A versatile studio type with swivel head. Mainly for incident-light readings; special slides can convert it for direct readings.

Fig. 8.3. A CdS zoom meter that varies acceptance angle by a continuously rotating dial, for use with different lenses

Fig. 8.4. A CdS meter with finder system and narrow acceptance angle for catching only that part of a scene which is to be measured for exposure

shutter speed, any one of which will admit the same amount of light.

This meter reading may be the best exposure for normal conditions or it may be merely a guide to the correct exposure, which could be influenced by any number of specific conditions requiring the photographer's judgment. It is especially important to learn to assess subjects as average, lighter than average, and darker than average—as discussed in the preceding chapter.

Additional Features. It is also important to learn to recognize average, lower, and higher intensities of light, and to remember that a given film may be slower in dim light than in bright light. In extremely weak light, a selenium meter may be a trifle less accurate than when used in ordinary illumination because the amount of current in the photoelectric cell is proportional to the intensity of the light.

There is a separate little accessory, called a *booster*, that can be jacked into some meters for reading unusually low light that the meter alone cannot measure. Some meters have a built-in booster for dim light and a mask for bright light. CdS meters may incorporate a device for high- and low-light levels with a

Fig. 8.5. A CdS marine meter designed specifically for underwater photography; it can be used also for normal photographic readings. Waterproof, it works free from hydraulic pressure.

switch for an "H" or "L" setting. Some meters have built-in battery checkers.

Some Meter Variations. Most meters provide for reading both reflected and incident light. A hinged or separate disk of opal glass to cover the regular light-sensitive opening is the usual method of converting from reflected- to incident-light reading.

In addition, there are meters which incorporate design features intended chiefly for advanced photographic work. There is, for example, a meter that can measure moonlight and give readings for up to eight hours. There is a marine meter designed to give direct readings of reflected light a few hundred feet under water, and there are meters that give readings for only one degree of arc; others measure the light of just one part of a scene. Zoom meters can provide continuously variable acceptance angles (see below), and there is a meter for color that gives individual readings for each of the primaries and equates them so as to give the correct balance in the final exposure.

Methods of Reading. There are two basic methods of measuring light quality by a meter reading: (1) *Reflected light* is the amount and quality of the light that reflects *from* the subject when you point the meter *toward the subject* and away from the

lens. (2) *Incident light* is the intensity of the light that falls *on* the subject and is read by pointing the meter *away from the subject* and toward the lens.

Most meters are designed primarily for reading reflected light. For landscapes and distant scenes, as a rule, the meter should be slanted downward slightly, because the sky is usually the brightest part of an average picture. This is not true of snow or some beach scenes; therefore, if you get a brighter reading by slanting the meter downward, then hold it level. To get a reflected-light reading for average brightness, you can point the meter toward the brightest area of your subject, then toward the darkest, and split the difference. If highlight detail is more important to your picture than shadow detail, take your meter reading toward the lighter areas. If your picture needs shadow detail, possibly at the expense of the lightest tones, then take your meter reading toward the darker areas. The quality of backlighting—that is, with the camera facing the sun or other source of illumination—can be read by turning your back to the subject, reading the meter in the opposite direction, then increasing the indicated exposure by one or two stops.

Incident light is read through an opalescent glass adapter or with an incident-light exposure meter. Hold the meter near the subject and direct it toward the lens: in other words, away from the subject. This method can be particularly useful in very weak illumination. Some photographers find that an incident-light reading for average subjects may frequently produce a more uniform density, but it is not recommended for subjects that have a wide brightness range. Furthermore, you must remember that the meter is measuring the light before it reaches the subject and, therefore, does not allow for the bright or dark quality of the subject itself.

Built-in Meters. As far as possible built-in meters should be handled in the same way as separate meters. Obviously, if the meter is part of the camera, it cannot be pointed toward the lens; but it can be pointed away from the subject. Think of the camera as a meter when taking a reading and hold it accordingly. On adjustable cameras you will probably find some dial to turn for setting the exposure at the meter reading, and the manufacturer's instructions should be followed.

One disadvantage of built-in meters is that whenever they

need repair, the camera itself has to be sent along. This is another reason why hand meters continue in favor.

Similar to built-in meters are a few detachable, coupled meters. These are designed to engage the shutter dial and the diaphragm of a particular camera and cannot be used on cameras for which they were not specifically designed.

Palm Reading. Some meter manufacturers and some professionals advise taking a meter reading from the palm of the hand rather than from the subject. The reason for this is that you can always hold the palm of your hand two or three inches from your meter, but you cannot always hold the meter close to a subject. Since skin color is one of the criteria of tone values, this provides a constant measurement. Cup the palm slightly in order to obtain an *average* light reading and compare it to the subject. If the major subject interest is a little or a lot lighter than your hand, close down the lens aperture by a fraction to a full stop. Conversely, if the subject is darker in tone, open the lens proportionately more than the meter reading indicates.

Gray Card. Another technique is to direct the meter toward a neutral, medium-gray card (at least a foot square). Place the card beside or in front of the person or object so that the card is getting the same light as the subject. A major purpose of the gray card is to bypass slight variations in the response of some meters to different colors, and thus produce a more consistent measurement of light intensity.

Color Sensitivity of Meters. The photoelectric and photoresistive cells used in exposure meters may vary somewhat, as films do, in sensitivity to different zones of the visible spectrum. To the midzones of yellow and green their response is not far from that of the human eye, but this is not true of their sensitivity to the blue and red ends of the spectrum. These minor variations are generally compensated for in the meter design, and in most instances they are negligible unless the blue or the red rays predominate in the subject being photographed.

Acceptance Angle. The angle of view included by an exposure meter is called that meter's *angle of acceptance*. Since this is quite often different from the angle of view taken in by the camera lens, inaccurate readings may result, especially when there are sizable lighter or darker areas outside the lens's view but within the meter's acceptance angle. Most of the early de-

signs had very wide angles, but for some time there has been a tendency to narrow the angle of meters.

Photographers with many lenses sometimes find it necessary to use more than one meter so that the acceptance angle will correspond to the angle of view of the camera lens. Or they may use a zoom meter to vary the acceptance angle. Slight variations in the angle of acceptance are sometimes necessitated to avoid infringing on the patented designs of other meters.

Learn the acceptance angle of your meter by studying the instructions which come with it and by making a comparative study of your exposure results. If a meter has a relatively wide angle of acceptance, it should generally be read close to the subject rather than from the camera position. This helps to limit the light by which the meter is influenced to the subject itself.

Which Exposure? A light meter can furnish useful statistics, but it cannot tell you which exposure you should select. As long as you understand your own meter and what you are doing with it, it doesn't matter whether you read reflected or incident light, whether you take single or multiple readings, or whether your meter has a wide or narrow acceptance angle. How you interpret the data supplied by the meter and how you evaluate the tones of your subject are the fundamentals on which correct exposure depends.

Suppose that you have taken a reading of a scene and that your meter indicates an exposure of 1/125 at $f/5.6$, or 1/30 at $f/11$, or other equivalent combinations. This is where your judgment comes in and where you can begin to ask yourself some questions, such as: Is the scene average—that is, composed about equally of lights and darks, and front lighted? Is there any fast movement in the scene? Is there any source of extra brightness, such as snow or white sand? Is there any exceptionally dark object or area in which detail is wanted? Is the picture to be a close-up, or is depth of field important? And what are the color values in terms of a gray tone scale?

Procedure Summary. Following is a step-by-step summary of the general procedure for using a light meter. First of all, be sure that the flap of the snug leather case in which the meter is probably enclosed is not interfering with the light reaching the meter; it's best to fold it back under the case. Then:

(1) Set the ASA index or other numerical rating to corre-

spond to the film being used. The calculator dial of the meter may be set between the numbers shown if the film speed is different from those numbers.

(2) Point the meter toward the subject to read the intensity of reflected light. Point the meter away from the subject for an incident-light reading. For distances, read from camera position. For correct close-ups, read six to twelve inches from the subject.

(3) For an average brightness reading, check the necessary darks and lights in either distant or close subjects. If you are taking several pictures in the same location under the same light conditions, take your readings once, for all the pictures, before starting to photograph.

(4) Be sure to read only the areas within the frame of your picture, not those outside your viewfinder.

(5) Set the meter dial to correspond to the light-value reading. More combinations of aperture and shutter speed will appear on the dial than will be found in any one make of camera, since meters are designed for use with all cameras.

(6) *Think.* Evaluate tones and compensations needed, then choose one combination of shutter speed and $f/$stop. They are all equal in exposure value. As a starter, this is suggested: For average pictures, try 1/125 of a second and the corresponding $f/$stop. For action shots, select a shutter speed of 1/250 or faster and the paired $f/$stop. If you need depth of field, pick a small $f/$stop, such as $f/16$ or $f/11$, and its corresponding shutter speed.

Maintenance. Proper upkeep of a meter is normally a matter of reasonably careful treatment. It requires no periodic inspection or lubrication and generally is not subject to deterioration. However, an exposure meter is a delicate little instrument and should be protected from damage and abuse. Dropping definitely disagrees with it, and dangling it at the end of a long cord or chain can easily disturb its proper functioning. Excessive heat and moisture are confirmed enemies of the key components of a meter, so do not leave it in the glove compartment of your car or on a handy windowsill. In a damp climate a meter can be used with impunity, but it is not wise to use it in pouring rain.

The meter's glass window should, of course, be kept relatively free of dust and dirt.

Zero Check. On all meters it is the fluctuating needle or arrow that indicates the quality of the light. Therefore, you should check occasionally to be sure that the needle points to zero when no light is entering the cell. You can do this simply by covering the meter window with something dark, like a notebook, or with the palm of your hand, while holding the meter level—that is, with its needle in horizontal position. Practically all meters have a small adjustment screw for resetting the needle at zero, if necessary.

Rules and suggestions for meter use can only generalize, can only give you an approximation or take-off point. After a good many pictures you may want to make a slight modification of your meter's zero setting, depending on whether your negatives show more or less density than you consider desirable. In that case, base any adjustment on color work, as it will give you a more precise calibration than black and white. With every meter it is the photographer's personal satisfaction with the results that determines its ultimate accuracy.

Color in Photography

Present-day color photography can achieve a wide variety of re-
sults, which are affected by choice of film, choice of subject,
light conditions, and processing controls. Exact realistic dupli-
cation of a scene is generally not possible, nor should it be the
goal of an original photograph. Just as a painting of a garden in
bloom or of a glorious sunset may inspire unlimited admiration
—along with such comments as "But tulips aren't *quite* those
colors" or "That doesn't look like a *real* sunset to me"—so a
transparency alive with unbelievably beautiful color may some-
times seem to have surpassed reality. Make it a practice to study
your own color photographs and the various factors that may
have influenced their success or failure.

BASIC CONSIDERATIONS

Color Perception. Color photography derives from the funda-
mental premise that all color perceptions result from single or
combined responses to three basic color sensations. Some sensa-
tions to which the brain-nerve-muscle mechanism reacts are dis-
tinctly unpleasant, like the energy waves radiating from an
overheated stove and threatening to burn the hand that tries to
control them. The waves of energy that we classify as color,
however, are apt to be quite pleasant sensations, on the whole—
and certainly not destructive ones, even when the color is "hot."

Different Primary Designations. A great deal of confusion
(and a few arguments) results from the ill-considered use of
the term "primary colors" without specifying which primaries
are meant. As noted in chapter 3, primary colors for mixing

paints are not the same as primary colors for mixing light rays. Likewise, the subtractive primary colors which control photographic color processing are different. Finally, if you pause to think about the everyday colors you look at and live with and wear, you will realize that every one of them is some variant of red, yellow, green, or blue; these, with black and white, are sometimes called the "psychological primaries."

White Light. Fundamentally and photographically, the subdivisions of white light are *the primary colors:* blue, green, and red. All other colors are combinations of these in different proportions. The respective *complementary colors* of the primaries are yellow, magenta, and cyan, each being a combination of the other two primaries (see figure 9.1). When a primary color and its complementary (secondary) color are combined to bring all basic colors together again, the result is *white light.*

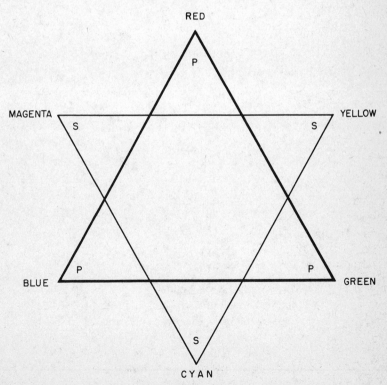

Fig. 9.1. Primary and secondary colors

All this adding and subtracting is what makes color photography possible and is why there are two different processes by which to obtain results: namely, the *additive* process and the *subtractive* process.

ADDITIVE PROCESS

The principle of color addition was demonstrated in a rudimentary way more than a century and a half ago. Any method that produces color by blending three primaries, in whatever amounts, from three discrete sources, is termed *additive*. Figure 9.2 shows diagrammatically the result of color addition,

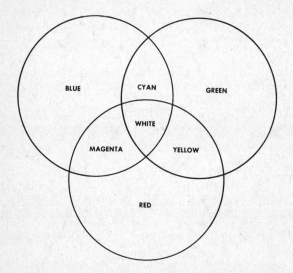

Fig. 9.2. Additive color process

which can be demonstrated by the following steps:

(1) When separate filters of blue, green, and red are placed in front of three light sources, such as projectors, and the three beams of light are superimposed in a kind of off-register projection, a core of white color results.
(2) If only the blue and green beams are mixed, the result is a blue-green for which the technical term is *cyan*.

(3) When just the blue and red beams are mixed, a blue-red results; to sound like a photographer, call it *magenta*.

(4) Mixing the red and green beams produces yellow which, surprisingly, is called *yellow*.

How Photographic Color Is Added. Using the additive color process, you can produce a color photograph by taking three separate but identical black-and-white exposures of a subject and employing three different color filters. If you expose one of the black-and-white negatives through a blue filter, the next one through a green filter, and the third through a red filter, the three negatives will have recorded all the blues, greens, and reds in the subject. When superimposed, after development, the three will appear to be one negative.

From each of these negatives a positive black-and-white transparency can then be made, in which the color-dense areas of each negative appear as clear areas in the transparency. The three positive transparencies should, if the film has been correctly exposed, transmit the proper amounts of light from the original subject. In this additive process a color transparency is obtained by projection. The three black-and-white positives are then placed in individual projectors, and a filter of the color through which the negative was first exposed is placed in front of each projection lens. Next, the three filtered images are superimposed on a screen to duplicate the original subject in colors that should be a fairly accurate reproduction—though slightly less brilliant because of the blackened metallic deposits in the black-and-white transparencies, which hold back more than half the light rays of the projector.

Summary. Thus, *adding* red, green, and blue light *from separate sources*, in amounts calculated to duplicate a given color, is the basic premise of the additive process.

SUBTRACTIVE PROCESS

Subtraction is the opposite of addition; black is the opposite of white. In the subtractive process of color photography, the three primaries and three complementaries of the additive pro-

cess swap places: yellow, magenta, and cyan now become the
subtractive primaries. When projected in overlapping beams of
light, they absorb their complementaries of blue, green, and red,
and a black core results. (See figure 9.3.)

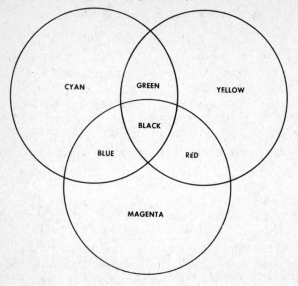

Fig. 9.3. Subtractive color process

How Photographic Color Is Subtracted. It is easy to demon-
strate this absorption by the subtractive primaries of their com-
plementaries. If you project a beam of white light through filters
of yellow and magenta, the yellow filter will absorb the blue
from the light beam, and the magenta filter will absorb the
green, leaving only the transmitted color *red* apparent on the
screen. Then overlap the yellow filter with a cyan filter: again
the yellow absorbs the blue rays from the light; the cyan sub-
tracts the red and you see only the green. Now, this time over-
lap the cyan and magenta filters; both filters absorb the red and
green, respectively, and you see the transmitted blue.

Summary. A color print or transparency is produced by dye-
stuffs which transfer, by transmittance or reflectance, the colors
absorbed in the dye, with certain opposite colors cut out. Thus,
subtracting red, green, and blue *from white*, by using cyan, ma-
genta, and yellow in controlled proportions, can duplicate any
desired color in the subtractive process.

STRUCTURE OF COLOR FILM

As noted in the chapter on films, there are two main types of packaged color films, *reversal* and *negative*, both of which are subdivisions within the *subtractive process* category of film manufacture. Reversal film, for color transparencies, is the more popular type. Both are similar in construction to the diagram shown in figure 6.1.

Three color-sensitive layers of emulsion are supported on a single base of the same type used for black-and-white film. Each layer after processing contains the image of one of the three subtractive primaries: yellow, magenta, or cyan. Each layer absorbs the complementary color to which it is sensitive. The top layer is a blue-sensitive (color-blind) emulsion which contains the *yellow* dye image. Under this layer is a yellow filter which absorbs blue but transmits red and green. The middle emulsion layer reacts to green and contains the *magenta* (blue-red) image. The bottom layer is sensitive to red and records the *cyan* (blue-green) image.

Reversal-type Color Films. There are two methods by which modern films achieve the color you see: (1) selective color development, the outstanding example being Kodachrome, in which the dye-forming substance is incorporated in the positive developers, requiring separate exposure and development for each of the three positive images, and (2) color-forming chemical development, used by other popular color films such as Ektachrome, in which the dye-forming intermediates are contained in the emulsions, permitting reversal development of all three layers in one developer.

SELECTIVE COLOR DEVELOPMENT. This technique, used in processing Kodachrome, requires precise laboratory control of temperatures, solutions, and timing. It is definitely not a do-it-yourself game—unless you have a backlog of professional know-how and about $100,000 worth of equipment. In this method the color images corresponding to the blue, green, and red of the picture you took are developed in the film's three emulsion layers by means of different couplers and filters.

The film is first developed to a black-and-white negative, and the usual minute silver particles are formed in all emulsion areas

not occupied by the positive color image latent in each layer. Then a different coupler (a substance that couples to a chemical brought out by the color developer) is introduced for each of the three subtractive primaries, or controlling colors: yellow, magenta, and cyan.

When the film is exposed to blue light and developed in a yellow coupler, a positive yellow image forms in the blue-sensitive top layer. In the next key step, the film is exposed to green light and developed in a coupler that forms the middle layer's magenta image. Afterward, it is exposed to red light and developed in a cyan coupler to produce the cyan image in the bottom layer.

Finally, after these major steps and numerous minor steps— including stop baths, hardening baths, washes, and rinses—the negative silver particles remaining in any areas devoid of color images are removed by a special chemical bleach. The wondrous result of this scientific progression is a three-in-one *color transparency* with its rich variety of subtle shades.

COLOR-FORMING CHEMICAL DEVELOPMENT. Used in processing films such as Ektachrome, color-forming chemical development is much less complex and, with a relatively inexpensive kit, the film can be processed in the kitchen sink. This is because the chemical couplers, which bring forth the color images in each layer of these triple-decker films, are combined with the sensitized emulsions during manufacture. After a negative black-and-white developer is used and the film re-exposed to white light, *a single color developer* brings out the yellow, magenta, and cyan images simultaneously.

Next, the film, which now contains a negative silver image, a positive silver image, and three dye images, is bleached to remove the silver particles—and *voilà!* your color transparency. All films that use this type of processing are fundamentally the same, with minor variations in the makeup of the coupling substances and in the color-developing agent.

Negative-type Color Films. The principal advantage of this type of color film is its relative flexibility. Basically, the reason for this is that the film in your camera and the finished pictures are *not* the same bit of material—as they are in reversal types. Although negative types have the standard three-layer structure of all color films, they are somewhat akin to black and white in their tolerance of exposure variations and their allowance of

some correction between developed negative and positive print.

Kodacolor is a popular example of a negative-positive color film. When this type of film has been exposed, then developed, fixed, washed, and dried, it is printed on a specially treated paper. Another similarity to black and white is that on the negative the darks show as light areas, and vice versa. Negative colors also appear as opposites of what the finished print will show: magenta lawns, yellow skies, little cyan schoolhouses—all very weird. The orange which shows during the development of Kodacolor is due to two color-corrective masks of red and yellow in the film itself.

Exposure Latitude. Because of the second-chance opportunity to compensate in the printing for slightly inexact exposure, films like Kodacolor have an exposure latitude not countenanced by reversal color films. Although one particular aperture and shutter speed may be *the* best exposure, you can still expect a good, printable negative if it is exposed anywhere within the manufacturer's recommended range of f/stops.

The sensitized paper on which the color prints are made contains an emulsion similar to the film's, except that the coupling substances are colorless so that they will not affect the values of your color picture. Color transparencies, or black-and-white prints, can also be made from negatives of this type of film.

10

Types of Filters

A filter in photography is a transparent piece of glass or gelatin used to alter or control the color of light reaching a film during exposure. Filters are for black and white *or* for color, not for both. The exception to this are the "neutral density" filters which have essentially no color characteristics; they are used to reduce light transmission and to prevent overexposure of fast films.

Filters are designed to transmit certain colors you want brightened in the final picture or to absorb colors you want toned down; thus they can compensate for differences between what the eyes see and what the film records. Although primarily intended for a more accurate translation of the color values of the subject, whether in color or in gray tones, filters can also be employed in unconventional ways for deliberate dramatic effects.

PRELIMINARY CONSIDERATIONS

Materials. Filters are made of glass or gelatin. Of the hundreds available from various manufacturers, the most permanent and highest in quality are made of molten *optical glass* to which coloring substances have been added. They are in the minority, however, since only a limited number of dyes can be added to glass, which is, furthermore, difficult to correct for proper transmission.

Gelatin filters, the most commonly used, are available in practically any color you might want and are usually combined with clear glass (for an exception, see CC filters). To make them, dyestuffs are added to a solution of high-quality gelatin, which is

then solidified into very thin sheets. To avoid finger marks or other damage, these sheets must be handled with extreme care.

Individual gelatin filters for hand cameras are cut from sheets and cemented between two layers of glass, usually of optical quality, then mounted in metal rings—like colored monocles. They must be handled carefully and should be kept from undue moisture or heat, which could overtax the cement. Some are sized and threaded to fit a specific camera; others can be used in an *adapter ring*, which has the effect of converting the filter size to fit your camera; the threaded collar of the ring permits it to be attached in front of the lens. Identification of the filter type is engraved on the metal mounting.

Filter Factors. The number indicating the additional exposure required to compensate for the reduced light transmission when a filter is used is called the *filter factor*; it can vary from zero to six or eight times basic exposure, depending on the type of filter. For example, the almost colorless "skylight" filter for color films has no factor, but a red filter for black and white has a factor of 8.

These numerical factors are determined by the manufacturer, based on a specific film such as medium-speed black and white. When the actual exposure, such as 1½ f/stops, is not given, or when you are using a different film, the simplest way to calculate the compensation required for a particular filter is to divide that filter's factor into the printed ASA index of your film to give it a new index. For instance, if you are using a red filter (factor of 8) with Tri-X (ASA 400), you expose the film at the new index of 50. The arithmetic won't always produce such nice even numbers, but you can get a workable approximation; for example, the ASA 125 of Plus-X divided by the yellow K-2 factor of 2 gives that film 62½ as the new index.

Filter factors or guide numbers, like meter readings and basic exposures, should be regarded as *average* suggestions, to be supplemented by the photographer's evaluation of specific conditions. Differences in camera lenses, direction of light, and the particular effect wanted are some of the considerations that may dictate a slight departure from the recommended key.

Suggested Review. Since the subject of filters concerns the modification of the color of light reaching the film, it might be well to review the characteristics of light transmission and ab-

sorption and the characteristics of different film emulsions. These are detailed in chapters 3 and 6, respectively. The basic principle of filters for hand cameras is the same as that of color addition and subtraction, explained in the preceding chapter; that is, *a primary color transmits its own color and absorbs its complementaries.*

FILTERS FOR BLACK AND WHITE

How the myriad hues all about you will appear in several shades of gray is a basic question for every photographer. You will recall that, while normal human eyes are most sensitive to the yellow-green portions of the spectrum, the greatest sensitivity of all films is to the blue and violet zones—and to the ultraviolet, which we do not see at all. For this reason, a film sometimes records light and dark densities contrary to those you expect; an apparently brilliant yellow dress may turn out a very dark gray, or the bright blue sky you admired in a scene may be a washout in your black-and-white print. The basic fact to remember is that a filter *lightens its own color and darkens its complementaries.*

Filters for black-and-white films are divided, according to their transmission abilities, into two general types: correction, or compensating, and contrast, or over-correction. *Correction* and *contrast* should not be thought of as sharply separate divisions, since the correction of related colors rendered as black and white may seem to require more contrast or exaggeration for a true appearance to one photographer than to another.

When filters transmit all the colors of the visible spectrum in varying degrees for different wavelengths, they are broadly classified as *correction* filters. By equalizing the rays of light, they compensate for discrepancies between what the eyes see and what the finished print reveals in terms of black and white. When this type of filter has the transmission characteristics appropriate to the film and the light source, it is possible to obtain the correct values of the gray tonal range, "correct" being that which most nearly corresponds to what normal eyes see.

The second general group of filters for black and white are usually called *contrast* filters. These are more selective, absorbing certain colors almost completely and shifting the percentages of

Fig. 10.1. No filter results in washed-out sky.

Fig. 10.2. Light yellow filter shapes clouds, gives pleasing contrasts.

Fig. 10.3. Red filter exaggerates contrast for dramatic effect.

the rays transmitted from the other colors. An over-correction, or greater than normal separation of colors, is thus produced, showing in the print as increased contrast between the light tones (transmitted by the filter) and the dark tones (absorbed by the filter).

Haze Penetration Filters. Probably the most useful filter for general photography is one of the yellow group, which illustrates the principle of color addition and subtraction. When you use a yellow filter to clear up a distant landscape that appears to be wearing a misty blue veil, you are simply subtracting some of the blue so that the red and green can get through to the film; otherwise you would get indistinct gray on gray in your print, as in figure 10.1. Haze consists of air, moisture, and particles of dust which scatter more blue-violet light than reds or greens; therefore, a yellow filter will help cut the haze by absorbing the light rays at the blue end of the spectrum, as illustrated in figure 10.4.

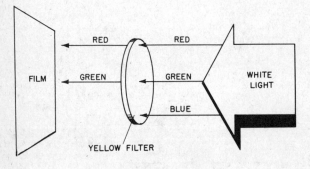

Fig. 10.4. Haze penetration

The choice of a filter for haze penetration depends on the amount of haze, the principal subject, and the effect desired. Orange or red filters are used for greater contrast, for example, since they cut out most of the green. On the other hand, a light green filter will produce a result similar to that of a yellow filter, but will render skin tones and foliage colors generally lighter and softer.

Wratten Filters. If you wonder about the origin of the term *Wratten*, that was the name of the first English manufacturer of present-day filters. Although they have been made by Kodak for

some time now, they are still called Wratten light filters; and the arbitrary letters and numbers assigned to them have become more or less standard during more than forty years. Good filters by other manufacturers have different numerical designations.

Only a few of the hundreds of available commercial filters are used by amateur photographers to any extent. As a rule, filters are practical only for panchromatic emulsions since pan films record all colors. A handful of favorite filters, with their factors for popular films of medium speed (such as Kodak Plus-X), follows:

Filter & Color		Factor (for Plus-X)	
		Daylight	Tungsten
K-1	LIGHT YELLOW	1.5	1.5
K-2	MEDIUM YELLOW	2	1.5
G	ORANGE (DEEP YELLOW)	2.5	1.5
A	RED	8	5
F	DEEP RED	16	8
X-1	LIGHT GREEN	4	4
B	GREEN	8	8
C-5	BLUE	5	10

Some Filter Uses. Most amateurs use only two or three of the filters listed; some are content with one or none. An initial choice is often one of the yellow group. Some of the choices, based on the preceding list and other makes, are described here.

Medium yellow is usually regarded as the best general-purpose filter for outdoor pictures in black and white. It cuts haze somewhat, increases contrast, makes clouds and lighthouses and steeples stand out against a darkened blue sky, softens skin tones slightly, and helps produce (to borrow a Kodak phrase) "correct monochromatic rendering of colored objects." The factor of 2 means one additional stop for daylight exposure.

Light yellow gives less correction than the medium yellow and is less popular. The factor of 1.5 is approximately 3/4 of a full stop.

Orange filters give greater contrast than yellow ones and are preferred by some photographers, especially for thick clouds, marine scenes, and a somewhat more emphatic separation of tones. The factor for daylight is 2.5, which is slightly more than one additional stop. (A factor of 3 would be 1½ stops.)

Light green, by absorbing blue and red and transmitting colors that contain green, can give more subtle separation of values

than other filters, imparting more natural tones to foliage and to the complexions of people photographed with the sky as a background. In artificial light, this green filter can be used "for correct monochromatic rendering of colored objects." It is a great favorite, but it does require more exposure compensation than the yellow filters: a factor of 4 for daylight or tungsten, meaning two additional full stops .

Blue filters can dramatize fog scenes during daylight by a sharp exaggeration of dark foreground objects against a mist-veiled background. For a factor of 5, the exposure should be increased by a little more than two stops; a deep blue (6X) filter would need 2½ stops.

Red filters are used for exaggerated contrast (see figure 10.4) when you are striving for a dramatic rather than a realistic effect and when you have enough bright light to compensate for the daylight factor of 8. Clouds, sailboats, and such will come out almost starkly white, while the landscape and other darks will seem almost black, definitely not for a gray day. In artificial light (factor of 5) a red filter is especially useful for copying work—reproducing blueprints, for example, or other documents. For daylight, the factor of 8 calls for three additional stops.

Caution. Again we mention *average* in determining your exposure. A darkish day is not average; neither is backlighting. In such conditions remember that you may need an additional stop besides the extra exposure required by the filter. Conversely, if the subject is glaringly bright, you may need less. Refer to the filter factors recommended on the film information leaflet; then consider whether or not your subject is average.

Inexpensive simple cameras which do not permit the user to adjust the exposure settings can use filters only to a very limited extent. For example, if the additional stop needed by a medium yellow filter corresponds to the camera's aperture and shutter speed, then of course the filter can be used. On the whole, though, filters are impractical for simple cameras.

Effect on Sharpness. Most single filters do not contribute to any loss of sharpness, even in standard enlargements. As a matter of fact, the increased contrast usually makes the print seem sharper, unless other conditions are affecting the definition. If you fail to obtain the effects expected, you may be overexposing; and you cannot get cloud-sky contrast on a gray day when there are no clouds and no blue sky!

Summary. Before looking at the quite different species of filters used only with color films, it might be a good idea to list briefly some very general helpful hints for the use of filters in black-and-white photography:

(1) Check the *factor* of the filter you intend to use and your *film speed* to see whether it is feasible to reduce the ASA index by the amount recommended.

(2) To reproduce a color as a *dark gray*, use a filter which *absorbs* that color. If you want a red rose to come out a dark gray, use a green filter.

(3) To reproduce a color as a *light gray*, use a filter which *transmits* that color. If you want the red rose to appear as a light gray, use a red filter.

(4) To emphasize a color, *determine first whether it should be lightened or darkened.* Regardless of size, a light area on a dark ground will usually be more prominent than a dark area on a light ground. However, details in a relatively large color area may show more clearly as a light gray, while a small area of color may be more prominent as a dark gray against a lighter ground.

(5) Filters are often unnecessary. If you are doubtful about the right filter and film combination, your best bet may be an *all-purpose panchromatic film with no filter.*

(6) Be sure your filter is not going to absorb *all* of the light reflected by your subject.

FILTERS FOR COLOR PHOTOGRAPHY

Filters are used far less in color photography than in black and white. Very few of them are used by amateurs, usually only the so-called skylight filter and a conversion type which permits the use of indoor film outdoors appeal to beginners and casual picture-takers. Less casual photographers are often devoted to the *polarizing* filter (see below), which, while mainly for color, can be used alone or with other filters for specific effects in black and white.

Haze Penetration Filters. For a slight haze correction, a faintly pink-tinted filter, such as the Kodak Skylight filter (Wratten 1A), is widely used. Its primary purpose is to reduce excessive blue, particularly in shadow areas, and it is often used for portraits in shade. *No increase in exposure* is required for the Skylight filter,

nor for the Ansco UV-15, which is more strictly a haze filter, designed to cut haze and to correct the image blurring caused by ultraviolet light, especially at high altitudes. Some photographers like to leave one of these no-factor filters on their cameras all the time, mainly to protect the lens from dirt and scratches. Others veto this, feeling that any glass attachment on the lens can impair the image quality.

Conversion Filters. The other type of filter that is popularly used is one that converts indoor film to outdoor use by cutting out much of the excessive blue contained in daylight. Most popular of these is a salmon-pink 85 filter which converts certain color films balanced for artificial light to satisfactory use in daylight. Since manufacturers are continually changing the available films, it is a good idea to obtain current information regarding filters for a specific film and to consult the film leaflet for any recommended change in the exposure index.

While it is quite practical, and frequently very convenient, to convert indoor film to outdoor use, the reverse is not true, as this slows the film too much. A daylight film, when converted to tungsten illumination by an 80B or 80A filter, loses at least half its normal ASA index for outdoor use. Photographers with SLR cameras quite often have different film in two, or even three, camera bodies to be used with one set of interchangeable lenses.

Polarizing Filters. The principle of polarization was discussed as one of the characteristics of light in chapter 3. Different makes of polarizing filters can be used to subdue glaring reflections from nonmetallic surfaces, such as water and glass, and to control the brightness of the sky. The action of a polarizing filter is concerned with the direction of light waves; the glare of oblique reflections can be lessened by its proper use, and a sky can be prevented from reproducing as too light a color. Many potentially good landscape photographs have failed because of a drab, washed-out sky. But a polarizing filter, rotated on the lens according to the manufacturer's directions, can effectively correct this condition so that the sky will reproduce as a rich, deep blue. Besides darkening the sky, a polarizing filter on the camera lens will minimize aerial perspective, giving more saturated color to scenic shots.

Color Compensating (CC) Filters. Designed primarily for professional work, these filters come in graduated densities of pri-

mary and secondary colors. Some are used only in the color head
of an enlarger to correct the balance of color between illumina-
tion and a particular film in color printing. Others may be fitted
into a special holder and used experimentally in front of a
camera lens. One of the favorite uses of CC filters is in slide
remounting, when undesirable color can be modified by sand-
wiching one or more gels into the finished slide. To correct a
"wrong" color, select its complement in a CC gel and remount
it with the transparency. The complementary color of the gel
will absorb the unwanted color in the transparency when the
slide is projected. (Slide remounting is discussed in chapter 20.)

11

Artificial Light for Photography

Photographic illumination from any source other than the sun is generally regarded as *artificial light* and referred to as *tungsten* or as *flash*. "Daylight" is used almost synonymously with "natural" light and refers to any normal sunlight, from very bright to very dim. Here, however, is another instance of inexact terminology, since moonlight and starlight are also natural illumination and call for "daylight" films; admittedly there is not much photography in this area, but a few hobbyists do attempt pictures by natural night light.

PRELIMINARY CONSIDERATIONS

Sources of Artificial Light. For photographic purposes, artificial light includes all tungsten-filament incandescent lamps: photofloods, photoflashes, and ordinary service bulbs; also fluorescents, gas lamps, carbon arcs, candles, and oil lamps. Photofloods require electrical connections and are standard equipment for pictures that need relatively prolonged lighting and have little movement—such as portraits, still lifes, and interiors. Flash is used for action subjects, such as an active child or pet, for sports events, for night shots away from electrical outlets, for fill-in lighting, and for any subject requiring momentary illumination; electronic flash, flashbulbs, and flashcubes are used, depending on camera and subject.

Fluorescent lighting varies because its color depends on the particular substance with which the inner walls of the tubes have been coated. The mercury vapor or similar gas within the tube does not produce color but merely activates the coating when an electric current passes through it. Since most fluorescent lighting

is closer to bluish daylight than to reddish tungsten, daylight-type color films are generally recommended. However, fluorescent lighting is often combined with tungsten, notably in places like museums, making it difficult to judge which is the prevailing light. Furthermore, there are slight differences in the color balance of different brands of color films. Here as elsewhere, the variables affecting satisfactory results are governed to a great extent by the judgment, experience, and preference of the photographer.

Lighting Variations. The different types of artificial light can be used in combination with each other and with daylight. As noted earlier, *available light*, which is also called *existing light*, generally refers to dim or otherwise unsatisfactory light conditions under which you may wish to take a photograph, indoors or outdoors, without supplementary illumination.

Artificial lighting was once equated with taking pictures indoors, but improvements in film speeds and lens efficiency have made it practical and convenient to take many pictures under what were formerly "adverse" light conditions needing supplementary flash or flood. Pictures indoors are often taken by natural window light or by the available light of room lamps without photographic lighting equipment. Moreover, flash is not confined to indoors; and it is well to note that there is a good deal of *un*natural light outdoors: in city streets, at carnivals, and around campfires, for example.

The Kelvin Scale. Developed by the British physicist William Thomson, Lord Kelvin, this system in its application to color is based on the fact that white is the sum of all color and black is the absence of all color. (See color addition and color subtraction in chapter 9.) Carbon, which absorbs light and was used by Lord Kelvin as a basis for comparison, was found to reflect no light at all at $-273°$ C. This point of blackness became zero in the Kelvin scale; therefore, a temperature stated in degrees Kelvin is always 273 degrees higher than when stated in degrees centigrade. For example, when the carbon body was heated to a redness of about $2000°$ C., this emission of light was found to have a color temperature of $2273°$ K. Thus, it was determined that as the temperature of an object goes up, it produces progressively whiter light with a correspondingly higher color temperature, which is indicated in degrees Kelvin.

It is interesting to note that the popular impression of warm

and cool colors is contrary to scientific theory—a difference reminiscent of the widespread misconceptions about primary colors (see chapter 3). In the everyday world about us, in scenery and paintings, in fashions and furnishings, blues and greens are usually described as "cool" colors, reds and oranges as "warm" colors. To the man in the laboratory, however, the opposite is true. The first visible light to appear when Lord Kelvin heated the carbon body was red; when maximum heat was applied, the carbon reached a blue-white color.

Measurement of Color Temperature. The color quality of a light source in color terms of red to blue is generally referred to as that light's *color temperature*, variations in these color temperatures being expressed in degrees Kelvin. Like the Fahrenheit (F.) and centigrade (C.) scales, the Kelvin scale is simply an approximate measurement, used at present to describe the degree of whiteness of a particular photographic light. The scale is commonly used in such applications as producing conversion filters, balancing daylight and tungsten, and lowering the color temperature of skylight filters.

Color temperature is not dependent on light intensity. For example, a fluorescent tube burns at a very low Fahrenheit temperature, yet has a high color temperature. In black-and-white photography, the important considerations are the intensity of the light in relation to the subject and the speed of the film being used. The same factors apply to color photography; but advanced amateurs who take their color work seriously will want to consider also the color temperature of the light. The chart in figure 11.1 indicates the approximate temperatures of common light sources.

ARTIFICIAL LIGHTING EQUIPMENT AND ITS USE

Ordinary tungsten or fluorescent room lights, floodlamps, or single and multiple flash units may be used in combination with each other and with daylight to illumine a photographic subject. Flash is the briefest illumination and the most mobile; other lamps supply sustained illumination and must be plugged into electrical outlets. Since floods have a useful life of at least three hours, as compared with a flash's split second, they are relatively economical despite their large consumption of current.

APPROXIMATE COLOR TEMPERATURES

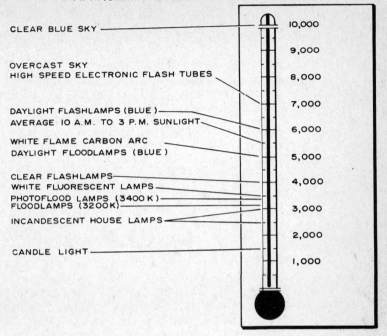

CLEAR BLUE SKY ——————————— 10,000

9,000

OVERCAST SKY
HIGH SPEED ELECTRONIC FLASH TUBES —— 8,000

7,000

DAYLIGHT FLASHLAMPS (BLUE)————
AVERAGE 10 A.M. TO 3 P.M. SUNLIGHT—— 6,000

WHITE FLAME CARBON ARC
DAYLIGHT FLOODLAMPS (BLUE) 5,000

CLEAR FLASHLAMPS————
WHITE FLUORESCENT LAMPS———— 4,000
PHOTOFLOOD LAMPS (3400 K)————
FLOODLAMPS (3200K)————————— 3,000

INCANDESCENT HOUSE LAMPS———— 2,000

CANDLE LIGHT———————————— 1,000

Fig. 11.1. Approximate color temperatures of common light sources

With the versatile flash, one must visualize how the briefly lighted subject will appear; with floods one can preview the lighting effects.

Photofloods. A *photoflood* is essentially an electric lamp using an excess voltage for sustained illumination. This type of light bulb was introduced at the start of the 1930s, about the same time that panchromatic film became available, and the two innovations combined to make photography by artificial light practical for amateurs.

Photofloods, which should generally be inserted in a metal reflector, resemble standard frosted bulbs, fit standard sockets, and operate on ordinary house current of approximately 110 volts. However, the tungsten filaments of floods are designed to produce more intense light per watt for a relatively shorter lifespan per bulb. A No. 1 photoflood looks like a regular 100-watt bulb but burns as if it were a 750-watt bulb and has a life ex-

pectancy of three hours. No. 2 photofloods are slightly larger (about the size of 150-watt regular bulbs) and give twice as much light (1500-watt intensity) for twice as long (about six hours).

There is a much more powerful lamp, the No. 4 photoflood, which draws four times as much current and gives about four times as much light as a No. 1 flood; but this type does not fit ordinary sockets and is intended for professional studio use.

When a photoflood has a letter *B* after the number, this indicates that the bulb has a blue filter and is designed for use with color films of the daylight type.

REFLECTOR LAMPS. A letter *R* with the photoflood number, such as the popular R-2 reflector photoflood, indicates that the lamp has a reflector lining which eliminates the need for a separate metal reflector. The filaments of the R-2 are about the same as those of a standard No. 2 flood, but the bulb itself is shaped like a funnel; its neck tapers toward the screw base, which fits a standard socket, and its broad, flattened top is frosted inside. The reflective aluminum deposit in the funnel concentrates the R-2's light over an angle of approximately 60 degrees. Almost identical in appearance and performance is the RSP-2, a reflector photospot; but the light beam of this lamp has been concentrated into about 20 degrees on a fresnel lens (a small positive lens circled by prismatic rings), giving the condensed spot of light more than seven times the intensity of the R-2.

CIRCUIT OVERLOADS. Most electrical circuits for household wiring are fused for maximum loads of 15 amperes to prevent overloading, and it is not considered safe to use more than 1500 watts on one circuit. If you are using the maximum number of photofloods, all other loads—such as customary room lights, television sets, radios, and clocks—should be turned off. An additional precaution against blowing fuses is to disconnect major appliances, like refrigerators, while the floods are in use.

BASIC USE OF PHOTOFLOODS. Artificial lighting employed in such a manner as to simulate daylight can achieve a natural effect. Whether the subject is a person, a piece of machinery, or a small object, it should be carefully lighted to bring out detail and avoid harsh shadows. Outdoors, of course, the sun is the one main source of light, with the sky serving as an immense reflector. Indoors, therefore, one photoflood should be your main

source of illumination, and it should be kept above an imaginary line from the camera to the top of the subject. If a second flood is used, it should generally be placed near the camera, but not turned directly on the subject. A third lamp should be used only for background illumination or special effects.

For stepped-up but natural lighting, a No. 1 photoflood can be used instead of an ordinary bulb in a table or floor lamp, with the other lights balanced so that the shadows will not be too dark. This device is best employed when the lampshade is large enough to keep its distance from the scorching heat of the flood.

Exposure for incandescent or fluorescent lighting is determined by reading a meter in the same way you would for natural light. If a combination of artificial and natural light is being used, always expose for the *main* light source.

"PAINTING" WITH LIGHT. This technique is sometimes used for soft, even lighting when you wish to photograph a larger interior area than your quota of floods can cover. It involves handling a single photoflood as if it were a spray gun during a time exposure. If near objects appear too bright and background objects too dark for a good black-and-white print, "painting" may be your best lighting method. Set up the camera, focus for the area to be included, and select an exposure of *ten seconds or more;* time depends on the size of the interior since the shutter, of course, must remain open while you are light-painting. *Keep the floodlamp moving constantly* across the subject area, up and down and sideways, making sure that you do not allow the beam or any reflective glare to strike directly into the lens. If the depth of the subject necessitates your walking into the picture to paint the far corners, wear something dark, keep moving, and hold the light away from you and away from the lens. Don't paint any one part too long, but try to cover the entire area evenly.

BOUNCE LIGHT. This term describes the diffused illumination produced by directing either a photoflood or flash at the ceiling or wall instead of directly at the subject. The quantity and quality of the light that is bounced will be affected by the color and distance of the surface at which it is directed.

In an average-size room with a height of about eight feet, the floodlamp or flashholder can be placed about halfway between ceiling and floor for even distribution of the illumination; a

lower white ceiling will require less than basic exposure, a high or dark ceiling will require more. When using color film, you will usually find it better to bounce the light from a portable reflector, such as white cardboard or sheeting, since even the palest off-white ceilings and walls can change color results.

BASIC LIGHTING SETUPS. The placement of photofloods, while applying to photography generally, is particularly important to formal photographs of people and is therefore examined in detail in chapter 16.

Flash. Flashbulbs were for a long time the only type of flash, but for many years now, the use of electronic units has become more general. Any discussion of flash use encompasses bulbs, cubes, and electronic flash—whichever goes with your camera and projects.

Flash photography falls into two general categories: *synchronized flash*, which employs a mechanism for controlling shutter action so that it coincides with the peak intensity of the flash; and *open flash*, which is without mechanical synchronization and can be used with any camera having a time or bulb shutter setting.

WHY FLASH? Although it is possible with fast films and modern lenses to take nearly any picture by available light, there are a number of reasons why some photographers like to use flash. For one thing, a specific type of flashbulb always discharges the same amount of light and, if properly used with a camera and reflector with which you are familiar, makes exposure more certain. Furthermore, flash can be placed where you want it when the existing light does not give the desired effect. A third reason is that the additional light permits you to use smaller apertures, even at action-stopping shutter speeds, thereby increasing depth of field. Still another consideration might be whether you intend to have enlargements made, since in that case the coarser grain of the high-speed films you might choose for existing light could be undesirable.

Flashbulbs. The forerunner of modern flashbulbs was a form of powder flash, touched off amid noise, smoke, and some justifiable apprehension. By contrast, today's safe and silent flash is a small sealed bulb coated inside and out with cellulose acetate to make it shatter-resistant. There are many sizes and types from which to choose, all standardized by the manufacturers

and designed to fill the needs of different cameras, shutters, reflectors, and photographic purposes.

BASIC BULB CONSTRUCTION. A standard flashbulb is filled with hair-fine flammable material and sufficient oxygen to assure fast and instantaneous combustion. A smaller and speedier midget type is filled with oxygen but, instead of foil or wire, has a chemical paste heavily applied at the business end of two little lead-in wires which are readily fused to produce an intense light of very brief duration.

The most popular flashbulbs have a "bayonet" base, and some larger bulbs have a screw base (both types are illustrated in figure 11.2). There are also a "miniature" base and a "baseless" (AG) lamp. A flashholder accepts only one kind of base.

Because of the brevity of the light discharged by flash, its duration is measured in terms of a *millisecond*, which is 1/1000 of a second; that is, 1000 milliseconds equal one second. *Lumen*, or lumen second, is the term used to measure light intensity; it refers to a somewhat smaller unit than the more familiar candle-power. It is unnecessary for you to use these measurement units since you will find the essential data calculated for you in the exposure tables published for all flashbulbs.

USABLE LIGHT OUTPUT. When a flash reaches approximately half-peak intensity, it is giving off enough illumination for normal exposure conditions. The useful light output of a bulb is generally calculated from that half-peak point to the same level on the downside curve. (See figure 11.2.) Since an average between-the-lens shutter takes less than 5 milliseconds to reach wide-open position and a standard flashbulb takes 20 milliseconds to reach peak intensity, it is obvious that most shutter action must be delayed to give the bulb a head start if the exposure is to receive maximum light from the flash. *Duration of flash* refers to the usable and fairly constant output of illumination at or above half-peak intensity.

TYPES OF BULBS. Flashbulbs are classified mainly according to light output and delay, *output* being the amount of light produced and *delay* the time required for the light to reach peak intensity after current has been applied.

The most popular standard flashbulbs in general use are *type MF* (*medium fast*), which reaches peak intensity with a 13-millisecond delay, and *type M* (*medium*), which peaks at 20 mil-

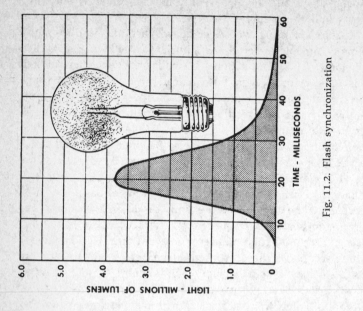

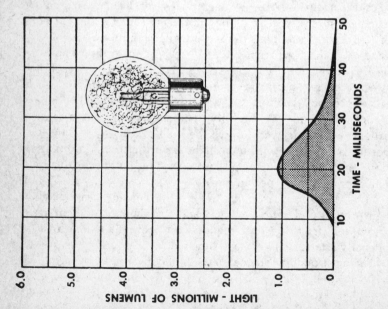

Fig. 11.2. Flash synchronization

liseconds. Flashbulbs classified as *type S* (*slow*) are primarily for professional studio use, and reach peak intensity about 30 milliseconds after current has been applied.

There is also a *type FP* flash for focal-plane shutters. The chief difference between these bulbs and the medium types is in their extended burning time after reaching half-peak intensity; this is necessary to supply a constant light output during the time it takes the opening in the focal-plane shutter to traverse the film. FP bulbs reach a useful half-peak intensity in about 11 milliseconds and then maintain a plateau of light. The extended burning time is achieved by modification of the bulb construction: there is an increase in the diameter of the combustible wire filling and the amount of fill used.

Flashcubes are units of four midget bulbs which rotate automatically by the film-advance mechanism to produce flash for four successive shots. Like the simple little AG type, the cube emits a brief flash after a delay similar to that of a medium-fast standard bulb. Battery-powered flashcubes fit regular Instamatics and 126 cameras, and can be used with an adapter on any camera that has a shoe.

Magicubes are batteryless four-flash units, introduced by Sylvania in 1970 to fit a line of Instamatic-X cameras; Magicubes are identified by an "X" and can be used with "X" cameras and with pocket Instamatics. A spring in the cube is activated by the shutter release to produce the successive flashes. They have a briefer delay (7 milliseconds) and give a small fraction more light than battery flashcubes.

Clear flashbulbs emit light that can be correctly balanced for color films under tungsten light by using the filter recommended for the type of film being used. They can be used with a filter for black and white. *Blue*-coated bulbs are used with daylight-type color films and also for fill-in flash in outdoor shooting.

If you are uncertain about which flashbulb type or size you should have for your camera and for the photographs you intend taking, ask your photo dealer for specific advice about basic types and new items.

FLASHBULB SAFETY. The common sense applicable to the use of electricity in general should be exercised in the handling of flashbulbs, which are considered quite safe unless treated carelessly.

Bulbs are packaged to protect them—and you. Keep them in their packages until you are ready to use them; never carry them loose, as friction may damage the protective coating of the glass or the glass itself might become cracked, causing the lamp to explode when fired. Some bulbs have, inside the tip, a blue spot of cobalt chloride which turns a light pinkish color if even an invisible crack has admitted any air.

The intense heat generated by flashbulbs makes them too hot to touch immediately after firing. Your flashgun probably has an ejector; if not, wait for the spent bulb to cool before removing it manually. Eject hot bulbs over an appropriate container, such as a metal can or wastebasket that contains nothing flammable.

Do not use flash in an explosive atmosphere, such as around gasoline vapor. Be cautious about picking up a flashbulb if you have built up an unusual amount of static electricity at the time.

Never drop a bulb you have just fired into a camera gadget bag or any other place where it might contact new bulbs which could be ignited by the residual heat.

If you are photographing anyone within six or eight feet, the flashbulb should be screened by a transparent or translucent shield over the reflector.

ELECTRONIC FLASH. An invention of Dr. Harold Edgerton provided photographers with a different type of flash, the *electronic discharge lamp*. In lightweight, portable models this flash unit usually has a slim strobotron tube filled with xenon gas and connected to one or more battery condensers by a kind of triggering circuit. When condenser-stored power is discharged through the tube, a practically instantaneous flash of extremely brief duration is released. This action-freezing speed and a capacity of thousands of flashes without changing tubes give electronic flash its principal advantages.

Since the flash from an electronic unit is between 1/500 and 1/2000 second, virtually all of the brilliant illumination is utilized. There is no problem of peak intensity; hence, the *guide number* recommended for a particular film is the same regardless of shutter speed. The color temperature, intensity, and duration produced by electronic flash equipment in proper working order are generally more consistent than they are with other types of flash. Daylight-type color films should be used, indoors or out, with electronic flash, which is similar to the spectral quality of

natural sunlight. Electronic flash is especially well suited to sports and other events where it is desirable to stop fast action. It is also good for informal portraits when you wish to stop momentary facial expressions and body motions.

The comparative cost of electronic and standard flash should be considered in relation to the photographer's program. Electronic units, which vary greatly in design, size, and price, are relatively expensive for occasional snapshots. But for someone who expects to take perhaps two hundred flash shots a year, an electronic unit can prove to be an economy. When auxiliary lighting is required, electronic flash can be combined with other, less expensive illumination through application of basic lighting principles.

GUIDE NUMBERS. The principle behind flash guide numbers is the inverse square law (see chapter 4), which explains how the intensity of light is related to distance from the source of illumination. Guide numbers, like basic exposures, are merely key suggestions for *average* conditions and should be altered to meet given conditions as you appraise them. Variations in synchronization and reflectors also influence individual use of guide numbers, which are based on the light output of a particular lamp in relation to the speed of the film and shutter speed being used with that lamp.

A *guide number* represents the approximate flash-to-subject distance in feet multiplied by the f/stop to be used. Conversely, if you divide the guide number by the flash-to-subject distance, you will get the recommended f/stop for that bulb at that distance. The chart for a particular flashbulb will list guide numbers according to the different shutter speeds you may use and according to whether the bulb is being used in a 3-, 4-, or 5-inch reflector and whether the reflector has a matte or polished surface. Lower guide numbers in a series indicate higher (faster) shutter speeds.

Short-cut calculations are sometimes used by photographers in situations where there is not enough time or light for too many settings or too much figuring. These quickie calculations may be evolved by the photographer from his own experience or may be culled from dealer or maker advice about his specific equipment. One manufacturer of electronic flash units suggests, for example, that in taking pictures at night you first set the

f/stop for the film speed you are using—say, f/8 for ASA 125. With a normal lens, f/8 gives you a depth of field from 7 to 13 feet, so you prefocus the lens for 10 feet and shoot away.

Charts of guide numbers accompany packaged flashbulbs and may also be found on the instruction leaflets packaged with films; many individual flashholders have all essential data right on the holder. Inexpensive little dialguides for flash are also available in photographic stores. Guide numbers, flashbulb numbers, film exposure indexes, and flash equipment are all subject to change.

OPEN FLASH. This nonsynchronized method of firing flashbulbs is not in wide use today, since most modern cameras are designed with built-in synchronization. However, open flash, which can be used with any camera having a T (time) or B (bulb) setting, is sometimes desirable, and the method is simplicity itself. Exposure is determined from the guide number recommended for "Open" or "Time" and, after setting up the camera on a tripod or other firm support, you open the shutter manually, flash the bulb, then close the shutter. Because a standard type M flashbulb produces effective illumination for about 1/50 second, your choice of subject should be limited to relatively still matter for which a 1/50 shutter speed would be appropriate in natural light. Also, the existing light should be at a fairly low level; otherwise, the room lights or window light may register too brightly.

Although open flash can be used on the camera, it is not recommended, as this position tends to overexpose near objects in relation to more distant areas of the room. Detaching the flashgun from the camera permits you to place the light in a more advantageous spot. It is further possible to use a variation of the "painting" technique explained for photofloods to light a sizable area with flash; the principal differences are that with flash you should keep yourself out of the lens's field of view and should cap the lens between flashes. For using open flash outdoors after dark, see chapter 18.

SYNCHRONIZED FLASH. The objective of synchronization is to time the shutter action so that it reaches maximum aperture at the same time the flash reaches peak intensity. For open flash there is a single guide number for a specific bulb; for synchronized flash there are several guide numbers, one for each princi-

pal shutter speed. Accurate adjustment of the synchronizer is especially important at the faster speeds because of the reduction in effective light output; at 1/250, for example, considerably less than half the illumination fired by a standard flashbulb is utilized.

Focal-plane shutters usually cannot be synchronized with electronic flash at high shutter speeds because the brief burst of light would strike only one strip of the exposed film; however, the amount of coverage varies in different cameras. At 1/60 second or slower, most focal-plane shutters expose the complete film area, thus allowing an accurately synchronized electronic flash to reach the overall picture.

Nearly all modern cameras have built-in synchronization for flash. Usually there will be an "X" and an "M" marking on the camera near the shutter-speed markings to indicate the proper setting or connection: the "X" is for electronic flash and the "M" is for flashbulbs. On the "X" setting, the shutter opens the lens diaphragm *before* the flash goes off. On the "M" setting, the shutter action is delayed until *after* the flashbulb goes off and reaches half-peak intensity. On some not-so-new cameras there may be a letter "F" (as in flashbulb) instead of the "M" (as in medium), but either letter indicates the same thing: flashbulb synchronization.

SINGLE FLASH. The majority of all flash photographs are made with a single flashbulb in a unit attached to the camera. This is by far the easiest way to use flash and very convenient for snapshots of people, pets, and various activities. The main objection to this popular procedure is that it often results in a strong flat lighting on the foreground subject and a background of black shadows. Nevertheless, on-camera flash is entirely adequate for many pictures, particularly when the flashbulb reflector is positioned to one side and somewhat higher than the camera lens— again imitating the direction of natural light. Be sure that the flash is not aimed at a surface which would reflect light back into the lens.

Single flash can also be used *off the camera,* not with simple box types but with most adjustable models. Detaching the flash-gun and using it on a flash extension cord allows you to hold the unit at arm's length to one side and above the level of the subject; the resultant highlights on one side and shadows on the

Fig. 11.3. Girl Scouts and their shell collections both benefit from indirect flash lighting.

other will create an effect of modeling and depth. Unless you are adept at operating your camera with one hand, you will also need someone to hold the flashgun, or you can get a flashgun clamp for attaching the unit to some support such as a shelf or chair.

Direction and distance of flash off the camera can be controlled in various ways, except for action pictures when there is no time to manipulate the equipment. By aiming the flash toward a central area of your subject, you can balance the lighting to some extent and avoid an overexposed foreground. This is especially desirable if your subject is a group of people: by directing the flash toward the farther members of the group, you obtain a more even lighting of the group as a whole. Another technique for groups is to place the flashgun appreciably higher than the group, then tilt the reflector slightly upward so that the flash will be directed toward the group but not full in their faces. This method, called *feathering*, is trickier to use and generally less satisfactory than other types of indirect lighting.

Like bounce light, it requires about two stops more exposure. Which kind of indirect lighting you decide to use should depend on the subject you are photographing and the overall effect desired.

Diffusion of the sometimes harsh light of flash is accomplished simply by draping a white handkerchief or its equivalent in front of the flashbulb, whether it is on or off the camera. The reduced light will require an exposure compensation (opening the lens by about one additional f/stop). *Bounce light* (previously described for photofloods) is another way to soften over-bright light in flash pictures. Directing the flash at the ceiling or wall lowers contrast and opens up shadow areas, which is an especially desirable effect when you are photographing people. Since the light will spread out and be reduced, an exposure compensation will be needed, usually about two stops.

MULTIPLE FLASH. For large rooms and groups of people in relatively stationary arrangements, multiple-flash units are sometimes used to provide crosslighting and background illumination for the elimination of black shadows and exaggerated contrasts. Since it is difficult for all but very experienced photographers to visualize how flash exposures will turn out, it is not advisable to attempt two- or three-flash setups until you have had some practice with single flash and have considered whether the photographs you plan to take are worth the expense and inconvenience of additional equipment.

For multiple-flash photography, you will need one or more extra flash units, along with appropriate stands, clamps, and possibly some live aides to help you accurately direct the additional light where it is needed. These extra flash units, called "slaves," are self-contained and need no wires to connect them to the primary light source; a light-sensitive triggering circuit in the unit is activated by the flash of the unit attached to the camera.

The basic setups for multiple-flash units are essentially the same as for photofloods (see chapter 16). In black and white you will probably get more depth and modeling if one flash unit is about one-third farther from the subject than the key light; in color, however, placing two flash units at approximately equal distances from the subject seems to work out better. If all the units are the same size, exposure should be based on the key

light, the one supplying the most direct illumination on the subject. Secondary flash is generally for fill-in and background lighting.

FILL-IN FLASH OUTDOORS. The same principle of supplementary light to fill in shadows and cut down contrasts is applicable to outdoor pictures (see figure 11.4). Formally this is called

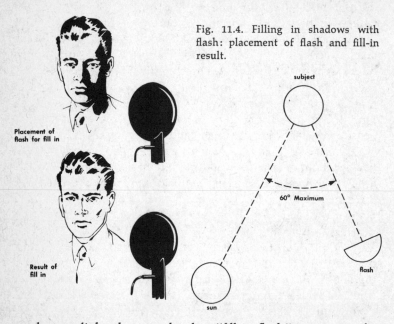

Fig. 11.4. Filling in shadows with flash: placement of flash and fill-in result.

Placement of flash for fill in

Result of fill in

subject

60° Maximum

sun

flash

synchro-sunlight photography, but "fill-in flash" is its more familiar name. For most sunlit subjects the brightness range is too great for satisfactory rendition of detail. The highlights, especially in color, should be no more than three or four times as intense as the shadows, and a fill-in flash can help solve the contrast problem. This technique is most frequently used to photograph people in back- or side lighting; such lighting avoids the discomfort or squinting occasioned by full frontlighting on a bright day, but causes unflattering shadows which fill-in flash can lighten. (See the two photographs in figure 11.5.)

With daylight color films, blue flashbulbs (any bulb with a "B") should be used to match the natural light. Exposure is based on the main light which outdoors, of course, is the sun. While expert use of this technique requires considerable practice

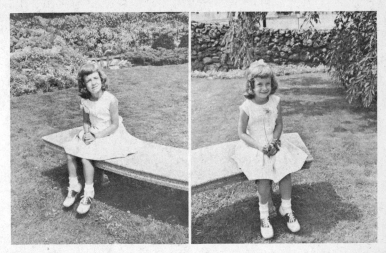

Fig. 11.5. Flash can solve some snapshot problems in bright sunlight. *Left:* Full frontlighting *Right:* Side lighting with fill-in flash

and depends to a great extent on personal preference, fill-in flash is a valuable addition to a photographer's skills.

Calculation of Fill-in Light. Since synchro-sunlight photography is predicated on using the sun as the key light, the fill-in flash should always be less intense than the existing sunlight. The ratio is governed by the *flash-to-subject distance,* which is calculated as follows: first, take a meter reading of the brightest sunlit area in which detail is wanted and determine your exposure for that part of the subject—say it is 1/60 at f/8. Next, determine the flash guide number for the shutter speed, film, and type of flashbulb you are using—for example, 80. Finally, divide the guide number by the f/stop of your exposure setting —ten feet is your flash-to-subject distance.

If the camera-to-subject distance at which you wish to take the picture is not the same as the correct distance between flash and subject, you must position your flash unit by means of an extension cord and move your camera to the desired distance. Or you can move the camera-with-flash closer to the subject and lower the estimated brilliance by diffusion; one thickness of a white handkerchief reduces the flash intensity by about half.

Fluorescent Lighting. Fluorescent lamps, while varying greatly

in types and sizes, have some common characteristics. They draw relatively few watts, and they supply a soft light of considerable photographic intensity that gives off very little heat. This comparative coolness is an advantage in studio portrait work where a sitter can be spared the twin discomforts of excessive heat and blinding floodlamps. The chief disadvantage is the softness of the illumination which, although sometimes quite flattering, is too diffuse to be concentrated into a small area and thus produces a flat kind of lighting. If you are arranging your own subject and lighting (not simply taking a picture where the lighting happens to be fluorescent), you can counteract this flatness by using photofloods and spots for background and highlights.

Fluorescent lighting is not often used in color photography. Although a white fluorescent lamp has a normal color temperature of about 3500° K., the temperature fluctuates with the age of the lamp, making it undependable as a light source. Fluorescents, unlike tungsten lamps, give better and more economical service if they are not switched off frequently but left on during the time you are arranging and taking your pictures.

12

A Look at Composition

Composition, being a subjective term, cannot be arbitrarily defined, nor can any set of rules ensure a successful composition in all situations. When the elements of a picture have a pleasing, unified arrangement, that picture can be said to have good composition. If it looks right to you, it *is* right. If you sense, however vaguely, some confusion or conflict, the composition is *not* right. In short, a composition should satisfy a viewer's innate sense of harmony and proportion.

Certain general principles can help you to develop a feeling for effective photographic composition. By being sufficiently aware of these guides to apply them where they fit and to forget them where they do not, you can often gain the emphasis and the organization of shapes and tonal values without which even the most interesting subject matter can fail as a composition.

MAIN INTEREST

Have you ever looked at a photograph and felt impelled to ask, "What is it a picture *of?*" If nothing draws your attention to any one area, the eyes wander all over the scene, consciously or unconsciously looking for some meaning. When the components of a scene are well integrated, they direct attention to a dominant element in the composition. This *center of interest*, or *point of interest*, should be the focus of everything in the picture and, as mentioned in the first chapter, should seldom be the geometric center of the photograph but, ideally, the *dynamic center*. Since "point" might imply restriction to a single object and "center" might suggest the central area, these customary usages can be misleading if accepted literally.

One idea only should be presented in a single photograph. This does not mean that a picture should be limited to one object, or even to a few objects; what is important is that all the elements included in your composition support and emphasize the one basic statement you wish to make. Any irrelevant material detracts from the subject and should be eliminated as far as practicable.

It is quite possible to have a pleasing photograph in which some design or overall *pattern* comprises the picture. Such compositions do not depend on a specific area of emphasis: the main interest is the whole pattern. This kind of picture can be dramatized by a break in the pattern; for example, suppose you intend to make a pattern shot of the circular shapes and textures offered by the sawed ends of a pile of logs: you can break the pattern by introducing an axe or a cooperative cat into the composition.

"Rule of Thirds." One of the most helpful techniques for positioning the main interest of a photograph is to divide the picture area roughly into thirds, horizontally and vertically. This is usually done with imaginary lines, although some photographers with larger cameras actually draw four lines on the ground-glass viewfinder. By placing the principal object of a composition somewhere near one of the four intersections indicated in figure 12.1 and keeping the supporting lines and shapes

Fig. 12.1. "Rule of thirds" pinpoints logical areas for main interest.

Fig. 12.2. Active and atmospheric shot gains impact by "thirds" placement. (Courtesy of the Newspaper National Snapshot Awards)

in a balanced arrangement, you can often strengthen an otherwise flat composition.

It is a mistake to follow this or any other "rule" blindly. Look to see what happens to a scene when you place your point of interest near one of the intersections and when you place the same element at an imaginary central intersection of one horizontal and one vertical line; note how this applies to the award-winning snapshot in figure 12.2. Fundamentally, the thirds guide is an extremely simplified, applicable version of the specialized art principle known as "dynamic symmetry," and its purpose is to help place photographic emphasis where the eye instinctively prefers to find it. A less obscure reason is that a central placement of the main interest tends to divide a composition into halves; this can create confusion for the viewer and give him the uneasy feeling that he is looking at two pictures instead of one.

Camera Viewpoint. The satisfactory arrangement of elements in a composition depends to a great extent on where you decide to place yourself and your camera. As a simple test, try the rule of thirds on the two views of an arbitrary "scene" shown in figure 12.3. In the top view you will note that the figure on the bridge is near the upper right intersection of the thirds, while the point at which the arc of the seemingly larger tunnel meets the water is at another intersection. Since the dark figure, although relatively small, is looking directly at the camera, it can be considered the point of interest, supported at the secondary intersections by the tunnel, the water, and the trees. Now notice how the various other darks all flow into an integrated pattern which gives unity and balance to the composition.

A poor choice of camera angle is apparent in the bottom view. The figure not only falls near the geometric center but also is too far away to be significant, the upper line of the bridge span seems to cut the picture in two, the dark tree stands apart from the other elements, the tunnels have no depth, and there are no unifying darks pulling the elements together.

Leading Lines. Any object, or series of objects, which serves to draw attention to the center of interest is called a *leading line*. Among the more familiar natural leading lines are roads, pathways, fences, hedges, tree trunks, shorelines, shadows, and the horizon. These directional lines can be strong and obvious, like a dark hedge directing the eye to the entrance of a white chapel;

Fig. 12.3. *Left:* Good placement of camera *Below:* Poor choice of camera angle

Fig. 12.4. Leading lines

or they can be subtle, like the long shadows, the footprints, and the tree trunk which lead unmistakably to the figures in the snow scene in figure 12.4. Notice also that, due to the arrangement of lights and darks, the two figures constitute one main interest.

Although the word "line" might suggest a lack of weight, as compared to other shapes and masses, this is not true of leading lines. Generally they are substantial elements of the composition and contribute importantly to the overall balance. A figure which is not the main interest can be a leading line, either in tonal values or because it looks in the direction of the principal object rather than at the camera.

Horizontal lines suggest tranquillity and repose more often

Fig. 12.5. Verticals can suggest dignity and strength.

than other lines; typically they are found in a low landscape or a reclining figure. Compositions that rely entirely on horizontal lines are apt to appear somewhat static, but they can acquire strength and interest when combined with vertical lines. *Motion* in a horizontal direction, such as that of a speeding car or a charging bull, immediately creates an action photograph. When there is action in a photograph, have your subject move *into* the picture by allowing more space in the direction in which the action is going and less space in the direction from which it is coming.

Vertical lines, usually in combination with other lines, can denote dignity and strength, as in figure 12.5. The classic example is a towering cathedral whose blend of many lines, domi-

Fig. 12.6. Diagonal and angular lines add to impression of co-ordinated activity. (Courtesy of Scholastic High School Photo Awards)

Fig. 12.7. A nicely handled example of the classic S curve. (Courtesy of the Newspaper National Snapshot Awards)

Fig. 12.8. Effective use of parallel lines. (Courtesy of the Newspaper National Snapshot Awards)

nated by soaring verticals, adds up to an impression of power and peace.

Diagonal lines, with their off-balance look, lend themselves to more dynamic arrangements. As they lead the eye to or away from other lines or objects, they suggest activity and movement in varying degrees and often increase the dramatic impact of a composition, as in figure 12.6. *Angular lines* formed by two or more lines from different directions can be very sharp, like a "Z," or open, like an "L"; they may converge in a pyramid-like "A" or meet in a "T" formation.

Curving lines usually lend grace and a smooth flow of movement that can enhance and coordinate other lines. These, too, tend to assume alphabet tags, the most popular being known as the *S curve*, which is very pleasing in landscapes, as in figure 12.7. Curving a diagonal into a "C" introduces a softened line which can lead the eye to the point of interest as surely as a straight line, but less urgently.

Parallel lines can be effective in directing attention to a subject if they run in a contrasting direction to the subject's dominant line, as in figure 12.8. If the parallel lines run in the same direction as the subject's, they usually weaken the composition.

Looking for letters or other familiar formations of compositional lines can be an interesting and sometimes instructive game. Generally speaking, however, it is inadvisable to embark on a picture-taking session with a fixed idea about photographing some scenery in an "S" curve or a figure in a symmetrical "Y." These terms serve merely to describe what we have seen in some photographs, not to dictate how the elements of a composition should be arranged.

BALANCE

Consciously or unconsciously, we seek in photographs the state of balance that exists in ourselves and in nature. Quite automatically we keep upright on two feet, place chairs so they will not tip over, and estimate the weight of objects we pick up. Although we may not be aware of doing it, we also assign weights to the elements that make up a photographic composition. *Weight* in a composition signifies a value in relation to all the elements, not necessarily heft or size.

A *balanced* composition refers to one in which all parts in opposing areas within an arbitrary frame appear to be of equal weight and to belong to an integrated whole. This must include a balance between primary and secondary objects, between unlike shapes and masses, between various color values, and between highlights and shadows. Tones, lines, perspective—all affect the balance of a composition.

Like Objects. Placing two similar objects of equal weight equidistantly from the center of a photograph (as if they were on a pair of scales) will produce a balance but usually not an inter-

Fig. 12.9. Triangle (*left*) and pyramid (*right*) balance of masses

esting composition. Three like objects can be balanced in an equilateral triangle. Such an obvious balance may be appropriate for comparative purposes, for certain merchandise and machinery, or for a close-up of identical twins, but it will lack a dynamic point of interest and rarely succeed as an interesting photograph.

Triangle and *pyramid* arrangements of seemingly dissimilar masses can achieve balance with fairly dull subject matter, as shown in the two matter-of-fact industrial photographs (figure 12.9). The same principle may be applied to more appealing material, as in figure 12.10; you have probably seen it in captivat-

Fig. 12.10. See what the boys in the backyard will have—with a balanced, triangular composition.

ing shots of two youngsters with heads together over one book, or one upright tot manipulating a pulltoy. By observing your subject and noticing these patterns, you can learn to judge when they might serve a specific composition.

Unlike Shapes and Masses. Dissimilar objects of different weights can also be balanced by placing them at *unequal* distances from the center of a composition. The object of lighter weight in this instance should be farther from the center to create an illusion of balancing the heavier one. At a much greater distance from the center, a fairly small mass can balance a considerably larger mass near the center.

Dark tones have more weight than light tones, as can often be seen in photographs. For this reason, shadows, clouds, and other intangible "objects" are important elements in balancing a composition, as are the leading lines already discussed in connection with main interest.

The impression conveyed by light and dark masses in a composition can be partially controlled by lighting. *High-key lighting,* which has predominantly light tones from medium gray to white, can lend airiness or softness to scenes and portraits. *Low-key lighting,* which has mainly darker gray to black tones, can impart a mood of mystery or seriousness. More often than not, you will want a balanced lighting between the two extremes.

Depth. Depth, or perspective, is simply the illusion of distance, the creation of an impression of space where none exists. It is possible to achieve this three-dimensional effect on a two-dimensional plane by the selection of camera viewpoint and lighting and by the placement of foreground and background objects.

The relative sizes of near and far objects determine the apparent distance between them, and our recognition of familiar shapes becomes a kind of mental measuring device. For example, in figure 12.11, the apparent sizes of the foreground and background trees on a wide road which converges to the point described as infinity all add up to an impression of distance. This is the way such a road actually appears to normal eyes, so this is how we see a picture of it on a flat piece of paper. If you were to look at a photograph showing a vast expanse of desert sand with no footprints, no indication of plant, animal, or human life,

Fig. 12.11. Depth

nothing except sand, you would get no impression of depth, even though the lens might have taken in a greater distance than in the snowy-road scene.

One of the simplest ways to relate size and distance is by the use of a foreground figure. A person admiring the craggy grandeur of a canyon wall or a mountain vista, for example, immediately establishes a dramatic contrast between the immensity of the scenery and the smallness of a recognizable object. Placing the figure at one side and looking into the picture can help to frame the composition as well as increase the apparent distance. The fact that framing is usually accomplished with identifiable objects related to the main interest—people, shadows, tree trunks, branches, doorways—tends to strengthen the illusion of depth.

Depth can often be gained by focusing sharply on the principal object and using a medium or large aperture to allow the background to go slightly out of focus. Backlighting, or a strong side lighting, can add depth by giving better separation and making the subject stand out more sharply from the background.

SIMPLICITY

The quality that more than any other distinguishes a strong composition from a weak one is simplicity. What simplicity is *not* is lack of interest; rather, the main interest is emphasized by the elimination of unessential or distracting elements, as illustrated in figure 12.10. When all the elements of a composition are successfully concentrated on stressing a single idea, the result is simplicity.

Contrast is one of the primary factors in clarity and simplicity. Except for deliberate effects, mergers of nearly equal tonal values should be avoided; dark hair against dark foliage, or a white flower against a white fence, for example, will almost certainly lack impact. For better separation and contrast try to get dark objects against lighter backgrounds and light objects against darker backgrounds. In color pictures, of course, you must consider not only the tonal values but also the ability of different colors to complement or blend pleasingly.

Backgrounds. A busy background can be even more confusing than one that lacks contrast. If your subject is up against a distracting clutter, as in figure 12.12, try another camera angle—

Fig. 12.12. *Left:* Busy background overwhelms subject. *Above:* Camera angle catches subject against grass background.

or another background. You can look at a scene and subordinate everything in it to your main idea, but the camera lens does not automatically distinguish a center of interest from its surroundings.

One of the best ways to cut out unwanted background is to get close to your subject, as in figure 12.10. Most beginners stand too far away, because they see a scene selectively, mentally isolating the main interest without realizing that the lens sees unselectively everything within the range for which it is exposed. Studying your viewfinder carefully and learning to move in closer will solve some of your background problems.

One of the best ways to change a background is to change your camera angle. Compare the two snapshots in figure 12.12: the pretty subject of the first picture is all but lost among windows, roof lines, lamp post, fence, dark driveway, white snow, and carriage handle and wheels; in the second a well-chosen camera angle has concentrated on the child's complete interest in the visiting bird. Frequently it is possible to eliminate houses and telephone poles just by aiming up, instead of level, and getting your subject against a fine blue sky, or aiming down toward a green lawn. Sky, grass, water, and sand are among the most desirable natural backgrounds. Indoors, a plain wall or plain drapery makes a much better background than a patterned fabric or distracting furniture; even the most attractive furnishings can take away from a main interest.

Selective Focusing. You can retain an interesting and appropriate background without loss of emphasis on the main subject by a sharp focus on the subject. You might be aware that there is space between a man and the tree beyond him, for example, but the lens sees them on one plane so that, if both are sharply focused, the tree may appear to be growing out of the man's head. Suppose you plan to photograph a fisherman and wish to include the rocks and surf of the locale: by choosing your exposure for a relatively shallow depth of field and focusing narrowly on the man, you can subordinate the background and give eye-catching prominence to your main interest.

Foregrounds. Much of what has been said about backgrounds applies also to foregrounds. Simplicity should be the keynote, with unessentials eliminated. Extreme close-ups of people, flowers, insects, and small objects obviously have no foregrounds to consider.

As a rule, foregrounds should be in focus; the eyes accept a fuzzy background more readily than an out-of-focus foreground. Leading lines usually appear in a foreground and, while these elements should be less emphatic than the area to which they lead, it is generally objectionable to have them blurred.

Large objects, such as buildings and trees, should have sufficient foreground to support the object. An example of this is shown in the facing illustrations that comprise figure 12.13. In the left photograph the building seems to be standing on practically nothing and to be overwhelmed by a top-heavy sky; in the right the same building has been given appropriate foreground depth, with a proportionate amount of sky.

Fig. 12.13. *Left:* Lack of foreground support *Right:* Foreground of proper depth

Cropping. Often a composition can be improved by a kind of reframing. Masking the negative or print along any of its borders to cut out unwanted areas is called *cropping*. The handiest way to study a print with a view to cropping is to use two L-shaped pieces of white cardboard, moving them to cover parts of the print until they border an area that satisfies you as a complete picture. (See figure 12.14.) Color slides can best be studied in projection by tilting the projector to block off a strip along any border. Since the projector cannot be tilted in all directions at once, it is sometimes necessary to study a slide on a light box to be certain of the effect of cropping opposite borders; or you can put tentative strips of masking tape on the shiny (base) side and have another look by projection before actually remounting the transparency. Larger negatives can always be cropped more easily than 35mm or smaller.

Fig. 12.14. Use L-shaped cardboards to mask print for cropping.

Composition and technique must be balanced for successful photographs. Do not become so absorbed with framing a subject that you forget to focus correctly, nor so concerned with technical calculations that you neglect to notice a bad background. Consistently keeping a record of what you do with your camera and constantly checking on the results can develop an instinctive feeling for what makes a good picture.

Landscapes and Other Scenery

Outdoor scenes photographed by natural light in the daytime or at night will be discussed in this chapter; the subjects covered have in common their predilection for daylight-type color films as well as for black and white. Other subjects usually associated with night photography, such as electric signs, Christmas trees, fireworks, and campfires, are considered in chapter 18.

Scenery in black and white can be greatly enhanced by the use of filters, especially for sky-cloud contrasts, if light conditions permit proper exposure. (See chapter 10.) In average light, it is best to use slow to medium films for their finer grain and a relatively slow setting (small f/stop) for depth of field. Beware of overexposure on bright days; it is better to err on the side of underexposure.

When taking scenery in color, remember that the continuous change in the color of the daylight itself—from the warm golden glow of the rising sun to the cool blue shades of early evening—can affect the tones and mood of a landscape. In most outdoor color photography, the "skylight" filter, which has no factor, helps hold back some of the excessively bright blues. A polarizing filter for darkening blue skies and diminishing reflections requires variable exposure increases. Before using a polarizing filter you should carefully study the instructions supplied by its manufacturer.

A *lens shade* is advisable for both black-and-white and color to keep the film from being light-struck.

LANDSCAPES

The pictorial wealth of great and small wonders in nature almost invariably entices the tyro in photography. Quite rightly, too, for a beautiful picture of a beautiful landscape is one of

the easiest successes. And being an easy success, it permits a learner to become better acquainted with his camera. Beyond that, however, there is the difficulty of finding original versions of grand views or more intimate scenes which may have been dulled by duplication on thousands of postcards, calendars, and magazine pages.

One way to avoid trite photographs of old favorites is to take pictures under unusual conditions of weather and lighting. Black storm clouds can be more arresting than fleecy white shapes; rain furnishes reflections on rocks and pavements as a change from sun and shade. Backlighting can make water sparkle or trees loom darkly. Seasonal changes provide new pictures of the same place continually, as do the hours of each day. Distinction is often achieved by breaking rules—by refraining from obvious framing, planted foreground objects, and S-curved pathways. Confidence and authority about rule-breaking, however, generally grow out of a knowledge of the rules you elect to break.

Spectacular Views. For spectacular scenery, a selective viewpoint can make the difference between a travel ad and a personal

Fig. 13.1. Mountain masses need small aperture, infinity focus, and foreground object.

expression. If time permits, study your viewfinder from many angles for a composition that really pleases you, and don't attempt to get everything into one picture. Increase dimension by having a person or strong foreground object at one side, but focus at infinity, using a small aperture for maximum depth of field. (See figure 13.1.) Predominant horizontals and a low horizon line will add to the impression of vast space.

To give mountains greater apparent height, keep the horizon line close to the top of the picture and let the steep verticals of cliffs and peaks dominate. At high altitudes on a clear day, pictures are apt to be too contrasty because there is little moisture and dust to reflect light into the shadows; it is easier to get shadow detail on a slightly cloudy day. Unfiltered haze frequently adds realism to photographs of mountains.

When you wish to avoid excessively dark areas, especially with color film, try to keep your back more or less toward the sun so that the view you are taking will be well lighted, with enough cross lighting to bring out contours.

Masses vs. Shapes. The fundamental difference between spectacular and less pretentious scenery is that at a distance of miles you are dealing with masses, while at distances within a few hundred yards you are dealing with definite shapes. A towering mountain can be masses of snowy slopes, dark forests, and stark cliffs; but church steeples or haystacks or oak trees are known shapes with characteristic details.

Fig. 13.2. Rural scenes need small aperture for depth, some foreground interest.

Fig. 13.3. Angle shot of steeple is dramatized by diagonal lines and shadow patterns. (Courtesy of Scholastic High School Photo Awards)

Small-scale Scenery. More intimate landscapes should have the focus on the main interest, which may be at infinity or nearer. (See figure 13.2.) A peaceful meadow with mostly horizontal lines usually captures more attention if it includes grazing animals, a figure or two, a running brook, or a rural mailbox, for instance, as leading lines in the foreground. Whether you find picture opportunities along country roads or in urban settings, the basic principles of composition and exposure apply.

Buildings in Landscapes. When a barn or house or other building is part of a composition, it should seem to be straight—unless you are after a deliberate angle shot or an abstract of one part of the building, as in figure 13.3. Standard practice is to align one of its dominant verticals—for example, the left side of the covered bridge in figure 13.2—parallel with the edge of the viewfinder, making sure that you maintain a level horizon line. With a small camera it is usually necessary to stand well back from a building to get its lines acceptably straight, and the

foreground should be filled in with shadows, shrubbery, or other elements appropriate to the composition as a whole.

Ordinarily, the eyes accept the illusion of lines converging horizontally in a landscape, but there is less occasion to observe that tall buildings have the same kind of "perspective" vertically. Shooting up at a building or colonnade, one cannot expect *all* its verticals to appear parallel, any more than one can keep those hypothetical railroad tracks from appearing to converge in the distance.

Architectural photography should not be confused with amateur pictures of incidental buildings or with record snapshots of a new home, a favorite inn, or a famous museum. Architectural photography is a highly specialized area which usually requires a view camera with adjustable front and back, and lenses of different focal lengths. Like outdoor portraits, successful architectural photographs benefit from practiced, accurate judgment in timing the most desirable light conditions and from a large negative size to facilitate cropping.

Good professional photographs of cathedrals, monuments, and historic landmarks can usually be purchased on location to fill gaps in your album or slide collection. Often they blend very well indeed with amateur photographs; they are especially welcome on sightseeing trips when time, weather, or inadequate lighting may curtail your own picture taking.

SEASCAPES, BEACHES, INLAND WATERS

Filters for Haze. Except for deliberately hazy effects, you will want to use a filter for most marine scenes. Yellow and red filters for black-and-white photographs will penetrate haze to some degree, decrease glare, and deepen contrasts. When lakes, rivers, and waterfalls are surrounded by foliage or shadows, a light green filter may soften contrasts and give good sky tones. A polarizing filter is used when a darker blue sky will improve a color composition, and to reduce glare on water.

Exposure Suggestions. Because sunlit pictures of sand and water are generally brighter than average, basic exposure should usually be decreased by a full stop. Foam and sparkle on rolling waves can be caught with a fairly fast setting—1/250, for example. A mass of surging water, like Niagara Falls, gains realism

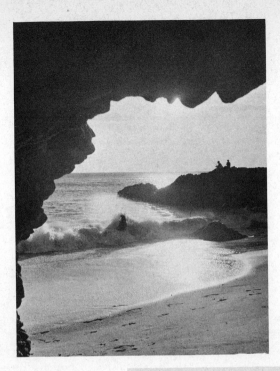

Fig. 13.4. Exposing for lighted water catches sea and sand textures, silhouettes fishermen and rock framing.

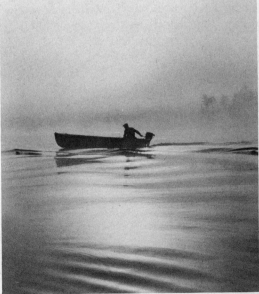

Fig. 13.5. Fog, sun, and solitary silhouetted subject were exposed at 1/125 second, f/11, for this winner. (Courtesy of the Newspaper National Snapshot Awards)

from the immense, moving blur you get with a very small aperture (for greatest depth) and the correspondingly slow shutter speed. To catch detail in surf, try exposing for the highlights in the water, at a medium-fast setting. If your composition is to include a natural dark frame of rocks or cave, as in figure 13.4, it should be exposed for the bright area beyond the frame.

Backlighting can be used to give a shimmering radiance, a feeling of animation to water scenes. By sending elongated shadows toward the camera, back light imparts an illusion of greater depth, as well as a more pronounced separation of lights and darks; a low camera angle further increases the depth illusion. The texture of wet sand can also be reproduced by backlighting. When facing the light source, remember to shield your lens from direct rays.

Focusing on Objects. Moving objects, such as people, birds, and boats, usually become the main interest when introduced into a picture; consequently, the lens is focused on them rather than on the water itself, as in figure 13.5. However, when objects at a distance appear as little more than dots on the horizon, they cannot be the focal point of interest unless you are using extreme telephoto equipment.

Marine scenes offer many pattern possibilities, especially in reflections, which are often the main interest. In figure 4.12, the focus is on the massed boats, with the rippling reflections contributing secondary interest. Figure 13.6 shows a telephoto close-up in which the reflections themselves, enhanced by technical skills, form the main interest.

Lens Protection. A filter, which is nearly always desirable for water scenes, helps protect the lens. Guard your camera against splashes, and especially watch out for salt spray and sand—particularly when there is action near you: people diving, hauling in fish, beaching a boat, building sand castles. When you are not actually using your camera, keep its case closed; if it does not have a case, keep it in a plastic bag or a closed gadget bag. In case of accident, wipe the camera with a cloth wrung out in fresh water and take it to a repairman as promptly as possible.

SKYSCAPES

Sunsets. The infinite splendor of a sky at sunset is an irresistible challenge to photographers, perhaps because the colors are

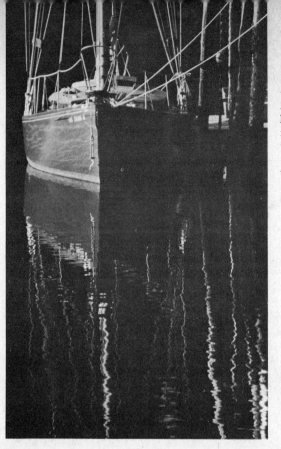

Fig. 13.6. Reflections caught by a 300mm telephoto lens make interesting marine pattern. (Courtesy of the Newspaper National Snapshot Awards)

always different, the light never quite predictable. If you are going after a sunset, don't take *a* picture, but as many as you can, for one picture can record but a single instant of the elusive beauty we admire in a sunset's constantly shifting colors. Take the pictures when a cloud, or some foreground silhouette, obscures the direct rays of the sun coming toward your lens, and try to select a camera angle that will give you a good composition, with the sky filling at least two-thirds of it.

Black-and-white tones can hardly do full justice to such a colorful subject, yet effective shots are sometimes obtained. As a start, you might try Verichrome film with a red filter at a lens setting of *f*/11 and a shutter speed of 1/125 second. Whether you take off with some such basic exposure or take a meter reading, it's a good idea to bracket your shots a full stop over and a full stop under the setting indicated.

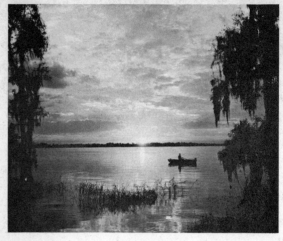

Fig. 13.7. Expose for sky colors in sunset scenes

When photographing a sunset in *color* choose daylight-type films for their warmer tones. But remember that no color film will have sufficient latitude to encompass the entire brightness range of a flaming sky and a darkening land.

In deciding on exposure, take a meter reading toward the sky. The dark silhouetting of everything below the horizon will emphasize the sunset drama above. When using reversal-type color films for slides, a slight *underexposure* will tend to intensify the colors; a slight *overexposure* will tend to lighten the colors and make the sunset seem earlier. Negative-type color films, such as Kodacolor, produce the opposite effect.

A typical setting for a reversal color film like Kodachrome II is $f/8$ at $1/60$ second when the sun is partially hidden by clouds. Once the sun is below the horizon, a typical exposure for the same film would be $f/4$ at $1/30$ second. Use a meter, if possible, and try to bracket your shots, this time by only a half stop because of the more limited response of color films as compared with black-and-white.

Sunrises. Most people are asleep at dawn and awake at dusk, so sunrises get less photographic attention than sunsets; but the basic suggestions apply to both. Sunrise colors are softer, on average, and early mists create a peculiar subtle radiance, particularly in the milder months, when early rising can prove pleasant and rewarding. Figure 13.8 shows how one wide-awake photographer caught not only the mood of heavy morning mists

but also the pattern of fish shapes made by reeds bending toward their reflections. The color of the sunrise light progresses in the opposite direction from that of sunsets, starting with pale grays and growing brighter and warmer as the sun climbs into the sky.

Rainbows. For greater saturation of color, a very slight underexposure of less than half a stop is recommended; otherwise, the exposure should be what you would use for sunlight alone.

Moonlight. Although not daytime scenery, moonlit scenes are related to other landscapes and call for daylight-type color film.

Some photographers collect shots of the moon to sandwich with their moonless pictures. These should be made with a telephoto lens, 135mm or longer to produce a larger image, and you should bracket your shots. As a starting point on a clear night, using Kodachrome II and a shutter speed of 1/125 second, or a fast film and 1/250 second, try an aperture of $f/4$ for a crescent moon, $f/5.6$ for a quarter moon, $f/6.3$ for three-quarters, and $f/8$ for a full moon.

Fig. 13.8. Heavy presunrise mists bend reeds for a winning picture taken from canoe. (Courtesy of the Newspaper National Snapshot Awards)

Double exposure can be used to get a moon into the same frame as the scene you are photographing by shooting the moon first, closing the lens, then exposing the scene for fifteen minutes after the moon has moved out of the picture. Since even the brightest moon gives only a tiny fraction of the illumination supplied by the sun, time exposures are required. (See chapter 18.) This entails a consideration of reciprocity failure, whatever film you use, and results are thoroughly unpredictable and determined only by individual experimentation.

AERIAL VIEWS

Any standard camera, even simple box types, can be used to photograph from planes or other great heights. Waist-level types of viewfinders, such as those on twin-lens reflexes, are the least convenient in planes.

On commercial airliners, the best seats for picture taking are back of the wing or well forward of the wing, on the side away from the sun. Occasionally a wing comes in handy for framing,

Fig. 13.9. Aerial views of landmarks of hometown can help fill in record shots of a trip.

but generally it is preferable not to have any part of the plane obstructing your view. Your shots will be *oblique* views, as in figure 13.9; *vertical* views are mostly for mapping and are taken from special small craft. Since there is a good deal of vibration on even the smoothest flights, avoid resting your elbows on the seat arms or leaning against any part of the plane structure. Try bracing the camera against your cheek and keeping your arms in tightly; then hold the camera as close to the window as you can without actually touching the pane, which should be reasonably clean.

Various Altitudes. Below 1,000 feet, exposures are about the same as on the ground. For takeoffs and landings, which cause additional vibration, very fast shutter speeds are recommended. Moreover, scenery seems to whiz by too fast for satisfactory shots when the plane is within 2,000 feet of the ground. As an airliner gains altitude, exposure should be gradually decreased, closing down by a full stop at about 4,000 feet. Unless the atmosphere is exceptionally clear, it is impractical to try for any pictures above 10,000 feet.

With mountain scenery, the matter of haze should be considered in deciding on an exposure and whether or not to use a filter. Aerial landscapes are best on a clear day, because clouds often cast dark, shapeless spots on the ground. Shooting through clouds, however, for a partly obscured but distinctive landmark can prove interesting. Midday light, when the sun is directly overhead, is the poorest time for aerial shots—and for most pictures. Side lighting improves detail, while backlighting increases the haze effect.

Exposure Suggestions. Black-and-white pictures benefit from the use of a yellow filter to reduce blue haze. With medium-speed panchromatic film and a light yellow filter on a bright day, you should find $f/11$ at $1/250$ (or $1/200$) about right for up in the air. A red filter, by holding back green as well as blue and ultraviolet, will give greater haze penetration and extremely sharp contrasts. Sometimes infrared film is used for similar striking results, but its major application is in reconnaissance; it is not very practical for general photography.

Exposure for aerial shots in color is, in general, less critical than for landscapes, because the shorter range of contrasts presents no problems of highlights vs. shadow detail. There may

be some slight color in a plane's window glass, but the effect is usually negligible. Since haze increases with higher altitude, a skylight filter or an ultraviolet filter is advisable. An average aerial exposure on a bright day for a color film rated ASA 25 would be about $f/4.5$ or $f/5.6$ at the 1/250 shutter speed. For sunset pictures in early evening, use the same aperture as if you were on the ground but a faster shutter speed, an average setting being $f/4.5$ at 1/125.

SNOW SCENES

Photography outdoors is less popular in winter than in summer for basically the same reason that sunrises are less popular than sunsets. Nevertheless, there are many hardy individuals who appreciate, through lens instead of window, the gleaming white brilliance of a snow scene. For those who do, the favorite time is soon after a snowfall so as to capture the unspoiled whiteness and sculptural surprises which may soon deteriorate into drabness and slush, especially in cities. In country or park areas, the tracery of fresh snow on tree trunks and branches, as in figure 13.10, creates myriad compositions for alert photographers.

Snow Textures. One of the most fascinating aspects of fresh snow is that it is never just plain white, but several different shades of white, which can be played against each other as well as against interesting shadows. Because the comparatively large grains of medium- and high-speed films tend to obliterate snow texture, it is necessary to use slow films with very fine grain to reproduce the white-on-white subtleties.

Snow scenes are natural black-and-white subjects and should be printed on glossy or semi-glossy paper to enhance the brightness and texture; matte prints cancel out much of the brilliance. A yellow filter is desirable for normal contrasts when the shadows are due to a sunny blue sky. If there are dark evergreens which might come out black, a green filter may give a better balance of tones.

Color film is more effective when the snow is a background for people rather than the primary interest. Colorful play clothes and winter activities will then determine your choice of film; for just the subtle colors of snow and the landscape, a very fine-

Fig. 13.10. For snow scenes choose fine-grain films to bring out subtleties of pattern and texture.

grain film will give best results. The standard Skylight filter is recommended for contrast and to tone down the dominating blues in sky, snow, and shadows.

Shadows on Snow. These are always present, even at noon, because the winter sun is never directly overhead. Especially against the lightness of snow, winter shadows assume definite importance as design elements, and the snow itself acts as a natural reflector to bring out shadow detail. For snow artistry,

backlighting is probably the favorite technique; it throws long shapes into the foreground and gives good separation to lights and darks. Also, shooting into the sun will light up any stray flakes which may still be drifting down. Side light, or any cross light which strikes the snow surface, is best for emphasizing snow textures, as in figure 13.10. A low camera angle helps take full advantage of winter shadows and increases the impression of quantity and height in the snow.

Exposure Suggestions. A sunny snow scene, being a lighter-than-average subject, takes the usual decrease from basic exposure. Since the snow reflects a good deal of light, it is important first to take as accurate a meter reading as you can. Then you may want to use a half stop less than the indicated reading to be sure you don't overexpose. Some photographers make it a practice to bracket such shots, as added insurance against overexposure.

Falling snow (or rain) can be photographed most effectively with a slow shutter setting: 1/25 or even longer if you are using a tripod and if light conditions permit. Unless you are under a shelter which positions you at a distance from the falling snow, the flakes just in front of the lens will be out of focus and consequently somewhat blurred.

While gaining practice in photographing snow at really accurate exposures, remember that underexposure will result in muddy grays and darkened colors. Since you are trying to capture light tones, it is better to err slightly on the side of overexposure. If it is a scene you really want to capture, the best insurance is bracketing.

Cold Weather Cautions. Camera lenses, like eyeglasses, will fog when transferred from a warm shelter into bitter cold, particularly if unprotected by a filter. Carrying a camera under your coat or outer jacket should keep it sufficiently warm to forestall fogging and keep the shutter operating smoothly. If fog or moisture freezes on the lens, do *not* attempt to wipe it off while frozen.

Comparatively warm film should never be loaded into a very cold camera, or vice versa. Film becomes increasingly brittle as the thermometer drops and should be advanced very slowly, not only to avoid breaking but also to prevent the scratchy marks caused by static electricity.

In extremely cold weather a cable release is almost a necessity, as it is difficult to operate a camera with covered hands. Mittens are much better than gloves for keeping fingers warm and workable; beware of bare hands: fingers can stick to icy metal parts, causing painful skin damage.

Winterizing is done only by expert camera technicians, usually for professional photographers working in subfreezing temperatures. Cameras can freeze, however, and if you expect to use yours in prolonged cold, it might be well to confer with a professional camera service to find out the cost for this kind of protection. Although winterizing is not inexpensive, it might be relatively less expensive if considered in terms of missed pictures and repairs for possibly jammed mechanisms caused by freezing.

14

Action in Still Pictures

The illusion of motion is sustained quite easily in a speeding "movie" sequence by the very rapidity with which the individual pictures are projected. What appears to be action in a "still" photograph, however, results from catching a sharp image of the moving subject at a single, telling instant, as in figure 14.1.

Stopping Action. When film is exposed to record a moving subject, the image is in contact with the film for a fraction of a second. A shutter speed of 1/300 second permits one-tenth as much movement on the film as a 1/30 shutter setting; in other words, the 1/30 second allows ten times as much chance for blur on the film as 1/300. A shutter speed that records action without blurring is said to *stop*, or *freeze*, the action. Your choice of subject, the effect you visualize, and the end use of the negative will determine whether a certain amount of blur, as in figure 12.6, can be appropriately tolerated or whether a completely stopped action is desirable. Figure 14.2 shows an effective combination of completely stopped action at the originating end of a whopping splash and a convincing amount of blur at its receiving end.

Factors affecting sharpness are (1) the speed of the action, (2) the direction of movement in relation to the camera, (3) the distance between the moving subject and the camera, and (4) the lighting conditions. In addition, the flexibility and limitations of your camera must be considered. A simple camera, for instance, has a much slower shutter speed than an adjustable camera. Some adjustable cameras have lenses of greater focal length than others, thus forming larger images which create more blur than smaller images.

Fig. 14.1. Low camera angle and 1/500 shutter speed freeze leaping lad against plain sky background. (Courtesy of the Newspaper National Snapshot Awards)

Fig. 14.2. Shutter setting of 1/250 second recorded this summer-camp fun. (Courtesy of the Newspaper National Snapshot Awards)

"Box-Camera" Techniques. While a simple camera is certainly not ideal for action pictures, it is quite possible to get creditable snapshots that have a feeling of motion. If you have a shutter speed of 1/40 second, it is highly impractical to attempt to capture fast sports action; a shot of the particular sports atmosphere at a relatively inactive moment will probably yield a more satisfactory picture. Suppose you wish to photograph some diving events at a pool, for example: if you shoot when the diver is poised at the end of the springboard, you can retain an impression of activity, whereas clicking the shutter during the actual dive would result in blurring the film.

When using a simple camera for any actual motion, such as children on roller skates or a dog ambling up a path, try a position that will bring the moving subject directly *toward* the camera (or directly away from the camera); this will create a minimum of blur, as compared to movement *across* the focal plane, which will emphasize the motion on the film. Even if you have a simple camera, you should note the recommendations for adjustable cameras, as well as the general instructions included in

this chapter, in order to learn how to use your own aperture and shutter speed most effectively.

Panning. The technique called *panning* can be practiced with a simple camera for action shots of subjects moving at a fairly even pace in one direction. It contradicts all admonitions about holding your camera steady, for panning means swinging the camera horizontally with the moving subject; it requires steadiness of a sort, however, as the follow-through camera motion must be very smooth and level. It works this way: assume your target is a boy on a bike. Center the subject in your viewfinder and, turning your body smoothly from the waist, follow the approaching subject in your finder until boy and bike are where you want them, then click the shutter and continue to follow the subject for a moment—the way a golfer swings through after his driver has made contact with the ball. In this way it is possible to maintain a smooth motion throughout the entire operation. Practice pressing the shutter release gently; you cannot shorten the 1/40 second by a hurried, jarring jab at it.

When the panning is done correctly, the subject will be in reasonably sharp focus, and the blurred background will have moved across the film in a direction opposite to the apparent mo-

Fig. 14.3. Short distance, camera angle, and appropriate blur increase impression of speed. (Courtesy of Scholastic High School Photo Awards)

tion of the subject, thus creating a definite illusion of movement. If you swing the camera slowly, there will be less blur; if you swing it faster, there will be more blur which will heighten the impression of speed, as in figures 14.3 and 14.11.

Effect of Distance and Direction. It is interesting to observe what happens to a passing scene from a speeding car or an express train. The trees and telephone poles a few yards from a train whiz by too fast to be counted. Shift your focus to trees at a middle distance and they will seem to move past very slowly. Then if you look at trees off toward the horizon, they will appear to be standing quite still, and you can watch the same trees for a relatively long time.

This basic principle is true for photographic subjects actually in motion. If you watch a car or train several hundred feet away, it is not readily apparent that it is moving at all. As it comes nearer, however, it appears to become much larger rapidly and to race past with accelerated speed. As you turn your head (or camera), the same effect can be seen in reverse as the speeding vehicle appears to dwindle in the distance—all this despite the fact that it has actually been traveling at the same speed during the time you have watched it. This is why faster shutter speeds are required to stop action at short distances from the camera than to stop action at longer distances.

Viewed from slower rates of motion, external objects appear to move in a direction opposite to the viewer's movement. For example, if you walk alongside a picket fence at a brisk pace (say, a military cadence of 128 steps per minute) and look at the pickets, the effect will be downright dizzying. But if you look beyond the pickets at the landscape, the houses and trees will be reassuringly stationary.

In observing a speeding object, you will notice that the angle, or direction, of the movement affects the way you see and interpret the speed. If you stand in the middle of a road on which a car is approaching, the car's speed seems much less than if you were watching it at the same distance from alongside the road; and its greatest speed will appear to be when the car passes at a right angle to your line of vision.

Choosing a Shutter Speed. Developing an awareness of how distance and direction affect the way you see a moving object will help you judge which shutter speed is most likely to succeed in stopping the action you want to catch. Table 2, showing

TABLE 2

RECOMMENDED SHUTTER SPEEDS FOR ACTION PHOTOGRAPHS

Typical subjects	Approximate speed (in miles per hour) of moving subject	Distance between subject and camera	When motion relative to camera is . . .		
			directly head-on	at about 45° angle	at right angle
Slow Motion					
Pedestrians	5	10–15 feet	1/200–1/250	1/300–1/500	1/400–1/500
Street scenes & construction	to	25 feet	1/100–1/125	1/200–1/250	1/300–1/400
Slow-moving water & boats	15	50 feet	1/50–1/60	1/100–1/125	1/200–1/250
Parades, etc.	mph	100 feet	1/25–1/30	1/50–1/60	1/100–1/125
Medium Fast Action					
Active sports	15	10–15 feet	1/500	1/500	1/1000
Horse racing	to	25 feet	1/200–1/300	1/250–1/500	1/500–1/1000
Scenes from trains, etc.	30	50 feet	1/100–1/200	1/200–1/300	1/400
	mph	100 feet	1/50–1/100	1/100–1/200	1/200–1/300
Swift Action					
Speeding cars & trains	over	12 feet	1/1000	1/1000	1/1000
Motorcycles	50	25 feet	1/400–1/500	1/1000	1/1000
Aircraft, etc.	mph	50 feet	1/200–1/250	1/400–1/500	1/1000
		100 feet	1/100–1/125	1/200–1/250	1/400

recommended shutter speeds for action photographs, should be studied carefully for the fundamental principles on which it is based. Theoretically, the correct exposure can be worked out by a mathematical formula; in actual practice, even assuming that you could be sure of the exact distance, the exact angle, and the exact rate of speed at which your subject was moving, the subject would have come and gone during your calculations.

Actual practice, in fact, is the answer to this problem. When in doubt, it is better to select a shutter setting that may be too fast than to risk using one too slow for a specific subject.

Timing. After you have decided at what shutter setting you wish to photograph a moving object, the next question is when to trip the shutter release. Usually it is a matter of anticipating where the action is going to be and clicking just before you actually see it take place. This gives the camera a fair chance to record the image on film at the same time it is recorded on your retina. In the panning technique just described for box cameras, the action follows a prescribed course; this is also true of the action of some sports, such as those in figures 14.4 and 14.5. But if you are attempting to stop motion which is being controlled by the subject, you will probably find yourself at a disadvantage in a fast guessing game. For stopping most sports action, the best times generally are at the start, finish, and middle.

The comparative inaction before and after some exciting movement, such as the throwing of a ball, can be recorded with a fairly slow shutter setting and often provides better pictorial possibilities than the action at its liveliest, such as while the ball is in flight. For example, in the brief instant when a basketball player is poised to toss the ball at the basket, or when a baseball has just landed in the Little Leaguer's mitt, there is a vivid suggestion of brisk activity.

Different people react at different rates of speed, so one cannot be arbitrary about how action shots should be timed. Your own timing of the actual click will doubtless become instinctive and practically automatic with continued practice.

Peak Action. Somewhere in the middle of most sports action, between the rise and fall of a complete motion, there is a split second of suspense termed the *peak action*. This refers to a pole-vaulter drifting over the bar (see figure 14.6), a skater at the top of a spinning leap, a halfback whose raised foot has just come

Fig. 14.4. Finish (or start) of most sports events offers best chance for action-stopping photo. (Courtesy of Scholastic High School Awards)

Fig. 14.5. Fast start-or-finish sports shot needs less shutter speed if action is toward the camera. (Courtesy of Scholastic High School Awards)

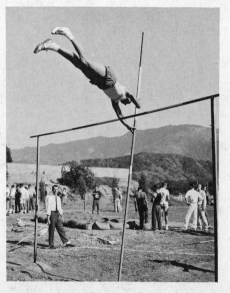

Fig. 14.6. Relatively slow shutter speed can catch midmoment of peak action if timing is perfect.

into contact with the football, a rower ready to dip oars again, a youngster clearing a large puddle, a rubber ball at the top of a bounce—any action during which the moving object seems, at the height of activity, to hang almost motionless in the air before resuming its movement.

Catching peak action depends more on alertness, familiarity with the action pattern, and luck than on a super-fast shutter. For the "pros" who get the exciting shots you see in the daily sports pages, there is—in addition to skill, speedy shutters, and extra-long focal lengths—a small accessory called a press pass. At certain public events it is just not possible for a grandstand amateur with a lens of standard focal length to record details of fast action when there is a considerable distance (and several dozen heads) between camera and action.

Films. The high exposure indexes of many films today are often more than enough to compensate for a relatively slow shutter speed; they also allow medium apertures for better depth of field than you would get at the widest f/setting. In black and white, a medium-speed film will produce less grainy prints than the extremely fast films. Some distinct advantages of black-and-white films for sport shots, if you are aiming at the action itself, include greater speed, far greater latitude, adaptability to lighting conditions, and economy, which invites taking many pictures for a better chance of getting some good prints.

For color slides, choose a fast film such as high-speed Ektachrome. Spectators at sports events are sometimes more colorful subjects than the main action, but the light can be a bit tricky. Outdoors in full sunshine the brightness range may be almost too great even for today's films, while on a really gray day some shots may turn out rather monotonous. Indoors, if it is possible or convenient, observe the lighting before loading your camera with the most appropriate film. Remember, too, that color films do not permit the darkroom corrections which add to the flexibility of black and white.

Atmospheric Close-ups. Groups of spectators or general atmosphere can often be photographed with quite simple cameras, but one with interchangeable lenses gives you a better chance of getting good shots even when there is no opportunity to move in close to either the spectators or participants. Close-ups such as those in figure 14.7 can be obtained with a telephoto lens or

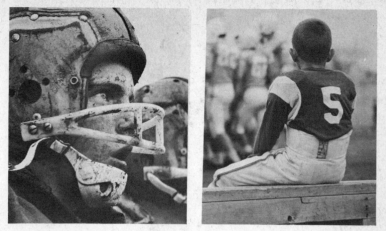

Fig. 14.7. Close-ups amplify photographic records of sports events. (Courtesy of Scholastic High School Awards)

by cropping a suitable negative. The close-up in the right-hand photograph was obtained by focusing on the foreground figure with a large aperture so that the other figures became an out-of-focus background. Close-ups can be used in slides or prints, just as in home movies, to give a change of pace or a dramatic accent to your photographic record of an event.

Some Sports Suggestions. If you plan to take occasional pictures of sports action, your camera should have a minimum shutter speed of 1/200 second—and preferably faster. If sports pictures are a major interest, you will want a shutter time of at least 1/500 second; shutters of the focal-plane type are generally preferred for fast action. Many sports-fan photographers like a single-lens reflex for accurately framing the action being followed and for its lens alternatives. Consistent, analytical study of professional sports shots can be very instructive, even when they are beyond the scope of your own equipment. A few starting pointers follow.

Sailing pictures can be made at fairly slow shutter settings, even with a simple camera, if the boat is moving directly toward you; if it is sailing across your line of vision, it needs 1/200. *Wrestling* and *boxing* are relatively slow action, with brilliant overhead lighting; if you have a ringside seat (close enough to touch the ropes), keep the ropes as foreground interest. *Figure*

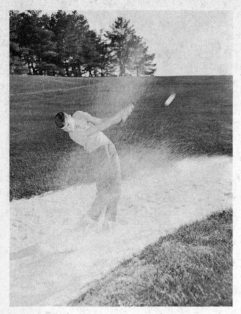

Fig. 14.8. Camera at right angle to swinging golf club intensifies blur.

skating can be photographed at 1/100 to 1/200 second on fast film.

Golf pictures depend more on where you stand than on shutter speed: at a right angle to a swinging club, you will get a blur at any setting, as in figure 14.8. It is best to try for a spot off to one side just ahead of or behind the golfer and to catch the beginning or end of the stroke. In golf, more than in any other popular sport, it is very important not to disturb the player with your camera.

Big-league *baseball* and *football* action is usually too far away for satisfactory shots, but sandlot and Little League games offer good opportunities to snap peak-action moments at 1/200 to 1/400 second with a medium aperture. (See figure 14.9.) Any thrown object—be it ball, pillow, box, or stone—requires a shutter speed of not less than 1/200 second.

A high viewpoint is generally good for *swimming* and *tennis* pictures. Sometimes, lake or pool water is clear enough for photographing swimmers through the water, but watch out for glare. To counteract it, a polarizing filter for color or for black and white may prove useful. Low-angle shots of up-in-the-air action (as in figure 14.1) are more dramatic than high or level

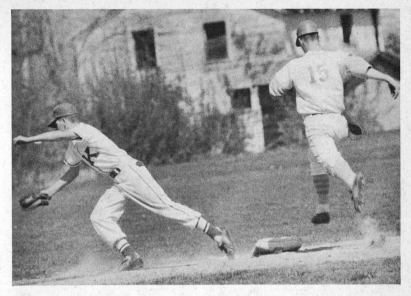

Fig. 14.9. Catching sports action requires practice not only in timing and prefocusing but also in holding the camera steady and level. (Courtesy of Scholastic High School Awards)

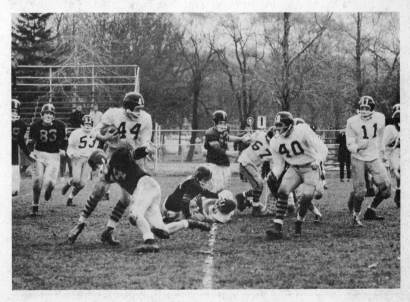

viewpoints; therefore, try to catch a *high dive* or a *ski jump* in midair, against a pictorial sky, at 1/200 or faster. A low angle is also good for leaping tennis smashes.

Prefocusing. When sports action is too fast to permit focusing as it happens, you will be better off to focus on the zone in which you expect the action to happen and hope for a reasonably correct guess, as in figures 14.9 (lower photo) and 14.10. If you are where you can move about, such as in an open ballpark or at an outdoor horse show, you can step back when you find the action coming nearer than you anticipated. Prefocusing works very well for informal sports.

Lighting Conditions. Just as in nonaction photographs, the illumination on the action you wish to record will affect your choice of exposure. The existing light, whether normal daylight outdoors or artificial lighting indoors, may vary over the area you are trying to cover; a subject in motion may move rapidly from sunlight to shade or from overhead floodlights to a relatively dim corner. You may find that your camera will give you an adequate exposure at only the brightest section of the action scene; in this case you can preset your lens for the best lighting and anticipate action in that area. (See figure 14.10.) Even when the lighting gives you a choice of exposures, it is generally more satisfactory to prefocus for the best zone of a fast-action scene.

Action Composition. In photographing fast action you must more often than not catch the subject as best you can and attend to the matter of composition later by cropping. This is one of the main reasons that sports and press photographers like equipment that accommodates a large format. Moreover, the fact that the longer focal lengths of larger cameras and supplementary lenses can produce larger images makes cropping less of a problem than it is with very small negatives.

When the action is comparatively calm and predictable, try to have it lead into the picture. For example, a walking figure or a horseback rider or a racer should appear to be entering the scene rather than moving out of it as if the action had already been completed. When the subject is moving directly toward you, as in figure 14.5, there is no problem. But if the movement is across the focal plane, as in figure 14.11, it is usually desirable to have the space ahead of the subject greater than the space behind the subject. Practice in handling your own camera and studying the results should give you more effective instruction than any rules.

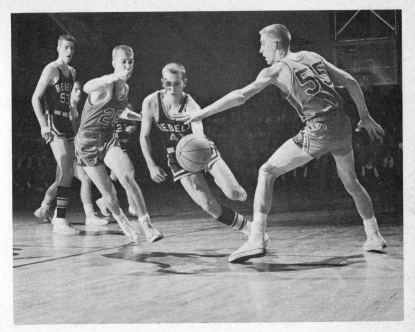

Fig. 14.10. *Above:* Choose best lighted area to prefocus for indoor sports events. (Courtesy of Scholastic High School Awards)

Fig. 14.11. *Below:* Action should move into, not out of, a photographic composition.

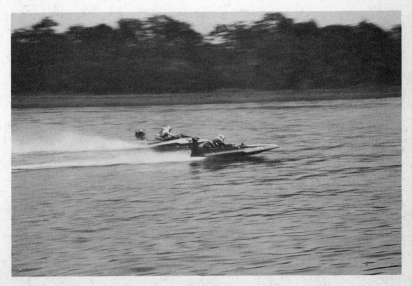

15

Snapshots of People, Pets, and Places

Informal pictures of family, relatives, and friends—including the dog and cat—account for the largest percentage by far of all classes of amateur photographs. Within this extensive category, pictures of babies come first, both quantitatively and chronologically, and much of what has just been covered concerning action applies to the popular sport of photographing youngsters of all ages and their pets. Babies in general are contentedly captive subjects, and teen-agers have been known to remain relatively still at a number of occupations; but in between there is action galore in the busy world of childhood.

This chapter deals with casual photographs of the snapshot variety, an area where there is only partial control of circumstances and subjects—especially on vacations and other favorite picture-taking occasions. The subdivisions are for convenience, not because the principles of catching expressive snapshots of children and adults are basically different; the various approaches, composition cues, and illustrations are pertinent to snapshot situations generally.

GENERAL SUGGESTIONS

Many of the basic recommendations for more formal portraiture in chapter 16 can be used to advantage for snapshots. Therefore, it would be well to read the next chapter in conjunction with this one, paying particular attention to the section on lighting to familiarize yourself with the general "rules" and how they concern outdoor portraits. To avoid repetition, they are not included here, although they will be referred to. Note that fast films make it easy to photograph people in existing light almost

anywhere and that hazy sunlight or partial shade is preferable to bright sunshine. Note also that midday sun overhead or any strong light striking the subject's face directly should be avoided.

People vs. Backgrounds. Including people in a scenery photograph is not the same as photographing the people. If you are taking a picture of someone, don't try to photograph a landscape or a house at the same time; move in as close as practicable and focus selectively on the person so that there is a minimum of background. (Compare the two photographs in figure 12.12.) Unless you have had quite a lot of practice, you will probably do better to postpone a detailed study of formal techniques and concentrate for a while on your subjects, backgrounds, and the smooth operation of your camera.

BABIES

New Arrivals. Starting a photographic story from the very beginning usually calls for the cooperation of a hospital nurse, either to hold up the infant for a few moments or to move the bassinet to a suitable spot. If the glass of a nursery separates you from your subject, keep the camera at an angle, rather than head-on, to minimize reflections. Use fast black-and-white film —save color for later on—and open one extra stop for available light through glass.

If you use flash close up, at hospital or home, be sure to cover the flashholder with one or two layers of handkerchief or thin white material so that your picture will not be overexposed. If you use a preset camera which does not focus as near as you would like, try one of the small close-up attachments described in chapter 17.

At Home. Pictures of baby during the first few weeks are likely to reflect a repetitious regime of sleeping and eating. A new father might like to try some high-angle shots of mother and infant. Standing on a chair, radiator, or other available perch is one way to keep background clutter out of a composition, and a wide aperture, with its shallow depth of field, makes the face you are focusing on stand out more sharply. If you are mother and homemaker as well as photographer, your first pictures will probably be taken at nap time, and a high angle will help simplify the background, as in figure 15.1.

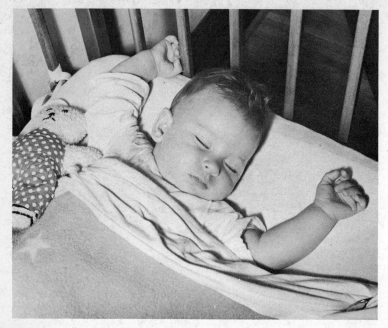

Fig. 15.1. High angle helps simplify backgrounds.

Window light and the reflective quality of white pillows and light-colored blankets will usually provide plenty of soft illumination for crib or bed pictures when you use fast or medium black-and-white films. Sometimes a bassinet or crib can be rolled nearer a window or onto a porch to permit natural-light pictures without disturbing the sleeping child. If you keep your camera loaded with fast black-and-white film, you won't need much light, and two or three shots every few days will not involve much time or expense.

Nonsleeping snapshots usually require an assistant or another photographer, whether it be father, grandparent, or neighbor. Even if such early activities as eating and burping, bathing and dressing, are photographed only on weekends, you can still obtain a consistent and rewarding record.

Sitting Up and Taking Notice. When a baby reaches the age of two or three months, you are no longer obliged to photograph it lying down but can experiment with propped-up poses. Try a big, soft bed pillow in a sofa corner or a well-cushioned chair,

Fig. 15.2. *Above:* A comfortable position helps elicit smiling expressions.

Fig. 15.3. *Below:* Pale pillows and blankets help reflect light.

Fig. 15.4. Choice of plain background, soft lighting, and close focus helps high-chair pictures.

or try propping the baby in a carriage or crib where he can watch a mobile—which makes a fine frame to shoot through— or other suspended toy. A single toy not of the mobile variety should always be smaller than the baby's face. Still more important, a baby, whether held by pillows or by knowing hands, should always look comfortable and *be* comfortable for picture taking, so don't prop him against a hard surface or in an unnatural position. (See figures 15.2 and 15.3.)

Part of the baby's comfort depends on your forethought: try to pick an hour when he is usually wide-awake and not apt to be fussing. Then have your exposure and distance determined and your camera ready before posing begins. If the session seems unsuccessful, don't force the issue: patience yields a big dividend in baby pictures.

Solo Sitting. When a baby is able to sit without being propped in a stroller or high chair, you may have more control over the

background. In any case, focus as close as your equipment permits and, if possible, get someone to stand off at one side and interest the subject in a toy or peekaboo game. This can produce delightfully expressive snapshots rather than a mere record of features. Plan ahead, perhaps with color film as well as an assistant, when you know that baby is to have a go at self-feeding, taking that first step, or some other eventful project.

Backgrounds are unwelcome distractions in pictures of people, and you cannot always get babies or other children in front of something plain. The solution is to get close enough to curtail the background intrusion and to focus on the face while letting background or foreground objects go out of focus. When you have a choice of equivalent exposures, select a large aperture so that there will be less depth of field; for example, 1/250 at $f/4$ will give a shallower zone of sharpness than will a slow shutter at a small aperture.

Lighting should be comfortable and fairly soft. When the child is still young enough to stay where placed, as in figure 15.4, a good scheme is to have the sunlight or other source of illumination behind him and something like a white cardboard or sheet beside you to reflect some of the light to his face. (See the suggestions about reflectors in chapter 16.) With a 2¼ x 2¼ twin-lens reflex you can see the ground glass without hiding your face, and the negative is a good size for cropping. But some tots like the peekaboo game you can play with an eye-level camera.

Getting About on All Fours. Crawling opens up a world of new adventures and new snapshot opportunities. (See figure 15.5.) As the baby grows more agile, the photographer must be more alert than ever and prepared to meet the subject on his own level. Don't expect to get a good picture of an exploratory crawl from your aloof height: get down on the carpet or grass or beach blanket yourself if you expect the lens to catch what is really going on.

Crawling pictures call for more flexibility than crib or highchair pictures. You may not be able to focus quite so close up, nor to decide what the background will be. But you can decide on a likely distance for prefocusing your camera, load it with whatever fast film it accommodates, estimate the average light level of the area, and determine the best exposure guess. You

Fig. 15.5. Crawling opens a world of new adventures. Framing tot in natural light of tall doorway tells a vivid story.

may have time to change the exposure setting, and you may not.

Be ready too when baby meets another baby or a new pet. (See figure 15.6.) For either of these live shows, an offstage crew of two is imperative: one to cope with the cast, the other with taking the picture. A good "director" can help keep the subjects' attention on each other rather than on the camera. And take as many shots as seems practical; you may be lucky, but patience and the law of averages are more apt to produce winners.

Meeting Oneself in a Mirror. If you place a fairly large mirror where it can be discovered by the exploring tot, you can be quite sure of some very interested (and interesting) expressions. Focus on the image in the mirror, and be sure that you and your camera are not in the picture; an angle of about 45 degrees to the mirror usually takes care of this. (See more about mirror snapshots later in this chapter.)

A Date with the Future. Don't trust your memory if you intend to keep a snapshot record of your children. It may seem at the time that you couldn't possibly *not* remember that Susie met her cuddliest doll on the second Monday in May, or that Billy met his first barber the last Saturday in. . . . Well, it just doesn't work that way. You should *date* your pictures right after you get them back from the photofinisher. When you get around to album arranging or slide sorting, whether weeks or years later, you will be glad you made those timely notations.

CHILDREN

Keeping your camera handy around children does not mean that you must spend hours on end following their every move. But you should be set to seize sudden snapshot opportunities—sometimes called *grab shots*—which you can learn to recognize more quickly and surely with practice. (See figure 15.7.) Habitual picture taking also accustoms children to having a camera in everyday use—like a clock or a lawn mower—and this in turn helps overcome excessive shyness or defensive mugging.

Fig. 15.6. Most child pictures should be taken at child level regardless of background.

Fig. 15.7. Alert grab shot depicts happy relationship of a youngster and his dog. (Courtesy of the Newspaper National Snapshot Awards)

Fig. 15.8. Children at their own games provide spontaneous and appealing pictures. (Courtesy of the Newspaper National Snapshot Awards)

Fig. 15.9. Position of doll in background and unexpected peek in foreground result in a delightful winning snapshot. (Courtesy of the Newspaper National Snapshot Awards)

Down with Dignity! If you are as interested in your photographing as children are in their games, you and your camera will be some place down around their level (as in figures 12.10, 15.6, 15.8, and 15.9), even if it involves a temporary forfeiture of dignity. Faces need not always be in the picture but, except for planned angle shots, looking down on children does not pay off in good pictures.

Catching children at their own games, as in figure 15.8, generally results in better snapshots than asking them to pose. Sometimes one can unobtrusively observe a favorite pastime or daily habit for several days before deciding on camera positions and exposure, as in figure 15.9. For more impromptu games you may be able to operate in the fringe areas of the activity without causing interruptions or self-consciousness. Plenty of absorbing games are played solo: if you come upon your small one curled up in a clothes basket, or sitting suddenly in a mud puddle, move in and grab a shot—naturally. But to request a child to assume such a pose would be unnatural, unsatisfactory, and unsporting.

Small Fry in Motion. The principles explained in the preceding chapter on action can be applied advantageously here. Consider

Fig. 15.10. Very simple props, or spectacular ones like this, can produce animated expressions in children or adults. (Courtesy of the Newspaper National Snapshot Awards)

the direction of action as well as the approximate speed and remember that movement *across* the lens axis requires a faster setting than movement *toward* the lens. For average motion, such as skipping rope or scurrying about in hide-and-seek, a shutter speed of 1/200 or 1/250 is suggested. The capabilities of your camera will determine the advisability of certain snapshoot-

ing. For motion such as a tricycle coming down a predictable route or a youngster riding a pony, you might try panning, which is also described in chapter 14.

Props for Naturalness. Children as a rule have no objection to posing; in fact, some insist on doing so, as in figure 15.10. Your problem is to maneuver the youngster into a natural pose, which is often accomplished by a helping hand and a well-handled prop. Advance planning is essential, especially with younger children. See that the camera is all set before revealing your *pièce de résistance*, which may be a toy, lollipop, flower, book, watch chain, kitchen timer, box of pebbles, or any other article that may enchant. The duration of the enchantment will be uncertain, so the prop should be kept out of sight until you are ready to click, then handed to the child by you or your helper. Total absorption may follow, or a bit of prompting—such as "Smell the posey" or "Hear the tick-tick"—may seem in order. An empty-handed "prop man" may be able to elicit animated or serious expressions by engaging the subject in conversation or by clowning a bit out of camera range.

Picture-picking. Since black-and-white snapshots of children are usually the most numerous, calling for the most weeding out, this may be an appropriate place to mention a helpful little textile gadget named a *pick glass* and sometimes referred to as a "thread counter." This is a small but powerful magnifier, mounted on a tiny folding metal stand, which is used for counting the "ends and picks" in a fabric swatch to ascertain the number of warp and filling yarns per square inch. It is not as available, however, as hand magnifying glasses, and a good glass can save on enlarging costs. Contact prints from 35mm negatives are too small for average eyes to read unaided, but examining the details under a magnifier greatly facilitates picking the pictures which are worthy of larger prints.

ANIMALS

Household Pets. If there is one area where props are more valuable than in photographing small children, it is in photographing pets. Four-legged creatures seem to move approximately four times as fast as two-legged subjects and can be sixteen times as exasperating. There is no easy formula, but it

Fig. 15.11. Subdued pup (*left*) and fenced-in pet with nobody-loves-me expression (*below*) make captivating snapshot subjects.

(*Left:* Courtesy of Scholastic High School Photo Awards) (*Below:* Courtesy of the Newspaper National Snapshot Awards)

is an interesting game, and patience plus watchfulness can win eventually.

Pets and children seem to possess an infallible affinity for each other and first encounters offer choice snapshot material. A puppy or kitten is normally gentle with youngsters and appears to accept mauling as a sign of the child's affection. Picture possibilities are limitless. If your camera is an adjustable type, you should not need flash, which is apt to scare pets and cause them to react by running off whenever a camera appears. Available light with fast film generally produces more and better pictures.

Basically, the other suggestions for photographing youngsters apply to taking snapshots of pets. Like people, animals offer endless variations in personality and behavior, but they are generally less manageable than children, less dependent on adults, and less susceptible to obvious coaxing. Another point: because pets move faster than people, the snapshooter should approach his subject *slowly*, not stealthily but naturally, and refrain from sudden movements which might startle the animal. If your camera is on a tripod or otherwise vulnerable, watch out for sudden movements by the pet. And beware the dog whose friendly tongue may lick your lens as well as your hand.

Asleep at the Click. Sleeping cats and dogs often make appealing subjects, especially if they are considerate enough to nap in an uncluttered spot with a reasonable amount of light. If the animal chooses the same spot frequently, you can study your viewfinder and calculate the exposure one day, then have your camera ready at the correct distance another day. You may even be able to improve the background between naps. Almost too easy, but good practice.

One improvement might be to place a light spread on a couch or chair for which a black pet shows a preference. Black cats and dogs are especially challenging, since they need a light background and some light on the face; conversely, white or light pets need a dark background. Figure 15.12 shows a successful close-up; in figure 15.13 a favorite nap spot has been used to advantage.

Cat Watching. Most cats go in for frequent periods of quiet alertness during which they may be contemplating a drapery cord, following a fluttering leaf, or bird-watching. Window sills, indoors and out, are favorite perches and provide interesting

Fig. 15.12. Black cats need a light
background for close-up or medium
shots. (Courtesy of Scholastic High
School Photo Awards)

Fig. 15.13. Framed "cats" and large
leaves make a fortuitous background
for a favorite nap spot. (Courtesy of
Scholastic High School Photo
Awards)

Fig. 15.14. Quietly occupied cats offer many possibilities to patient snapshooters. (Courtesy of Scholastic High School Photo Awards)

silhouette possibilities, even without the cat's face. (See figure 15.14.) When snapping toward natural window light, set your exposure for backlighting (see chapter 7) and, if feasible, have a reflector or lamp on hand for fill-in light.

Props and Close-up Tips. Food is an almost surefire coaxer, though you may not want a dog biscuit or a saucer of milk in all your snapshots. A ball, a length of string, a fake bone, a catnip mouse, or other playthings can be useful. Try prefocusing on a spot to which you would like to entice the animal, then use a bit of masking tape, or an extra pair of hands, to anchor a suitable prop briefly on that spot.

With some assistance you can also attempt a neat little method for snapping a small kitten or puppy close up, either at the minimum focusing distance of your adjustable camera or with a close-up lens attachment (see chapter 17) for a simple type. *On your mark:* while the helper holds the pet, place a piece of paper or other marker exactly where you want the subject to land. *Get set:* after determining the distance and correct exposure, hold yourself ready to click. *Go:* at a signal from you, the helper

Fig. 15.15. For close-up snapshots of most zoo animals a telephoto lens is needed. (Courtesy of the Newspaper National Snapshot Awards)

should pick up the marker, place the pet in position, and move out of the picture—all in one swift step.

Tropical Fish. These little subjects should be photographed at an angle similar to that recommended for taking a new baby's picture through the glass of a hospital nursery. Unless your tank is exceptionally shallow, or contains very few fish, you might try placing a glass plate inside the back wall of the tank and moving it gently forward to keep the fish near the front wall. Plenty of patience will still be needed to snap the moving fish where you want them, so have your camera set before crowding them into close quarters. Flash is preferred to tungsten for less heat and because illumination from room lamps might cause problem reflections on the glass of the tank.

Public Pets. Flash is usually best at large aquariums where fish of various sizes are in display tanks, and also for relatively small, indoor cages like those for monkeys or tropical birds. But before shooting, be sure flash is permitted.

For zoo subjects in outside cages, including seals in an outdoor pool, use available light and a fairly fast film. Select a shutter speed of 1/100 to 1/250, if possible; if you have a simple camera, try to catch the subject poised or resting but not actually moving. If you have a telephoto lens, you will probably want to take close-ups like those in figures 4.13 and 15.15.

Animals behind bars can be as perverse as a free-wheeling cat. You may be all set to snap a zebra in good light near the front of a cage only to have your subject suddenly decide to loiter in the farthest dark corner. There is not much you can do about this other than to accept the animals and backgrounds as you find them. Very often a camera can be held between bars to keep the bars out of the picture. If the animal is touching the bars, possibly reaching a paw or trunk through them, step back about four or five feet and take a picture with bars. If the light seems satisfactory but the animal's position is such that you cannot focus, hold the camera through the bars (or above a high railing), aim as best you can, and shoot blindly. You may get your picture, but it is not advisable to bet heavily on its being a good one (and stay away, of course, from the bars of cages containing lions, tigers, and other predators).

ADULTS

The big difference between getting good shots of adults and good ones of children is that it is usually more difficult to capture naturalness in adults. But whatever the subject's age, a natural expression is seldom achieved by asking the subject to pose; stiffness and self-consciousness are the usual human reactions to facing a camera.

General Suggestions. Subjects preoccupied with a hobby or momentary interest generally show the most animated or characteristic expressions. This preoccupation is the equivalent of a prop, the same idea as diverting a child's attention with a toy. Photographs of people doing things are not necessarily action shots. A college student with an armful of books may be simply leaning against a campus doorway or pausing on the library steps; the books and background tell a story. An older person may be completely engrossed in a knitting project or a piece of hand carving or a grandchild.

Expressive snapshots of people need not always show their faces. You may recall, as a striking example, the prizewinning press photographs (Pulitzer Award, May 1962) of Presidents Kennedy and Eisenhower, taken from the rear as they strolled thoughtfully along a walk at Camp David in Maryland. Casual snapshots can convey an impression of character and activity even with the subject's back to the camera. You might try it sometime with a fisherman reeling in a line or a farmer at a pump, a backyard chef, or a stretching sunbather. Watch for opportunities without forcing the poses.

The Surreptitious Approach. If your intention is to photograph someone in a relaxed or characteristic attitude, a certain amount of stealth not only can be condoned but should be encouraged. On the other hand, subjects can be justifiably annoyed with unkind attempts to portray them in embarrassing or unattractive positions; such snapshooting among acquaintances may result in a collection of *former* friends.

Although furtiveness does frequently succeed in catching pleasantly natural poses, the major drawback is that it may not permit you to photograph as close as you might like to. The nearer you and your camera get to the unwary subject, the more likelihood there is of your being discovered before the picture has been taken.

Shooting from the Lap. There is a crafty little technique occasionally practiced by experts for snapping unsuspecting subjects on public premises, such as in a subway or on park benches. It is a little like aiming blindly at zoo subjects, and you might like to experiment among friends on private property.

The ruse is this: after measuring the distance between two usually occupied seats, say a pair of lawn chairs, set your lens for that distance and the existing light; hold your camera down in your lap, or simply away from the intended subject. Then, while you are ostensibly examining a lens cap or light meter in your left hand, casually position the camera in your lap, training it on the target as best you can *without looking at the subject* directly. Continue your feigned interest in the left hand, or in a fleecy white cloud, until well after your right hand has gently pressed the shutter release. Later, by faking a shot of some scenery in the opposite direction from your subject, you can reset your camera and try again. Nothing lost really if you are found out;

the point is that you have gained some practice so you will know whether you would like to try the technique elsewhere.

The Conversational Approach. Probably the most effective means of inducing a natural expression, when you are neither being secretive about the picture nor utilizing a prop, is to engage the subject in light conversation. An easygoing query or comment which will get the person to talk is often better than talking *to* the person. Generally it is preferable to choose a rather innocuous topic, not one tending toward controversy or overenthusiasm which might promote gesturing and too much motion. If you have an accomplice to arrange a triangular chat, this makes it easier to catch the subject at an angle; practically any angle is an improvement over a wooden-Indian stance squarely facing the camera. Something to sit on, lean against, or rest a hand on usually contributes further to a relaxed appearance.

People in Pairs. When taking a photograph of two people, see that they present a unified appearance (as do the youngsters in figures 12.9 and 15.8), so your photograph will not look as if two pictures happened to get on one snapshot. Seated or standing, the subjects may be very close together, or they may have a space between them that relates to the composition as a whole. Asking two posing adults to smile at each other, or to pretend to be talking to each other, is conducive to the same sort of stilted expressions that result from requesting any subject to smile, please, or to look at the birdie. Unless the subjects can be genuinely interested in some prop within the picture, try to interest them in something outside, perhaps in the conversation of another person standing a few feet to one side of your camera.

Groups of People. The basic principles of composition discussed in chapter 12 are applicable to snapshots of two or several persons, and it might be worthwhile to reread that chapter with snapshots of people in mind, particularly specific groups which you may be planning to photograph. Masses and weights, whether scenery or people, can be arranged in pleasing balance, and small or medium-sized groups can often be arranged about an authentic center of interest: for example, family members grouped about the baby or pet, young people arranged around a guitarist, or friends admiring some new handiwork.

Very large groups which must be arranged in compact rows

Fig. 15.16. *Above:* Don't ask your subjects to stand in a row and look into your lens. *Below:* Do try to catch subjects in some natural grouping.

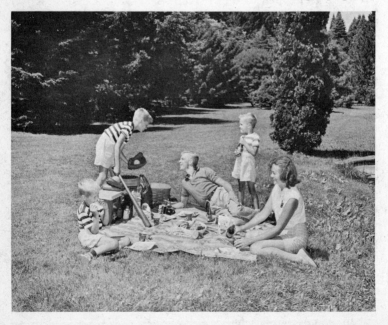

in order to include everyone are bound to have a more formal and static appearance. The purpose is to show all the faces, as appropriately smiling or serious as possible; it is not to create a composition, and there is not much leeway to do so. A better feeling of balance can be achieved if you do not crowd the edges of your picture; it is preferable to crowd the subjects or arrange an extra row. Semicircles often fit the picture frame more satisfactorily than straight rows. Photographs of sizable groups really need a wide-angle lens.

If your viewfinder indicates that the group fits comfortably into two rows, you can seat the taller ones in front. A third row is often asked to sit on the ground or floor or a bottom step; be sure that their feet and legs are not thrust toward the camera. Try to keep an unequal number in the rows, so that rear subjects can stand between the heads of the row in front. A slightly higher camera angle than eye level can help to eliminate background areas. For a very formal group with a guest of honor, or some executives among business personnel, a standard arrangement is to place the senior subject in the center of the first row, seating other persons alternately in order of seniority to the right and left of center in that row.

TIPS FOR SPECIAL EVENTS

Birthdays, weddings, graduations, costume parties, vacation trips, and special holidays like Christmas Day and New Year's Eve are some of the special photographic opportunities for snapshots of people. Parties and pictures both benefit from preparedness, including a survey of lighting conditions and anticipated activities; you will want to decide also whether to give prints to everybody or to show slides.

Children's Parties. Outdoor parties are easier on the parents and give the photographer a break as well. A camera seems less conspicuous outdoors, especially if an indoor picture requires flash, and usually the photographer can move about more freely outside, catching the subjects in more natural poses. Indoor parties, when given on a sun porch or other multiwindowed room, can often be captured on fast film in natural daylight. Decide in advance what film should be in your camera when the party starts and where any activities you particularly wish to

photograph should take place—for example, the opening of gifts or the awarding of prizes.

Lighted Candles. If a lighted birthday cake is to be a high point of party festivities, plan ahead for this feature. Decide where the cake should be placed, where you want the candle blower to sit, and whether there will be a group of guests in the same picture. Lighted candles can make quite a glare in the foreground of a snapshot; this effect, called *halation*, is caused by shooting across the candles when focusing on the person or persons back of them. You can focus on the candle lights, and the people behind them will be interesting, though somewhat darker than the flames. Or you can arrange the people in the foreground, preferably a bit off to one side, and focus on the candles. A possible arrangement to catch someone blowing out the candles is to get the subject in profile so you can focus on puffed cheek and candle lights, leaving any watching guests slightly out of focus behind the main subject.

Mirror Snapshots. Sometimes at parties or other events you may have occasion to photograph a subject reflected in a mirror. As a specific example, consider a bride trying on her wedding veil in the foreground and her face reflected in the glass. This requires a slightly different exposure estimate than for catching a tot close to or touching a mirror, with no problem of depth.

For mirrored subjects in general, it is necessary to allow for the distance from camera to mirror plus the distance from mirror to subject. If you have ground-glass or rangefinder focusing, you can just focus on the image reflected in the mirror without measuring the distance. Choose a fairly small aperture to assure adequate depth of field; if you wish to be certain of having both the bride's reflected image and the back of the veil in focus, it is best to consult a depth-of-field scale.

Weddings. Even large affairs for which a professional photographer may be engaged usually leave ample snapshot opportunities for the hobbyist, especially during preparations for the ceremony. Pictures may start with the engagement party; may include showers, fittings for the bridesmaids, the bride trying on her veil, the table of gifts, and the floral decorations; and may conclude with an exit from a chapel, the reception and cake cutting, some "just-married" car tags, and goodbye waves at the couple's departure.

The first rule for taking pictures of any wedding event is to obtain the permission of the principal participants; if there is any objection or hesitancy in granting it, refrain from photographing. For the actual marriage ceremony, be sure that you have express permission from the bride and bridegroom and from the person officiating. It should be understood, without even asking, that the picture-taking privilege does not extend to flash. Ordinary good manners prescribe further caution in not abusing the permission when given: be quiet, keep out of the way as much as possible, and do not obstruct a working professional. Even he, away from his studio lights, frequently encounters lighting and exposure problems.

Vacations. Whether taken on a honeymoon, a cross-country jaunt, or a tour abroad, many vacation and travel snapshots are pictures of people. However, pictures of landmarks or scenery or fiestas should not attempt to be snapshots of your travel companions at the same time, or they will be neither. People may be included as secondary interest if they are involved in the actual scene or are looking at it and not at the camera. When a group or a person, whether close friend or picturesque foreigner, is intended as the main interest, get as near to your subject as possible and minimize the background.

There seems to be a rather universal urge among traveling snapshooters to interfuse pictures of places with pictures of people, as if to tell friends "That's us at the Grand Canyon" or "That's Mother in front of the Taj Mahal." Try to believe that this is not necessary. If a foreground figure looking into the picture happens to be John or Mary, well and good. But anonymous figures will often do equally well or better, and separate snapshots of yourself and friends, combined with pictures of places and things in your slide show or album, can be quite convincing evidence that you were there—and will probably provide you with a more satisfactory photographic record.

Travel Planning. A brand-new suitcase may be an excellent travel item, but an untried camera is not. Even though you have carefully reviewed the operation of a new model and studied the instruction manual, it is not enough for your head to know the camera: it is even more important for your hands to know it. When the camera is your first one, allow several weeks for practicing with different types of film in order to familiarize yourself

with the camera and to decide which films you prefer to take with you. If you plan to replace your camera, do this well in advance of a trip so that you can shoot a number of practice rolls and still have plenty of time for the camera to be checked, if necessary. A minor slip-up in some step of the camera operation can mean the difference between good pictures and the possibility of no pictures at all.

If you intend to take a familiar camera but have not been using it very recently, shoot a roll of black-and-white film and have it processed a couple of weeks before departure to be sure that everything is in good order; check other equipment, such as your light meter and flash unit, at the same time.

TRANSPORTING EQUIPMENT. When you are traveling entirely by car, space is usually not a problem, but cameras and film should be safeguarded against excessive heat, vibration, and theft. The most desirable spot is on the rear floor, where bulkier items can be covered; the worst places are glove compartments and window ledges. A car trunk is all right unless sun and high temperatures make it too hot for film storage.

How much equipment to take when traveling on buses and trains, ships and planes, depends on your itinerary, probable climatic conditions, and packing problems. Suggested minimum items, when you must consider weight restrictions of luggage on planes, would be camera, light meter, lens shade, filters, optional accessory lenses, and a good supply of film. Good films can be purchased in many places all over the world, but some of the brands may be unfamiliar. American films to which you may be accustomed cost more in other countries and are sometimes scarce.

PHOTOGRAPHING PERMITS, FEES, AND PROHIBITIONS. In quite a number of historic buildings, museums, and other places, both at home and abroad, cameras are prohibited for one reason or another. Museums, for example, customarily forbid cameras if all or part of an exhibition is on loan rather than in the permanent collection.

Sometimes a professional photographer owns the picture-taking concession at an interesting spot, and good photographs can be purchased on the premises. Other places may require a special permit or a nominal fee. If there is any doubt, ask permission. Asking permission is a courtesy which should extend

also to people when you wish to photograph strangers while traveling.

No permission is needed to photograph many ready-made titles: road signs and billboards, city-limits markers, street and shop signs, plaques on monuments and landmarks, names over entrances, all sorts of public local identification items. Watch for snapshot opportunities which will help round out your album or slide collection.

U.S. CUSTOMS. When taking "imported" equipment on a vacation abroad, you can either register the items before leaving this country or carry proof of ownership in order to avoid reentry problems. To register your camera, ask the Customs Department for current rules and explicit instructions. Proof of ownership is best established by a bill of sale, but a document such as an insurance policy listing the item or items by serial number should do. Equipment identifiable as of American manufacture need not be registered.

Because regulations vary from country to country and from year to year, even within the United States, it is advisable to rely only on up-to-date information. Customs offices, travel agencies, brochures of various countries and carriers, and local bureaus provide data without charge. In addition, there are numerous and frequently revised booklets, and monthly travel and photography magazines.

RETURNING FILMS TO THE U.S. If you are moving about a good deal while abroad, you may prefer to send your American films home for processing rather than try to find foreign photofinishers at the right times and places. Present regulations permit films of U.S. manufacture, clearly marked *For Processing*, to be mailed duty-free to yourself, your photo dealer, a processor, or the film manufacturer. Unused films may also be returned by mail if the parcel is marked: *Handle with care. Undeveloped photographic film of U.S. manufacture, for personal use only.* This declaration also cautions customs examiners and other officials against storage or handling that might cause film damage.

Note that some foreign color films are sold *with processing*, which means processing in that country. The usual tourist tendency is to switch to these unfamiliar films only when the imported supply has run short; then the films must be sent to the foreign processor who in turn will mail them to the given ad-

dress. However, if you are going to be in one country for a few weeks and plan to take a lot of pictures, try a couple of the foreign films right off; find out about how long processing takes, and have the slides or prints mailed to your address abroad. In this way you can see which films you prefer, can avoid a long wait for pictures after your trip, and may even be able to retake some pictures that didn't turn out as well as they might have.

INTERNATIONAL REGULATIONS. How many cameras may be taken into another country varies: better check on this if you plan to travel with more than one. Some countries allow a "reasonable number," some only one, some two if they are of different sizes or types. Some countries may interpret "reasonable number" rather freely in favor of the tourist; however, equipment in excess of allowance is subject to some kind of bond or in some instances, to payment of duty. Some countries require you to enter and leave with the same number of cameras, to circumvent unlawful sales.

Restrictions regarding rolls of film vary, too: sometimes it is a "reasonable number," sometimes it may be 6, 10, 12, or another specific number of rolls. Whatever the regulations, they are that country's laws and must be observed. Moreover, officials generally tend to respond favorably to a polite and cooperative attitude; argument and arrogance, on the other hand, can only discredit your intentions and your country.

Today's camera-carrying air travelers share with the airlines an unsolved problem resulting from the need for additional precautions and more elaborate detection methods in the search for weapons or destructive materials in luggage or on persons. Metal-detecting devices do not damage films, but X-ray machines can. If you have any exposed or unexposed films with you, it is not wise to pack them in bags bound for the luggage compartment. Instead, keep films in a camera bag or other carry-on bag, to be inspected visually before going through customs.

Fundamentals of Portraiture

"Portrait" has a rather formal connotation for many people, partly because of its association with the paintings of old masters and partly because of the "pictorial representations" of many portrait photographers. By contrast "snapshot" seems extremely informal and unplanned, and a "study" of a person perhaps lies somewhere in between. Nevertheless, any picture that successfully conveys some facet of the subject's personality may be correctly considered a portrait, whether taken with professional equipment under studio lamps or with a simple camera in sunlight.

Portraiture styles and techniques are as diversified as the human beings involved. A portrait may be a close-up of a face or a head-and-shoulders view; it may be a three-quarters or full-length figure; it may be pensive or animated, with props or with none. The principal difference between making a portrait indoors and making one outdoors is that greater control of lighting is possible with lamps than with sky light.

With amateur equipment, which is the concern of this text, there are a few basic pointers and pitfalls to note. After considering the broadest of these, this chapter will cover (1) relatively formal portraits indoors and (2) relatively informal portraits outdoors.

BASIC CONSIDERATIONS

Cameras. As a rule, the best camera for taking successful pictures is the one with which you are familiar. Especially in making portraits, operation of the camera should be practically

automatic so that you can give your attention almost wholly to the subject. While professional portraitists generally use an 8 x 10 studio camera and possess a dazzling array of lighting equipment, these are not requisites for good portraiture.

Reflex types of cameras with ground-glass viewing screens have the advantage of letting you compose your portrait in the viewer, with the image upright (instead of upside down, as in a studio camera). An optional waist-level finder, which is available for some 35mm SLR cameras, permits you to look down at an image on the ground glass while the camera is positioned on a tripod below eye level.

Photographers who specialize in portraiture frequently prefer to work with a 4 x 5 press camera and sheet film, or with a 2¼ x 2¼ reflex camera, as the larger negative size is more practical for cropping and retouching and requires less enlargement than 35mm (or smaller) films.

A telephoto lens of 85mm to 135mm focal length, preferably 105mm, is advantageous to have if your 35mm camera accepts interchangeable lenses. Such a lens, with its narrower angle of view, allows you to get a large frame-filling image without bringing the camera abnormally close to the subject. This, in turn, makes possible a substantial decrease in depth of field, which reduces the likelihood of undesirable background emphasis or too much foreground. Another advantage of a greater than normal focal length is that a more pleasing perspective can be maintained—i.e., you can avoid the distortion caused by placing a camera extremely close. A too close placement, besides cutting down on the working area you may need indoors for arranging the lights and the pose, usually results in making the subject uncomfortable and self-conscious.

All of this points up our earlier observation that no one camera (or focal length) is best for every kind of photography. The 2¼ twin-lens reflex is a good size for informal portraiture. A majority of amateurs with one 35mm camera quite logically prefer the all-around versatility of the so-called normal focal length of 44mm to 58mm, with the 50mm lens the continuing favorite. Even within this relatively narrow normal range for cameras using 35mm films, there are differences which could be important to you, depending on your aims and preferences. A 44mm or 45mm lens tends toward a wide angle, covering slightly more

picture area and resulting in a freer composition having greater apparent distance between foreground and background. Lenses of 50mm to 58mm focal lengths, normal for SLR cameras, have a narrower acceptance angle, which results in an apparent condensing of the picture area and a slightly tighter composition.

Avoiding Distortion with a Normal Lens. Particularly with a 50mm lens, it is important to keep the entire subject more or less *on one plane*—that is, the face, hands, shoulders, and legs should all be approximately the same distance from the camera. A common error, for example, is to permit a person's hand to pose on a plane nearer the lens than the plane of the face on which you are focusing, thus causing the hand to appear disproportionately large, much as the right hand does in figure 12.14. When photographing a full- or half-length figure close up, of course, it is sometimes difficult to have all parts of the subject seem equidistant from the lens; therefore, the face will often be in sharper focus than the rest of the figure.

Distortion can be further controlled by posing the subject at an angle to the camera rather than facing it squarely. This is especially important if you are focusing down to the minimum distance of your lens or using a close-up lens attachment for an even closer focus. Placing an average small camera farther away from the subject—say, eight or ten feet—will improve a head-and-shoulders perspective but give you a smaller image than you may want. To obtain a close-up, portrait effect from such a shot, you can have only the center portion of the negative enlarged and printed, a procedure which is more satisfactory with film sizes larger than 35mm. With a standard small-camera lens, it is not advisable to attempt to fill the negative with a head only; you should include about a third of the figure as a minimum image before cropping.

PORTRAITS INDOORS

Lights. Photoflood lamps are favored for indoor portraits because of their convenience and flexibility. However, any light source, including natural window light or table lamps, can be used effectively with practice and judgment. The success of a portrait does not depend on the type of lighting but on your use of it, as well as on your handling of camera and subject.

Ordinary photofloods or high-wattage tungsten bulbs need a metal reflector; reflector-type floodlamps and spots can be used in any convenient holder with an adjustable neck.

A single photoflood used with ingenuity can prove quite adequate for home portraits. It can be supplemented by the existing light, by flash, or by a simple subject reflector, such as a large sheet of white cardboard, for filling in the heavy shadows. When two photofloods are used, one serves as the main or modeling light and the second as a fill-in.

Accessories. Photographic supply stores offer a variety of *lampstands* and other accessories, none of which you need to start taking portraits. If you do wish to buy a basic lampstand, select one that adjusts in height as well as in direction; most come with *barn doors,* which are hinged metal flaps for better control of light distribution—including shielding the camera lens from the light. These barn-door brackets are also available for attaching to reflector photofloods. Be sure that your *extension cords* are the right length for moving lamps easily anywhere in your working area. If you plan on flash as a fill-in, check beforehand on *bulbs* and *batteries.*

Besides the lighting fixtures mentioned, a *tripod* is recommended for home portraits, and a simple *cable release* as further insurance toward camera steadiness. Better still, a *long* cable release with a switch allows you to stand conversationally close to the subject and away from the camera while the photograph is actually being taken. See that your tripod is not surrounded by such a clutter of fixtures and extension cords that it will be in danger of being knocked over while you are posing and lighting your subject. On the whole, it is best to begin with minimum equipment and add to it as your own personal techniques and requirements evolve.

Indoor Backgrounds. Simplicity should be the keynote of all backgrounds. Particularly in portraiture, nothing should detract from the subject. Plain walls are usually the most available and satisfactory backgrounds; otherwise, it is advisable to have some sort of plain material which can be tacked up behind the posing bench. Except for special effects, such a backdrop should be sufficiently light in color to be reflective. Keep the background really *back*, allowing five or six feet between bench and wall if space permits; if you don't, the subject will merge with the background and your portrait will have no illusion of depth.

For the relatively formal portraits under discussion here, a bench or stool is preferable to a chair. There are several reasons for this recommendation. First, a lightweight bench or box—whatever backless seat of a comfortable height is available—can be placed where you want it in relation to background and illumination. This will make your working space more flexible and will eliminate the problem of how to incorporate (or exclude) the back of a chair in your composition. More importantly, your subject will sit straighter, and clothing will fit more smoothly; jackets and other collared garments especially tend to bunch at the neckline if the wearer leans back. A further reason is that any slump will be more pronounced in the finished picture. Finally, when the subject is fairly erect, you will find it easier to arrange the pose on a single plane and at the most advantageous angle.

Films. Unless you have had a good deal of experience, by all means begin your portrait practice with black and white, choosing a slow or medium-speed film for fine grain. This gives you not only great latitude and enlargement possibilities, but also an opportunity to experiment more freely with a variety of poses and lighting arrangements in order to determine what effects you can achieve with your equipment.

For color portraits indoors in artificial light, choose a medium or slow, fine-grain film balanced for tungsten. It is generally not practical to convert daylight-type color film to tungsten use by means of a filter. Color portraits are often more successful in natural light, which can be imitated by using blue bulbs with films balanced for daylight.

Basic Lighting Setups. Ideally, portrait lighting should simulate the natural conditions of sunlight or of a well-lighted room. The best preliminary study is to observe the highlight and shadow patterns on people's faces, indoors and out, under any and all types of lighting. Because we do not normally see faces lighted from below, shadows cast upward on a face produce an unnatural effect which offends our innate sense of rightness. Good lighting can show the subject to advantage, with pleasing modeling that lends depth and expressiveness to the features. Inept lighting can distort features, even to the point of making the subject unrecognizable in the photograph.

The basic suggestions and diagrams in these pages should be considered takeoff points, not rules. They will give you some

idea of where to place your lights, but the correctness of the placement can be ascertained only by studying the effect of the illumination on the subject's face. Lighting should blend with the mood or personality you wish to portray—for instance, softened lighting to suggest femininity and less diffuse lighting for a more forceful impression.

Main Light. To acquire a confident control of portrait lighting, start with a single light, preferably a No. 1 photoflood. With the lamp about six feet from the subject, and above eye level, observe its effect on the subject's face as you move the light very gradually to one side and then the other. The distance between subject and lamp will depend on the lens you are using, how close your camera can be brought in, and the intensity of the light. Keep the movement of the lamp in an arc, at a uniform distance from the subject, as indicated in the diagram in figure 16.1. Notice carefully the highlights and shadows on cheeks, forehead, nose, and chin as you shift the lamp position, for it is these highlights and shadows that reveal a face's characteristic curves, which give modeling, dimension, and expression to a portrait.

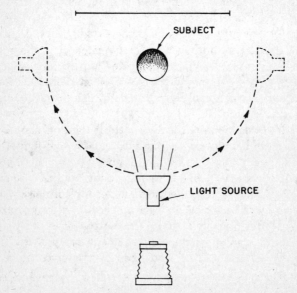

Fig. 16.1. Study effect on face as you move light in an arc about the subject.

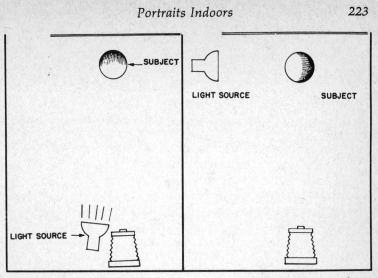

Fig. 16.2. Flat lighting tends to make a face appear broad.

Fig. 16.3. Side lighting tends to make a face appear slender.

Light Position for Broad or Narrow Faces. As you move the main light in a semicircle, watch how it seems to alter the shape of the face. When the lamp is close to the camera, as in figure 16.2, the front or flat lighting appears to broaden the face. When the lamp is at the end of the arc, as in figure 16.3, the side lighting appears to narrow the face. As a rule, therefore, it is advisable to use flat frontlighting on a long, thin face, and a modified side lighting on a round, wide face.

If the side lighting is extreme and without fill-in light, it can produce a hatchet-like division of half brightness and half deep shadow. Frontlighting, especially the type referred to as "butterfly" lighting, is frequently preferred for feminine subjects; the main light is raised just enough to produce a butterfly-shaped shadow about midway between nose and mouth. The reason this lighting style is rarely used for men with short hair is that it would highlight both ears and make them protrude. If a setup of more than one light is arranged so that a central panel of the face is brightly lighted and both sides somewhat shadowed, this has a narrowing effect on a broad face.

Normal Light Position. For most faces the main light should be placed more or less halfway between the front and side extremes of the arc, about 45 degrees to one side of the subject, in

approximately the triangular lamp-camera-subject arrangement shown in figure 16.4. When the subject is facing the camera, the main light is placed on whichever side seems to present the more photogenic appearance, leaving the other side of the face somewhat in shadow.

Height of Main Light. The main light should not be allowed to cast a shadow from the nose or brow across the eyes of the subject. A standard practice is to elevate or lower the lamp until it forms a triangle-shaped highlight below the eye and adjacent to the nose shadow on the cheek away from the light. On some faces this key highlight may be more of a rounded U-shape than a triangle. This effect is normally produced with the light coming down at an angle of about 45 degrees. The side of the face away from the light will be in shadow except for the triangular patch of highlight which should extend no lower than the base of the nose. This type of lighting, approximately 45 degrees to one side and 45 degrees above the subject, is frequently referred to as "Rembrandt" lighting.

Adjusting for Eyeglasses. If your subject wears glasses, attend to the problem of reflection before considering lighting adjustments or the rest of the pose. Place your lamp or lamps in the

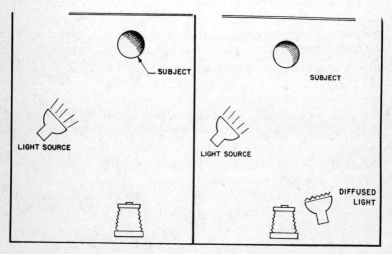

Fig. 16.4. Normal light position for average subjects

Fig. 16.5. Normal two-lamp lighting arrangement

basic setup you plan to use; then, when your subject is seated, look at the image on the focusing screen or viewer for the spot of light you are almost certain to find on the glasses. Watch the image, and ask the subject to move his head very slowly until the light spot disappears; it may be necessary also to move the main light slightly to get rid of the eyeglass light. There are many types of glasses and optical corrections, just as there are many types of photographic lenses; consequently, the characteristic spots of light on glasses will vary and must be coped with individually.

Position of Second Light. When using a basic two-lamp setup, place the fill-in light close to the lens axis, on the side of the camera opposite the main light, as indicated in figure 16.5. If you have a small camera at a close-up limit of three to four feet (or even closer with a "portrait" attachment), your fill-in light will be a bit back of the camera position. It should be diffused light, about eye level, and always farther from the subject than the main light—usually about one and one-half times the distance. For example, if the main light is four to five feet from the subject, the second light should be six to eight feet away.

Diffusion of fill-in light follows common sense and can be achieved in numerous ways. Lower wattage, greater distance, and a screen of cheesecloth or thin, plain material are some of the ways to reduce the relative intensity of the secondary light. Natural window light or a portable reflector can serve the same purpose as a second lamp, which is to balance the main light by subduing too dark shadows. The mean ratio of brightness between highlights and shadows is generally accepted as about 4:1.

Using Three Lights. The main light and the fill-in are primarily to show the subject's face to best advantage. A third light (photoflood, focusing spotlight, flash, or other illumination) can be used for background, for accent, or for raising the general light level. Its background purpose is to soften or eliminate shadows and to give a feeling of additional depth and definite separation of subject from background. The best separation is usually obtained by using a dark background, with or without light on it. For high-key portraits, the background should be almost white, in order to obtain a proper separation between it and the skin tones of the subject.

A third lamp is sometimes used as a back light, especially to

accent attractive hair. The light may be placed at an angle directly behind and above the head—anywhere that seems to achieve the effect you want as long as it does not strike the lens or interfere with the basic lighting of the face. Often it is directed at the background from a low placement behind the posing bench.

Caution. The three most common errors on first attempts at indoor portraiture are (1) placing the main light too close, thus causing glare, discomfort, and excessive contrast; (2) placing the second light at the same distance (and intensity) as the main light, resulting in a harsh crosslighting, which tends to eliminate shadows entirely or to produce two undesirable shadows close to each side of the nose; and (3) using too many lights. The simplest arrangement is usually the most successful.

Posing the Subject. If you are a beginner, practice on a willing friend or on a model arranged for by a group; but let even the most informal practice include an awareness of being considerate and agreeable. Try to keep the subject in a relaxed mood and interested in something other than the mechanics of having a picture taken—unless you have a professional model—and refrain from making excessive demands. See that there is a reasonably convenient mirror for the subject's use.

Sometimes a photographer can loosen a rigid pose or thaw a frozen expression by letting the person think that the camera is being clicked, then taking the actual picture quickly before the pose itself is changed. Rather than asking the subject to "smile" or assume a specific expression, try casual conversation. If you talk easily about the weather, a news item, or any little topic that comes to mind, the person will inwardly "look" at that topic and his face will reflect some degree of interest instead of the blank or tense look which results from having his attention only on the business of having his picture taken.

WHICH SIDE? One side of a face is nearly always more photogenic than the other, and the better side should be turned toward the main light. Unless the subject has definite opinions about this, it is the photographer's responsibility to determine which side is more flattering.

BASIC BODY-AND-HEAD POSITION. Start by having the seated subject turn away from the camera, then turn *just the head* very, very slowly back toward the camera. This kind of pose gives an

impression of motion and is generally more graceful than a head-on position, which not only tends to be static and awkward but makes uncovered ears too prominent. In most poses it is desirable to have one ear wholly or partially out of the picture, but be sure that a partial ear is recognizable as such.

Regardless of the head angle, the eyes should normally look straight ahead so as not to show too much of the whites and so they will appear natural. Since the eyes are the primary focal point of a portrait, whether looking at the camera or at an angle to it, special care should be taken to see that the posing and lighting does not distort them. Hands and arms should be kept quite close to the body; even when not showing in the picture, they affect the balance of head and shoulders. When hands are part of a portrait, as they frequently are, keep them back on the facial plane to minimize distortion; usually it is best to have just the edge of a hand toward the camera. (Note figure 12.14 again.) If a portrait is to include the legs and feet, have whichever leg is nearer the camera crossed over the other; this will avoid having a foot and knee—and possibly a shoe sole—pointing at the lens and appearing exaggerated. *Any part of the body that is nearer the camera than the part being focused on will appear unduly large.*

Effect of Camera Angle. Although an "average" or "normal" subject is purely hypothetical, we must assume such a classification to refer to a face of oval shape, with medium-size head, neck, nose, and chin. On this predication it is suggested that the camera lens be approximately at eye level and the lights placed as already indicated. From this norm the interrelated positions of subject, lights, and camera can be altered to achieve a particular effect.

A high camera angle—that is, above eye level—will tend to shorten a too-long neck, play down a double chin, and play up the hair. A low camera angle tends to improve a very short neck and can often camouflage a long nose, but a low camera angle is difficult to work with, and it usually requires elevating the modeling light so that the nostrils blend into the shadow area. Sometimes it is used for deliberate "horror" portraits like the ones sometimes seen on the covers of mystery novels. A high camera angle can sometimes impart a "highbrow" feeling by emphasizing the forehead, while a low camera angle may add a feel-

ing of "glamour" or sex appeal by emphasizing the mouth. It is important to note which features are most in need of suppression or accent; for example, you would not normally choose a high camera angle or an elevated main light for a subject with thinning hair. To repeat: successful portraits cannot be created by rules or diagrams.

Makeup and Minor Blemishes. Freckles can be quite appealing on a youngster, but adults are inclined to consider them something to be hidden or subdued, like scars or wrinkles. All these can be softened to some extent by diffused lighting (or a special soft-focus lens, which is under-corrected). Although professional makeup is used extensively to glamorize movie stars, heavy cosmetics are not recommended for amateurs. Generally speaking, darker areas tend to recede, while lighter skin tones receive more emphasis; but unless expertly applied, makeup should be simple and natural looking. Distracting blemishes, which would be exaggerated in enlargements, are usually corrected by retouching.

Clothing. The principles of makeup also apply to what the subject wears. Dark colors tend to recede and light colors to stand out. To minimize a stout or larger-than-average body, the subject should wear dark clothes and avoid large patterns. A dark background can further reduce apparent size by softening the contrast between subject and background. A person who is too thin may appear a bit plumper in light colors and patterned fabrics against a plain dark background.

Focus and Composition. Since eyes are a person's most expressive feature and the point to which a viewer's attention is instinctively drawn, they are generally considered the main interest of a portrait composition. The critical focus in a close-up, therefore, should be on the eyes even if other parts of the portrait are not quite so sharp. Allowing each eye to catch a tiny bright reflection from the lighting will impart a sparkle and liveliness to the expression as a whole. This "catch light" should not be confused with the distracting spots of light reflected by eyeglasses.

The fundamentals of composition discussed in chapter 12 are applicable to portraits. While it is desirable to fill the picture frame, try not to have the negative so crowded that it cannot be cropped. The side toward which the head turns is the direction

of the "action" and should have more space beside it than the other side. See that the pose seems to support the head in such a way that arms and shoulders will not "fall out" of the picture. Usually the arm nearer the camera should be pulled back slightly and the farther arm brought slightly forward; arms should always be sufficiently close to the body to block out slits of background. It is important to learn to watch for all these things easily and confidently, almost automatically, if you are to keep your subject comfortable and relaxed once the pose has been decided upon.

Exposure. A shutter speed of not longer than 1/25 of a second, and preferably 1/60, should be used for portraits. Besides the possibility of unnoticeable camera movement, even with a tripod and cable release, there is the physical fact that a live face is never completely motionless. Although the subject may be sitting very quietly, eyelids blink and facial expressions change with subtle yet surprising rapidity. The blurring caused by some almost imperceptible change of expression may be so slight as to be detected only after the negative has been printed or enlarged.

The aperture you choose for a portrait will be determined by the intensity of the lighting, the index of the film, and the f/stops of your camera. You will recall that when a lens is wide open, only one distance is sharply in focus, and there is practically no depth of field; also, reducing the distance between camera and subject reduces the depth of field. Since you generally take portraits close up, with a fairly fine-grain film, and do not want the background to be in focus, you will probably work near your camera's maximum aperture (lowest f/number) for most takes.

Exposure for a combination of artificial and natural light is always based on the *main light*, whether from a photoflood or a window. It is possible to use photoflood lighting without a meter by following the directions which come with the lamps. A meter is a much surer guide, however, even though your own evaluations are what count most in the long run.

Meter Readings. A reflected-light reading of the triangular highlight on the shadow side of the face is a standard way to determine the amount of exposure (shutter speed plus aperture) required for a portrait. In any case, the measurement should be

based on a facial highlight. Such a reading, which is of light reflected *from* the face, should be taken at a closeup range of 6 to 12 inches. Be sure that you do not cast a shadow on the area being read, since this could result in overexposure.

Some photographers prefer an incident-light reading, which also should be taken at a close point. Since it measures light coming *toward* the face, an incident reading should be taken with the meter held close to the subject and directed toward the camera.

One of the most effective methods for studying lighting techniques is to work with an inexpensive plaster bust, observing how various lighting arrangements affect the modeling of the features and the total appearance. Make notes of your working data as a basis for evaluating the photographs.

OUTDOOR PORTRAITS

Although the photographer has greater control of artificial lighting than of daylight, taking portraits outdoors offers many compensating advantages. When nature supplies the background, a subject usually appears more natural, and pleasant weather generally induces a pleasant, more relaxed mood. Color films, by and large, produce more satisfying results when knowingly used in natural lighting. Moreover, most amateur photographers enjoy combining the multiple pleasures of a trip or other outing with outdoor portraiture.

Sun as Main Light. Visualize the basic lighting arrangements described in the preceding pages and think of the sun as your main light. Indisputably you cannot move it about, nor decide how diffuse it shall be on a given day. But you *can* decide where to pose your subject in relation to this main light. Whether or not you try close-up portraits outdoors before attempting indoor portraiture, it is essential to develop a habit of observing the effects of various kinds of daylight on faces; the fundamentals of good lighting remain valid anywhere.

How Much Sunlight? One of the first things to learn—or un-learn—is *not* to pose a portrait subject in direct sunlight if this can be avoided. Hazy sunlight or open shade is generally much more satisfactory, and shadows are regarded as less objectionable than squints.

Under a hazy sun the sky is slightly overcast with thin clouds. Open shade assumes a sizable area of clear sky above and ahead of the subject but no sunlight striking the face directly; it should not be confused with ordinary shade, such as under heavy foliage or a porch roof. Open shade is somewhat more diffused than haze. For example, if you are using a color film rated at 32 and have calculated your exposure in hazy sunlight as 1/60 second at $f/8$, your correct exposure for the same film and time of day in open shade would probably be 1/60 at about $f/4$. If the light is much less, it is not open shade.

In open shade or haze, the light is a trifle bluer than when it is being warmed by direct sunshine. For daylight color films, therefore, it is usually desirable to use a no-factor filter, like the popular skylight type, to reduce the blueness. The same holds true for water, snow, or any other condition that may be imparting a bluish cast to the light.

Softness vs. Strength. If you are taking an informal portrait where you cannot find a suitable spot in open shade or hazy sunlight, your next best bet may be backlighting, with some sort of reflected light in front as fill-in. This is a favorite with many experts, particularly for feminine subjects; expose for the face and allow the background to go overexposed as well as unsharp for an effect of softness and also for a good separation of subject from background. If you wish to give a masculine subject strong shadows, try crosslighting with sky light on one side and a reflector or flash fill-in on the other; see that the lighting is far enough to the side to prevent the twin nose shadows which often occur when crosslighting is used carelessly.

Midday sunlight during the months when the sun is directly overhead should not be used for portraits, as this top lighting casts dense shadows under brows, noses, and lips. The best time is midmorning or midafternoon, when the sun slants down at somewhere near a 45-degree angle. If you place the subject so that this slanting sunlight produces approximately a 45-degree side lighting, you can get the key patch of triangular highlight on the shadow side of the face—just as with a photoflood. Similarly, you can use flat frontlighting or extreme 90-degree side lighting to alter the apparent shape of a face in sunshine, just as you can in artificial light.

Fill-in Light. Portrait lighting outdoors benefits from secon-

dary illumination, such as flash or some type of reflector, even though this may not be as necessary as it is indoors. Since the fill light should always be appreciably less intense than the main light, you will need very little filling in of shadows if the main light is already diffused, as in haze or open shade.

Watch for natural reflectors outdoors. Often the side of a white house or nearby monument, for example, can reflect as much fill light as the shadow areas of your composition need. In open shade, an open newspaper strategically placed on the side away from the main light will sometimes do a remarkably good reflecting job. If you can find open shade near a beach or water, try to pose your subject to take advantage of indirect sunlight on one side and the reflected light on the other.

Portable Reflectors. A large sheet of white cardboard (about 30 to 40 inches) will furnish good fill-in illumination outdoors as well as indoors if someone—or some*thing*—will hold it where you want it. For more convenient carrying, a hinged reflector, like a miniature folding screen, can be built of two or three smaller panels of thin plywood, with one side painted white and the other covered with crinkled silver-color foil. Foils are too harshly reflective for most portraits, and any foil less neutral than silver will affect the results if you are using color film; however, with some experience and experiments, you can aim deliberately for different color effects, such as a warmer tone with gold foil.

Flash as Fill-in Light. The principle of fill-in flash and calculation of flash-to-subject distance has been explained in some detail in chapter 11. Remember that if you are using on-camera flash at a close-up position, the bulb should be diffused by covering it with one to three thicknesses of white handkerchief, depending on the distance; extreme close-ups, such as under four feet, should have three thicknesses for black and white or color.

Remember also to use blue flashbulbs, or the blue section of a plastic diffuser, with daylight color films. Too much distance or other diffusion will nullify the flash effect; on the other hand, too intense a flash will destroy the naturalness of the daylight and produce even more unsatisfactory results.

Fill-in flash can be a very helpful tool to a photographer, out-

doors or indoors. But its value depends on the skill and judgment which come only with practice.

Backgrounds. One of the most important aspects of outdoor portraiture is choosing a background; simplicity is paramount. You may be looking only at the person you are photographing, but bear in mind that the lens is looking at everything within its range. Particularly with an average small camera, which has a short focal length and relatively great depth of field, it is important to keep the background as unobtrusive as possible and to be sure that such objects as posts, branches, and door frames do not seem to be growing out of the subject's head.

Selective focusing on the face from a reasonably close camera position will help cut out extraneous scenery and reduce depth of field. Some of the loveliest backgrounds are the most available if you simply angle your camera so that the subject is against a blue sky, green grass, or blended fall foliage. Deep shade can prove a very satisfactory dark background if the subject is in sunlight and the background is out of focus. Be sure your subject is not placed where adjacent shrubbery or overhead leaves will reflect on the face and give it a greenish tinge.

Posing. Outdoor posing can be comparatively casual, or should seem casual enough to put the subject at ease. However, careful attention to details, especially the background, will be worthwhile. Some sort of seat, or something to lean against or touch, may contribute to a pleasantly relaxed pose; and a conversational distance (neither close enough for whispering nor far enough for shouting) will also make the subject more comfortable. When you have decided on the general camera position, ask the person to turn the body slightly away, then turn the head slowly back toward the camera—just as you would indoors. See that the hands and other parts of the body are on approximately the same plane as the face. If an informal portrait is to include a "prop" of some sort, such as a book, a pet, or a tennis racquet, you may need a bit more than minimum depth.

People are by far the most popular of all photographic subjects. Studying photographs of them in newspapers and magazines can be instructive; but learning really to *see* them makes a more fascinating hobby.

Ultra Close-ups of Small Objects

Concentration on the main interest is perhaps the basic reason why extreme close-ups fascinate practically everyone who takes or looks at pictures; the distracting elements must be eliminated, which in itself helps to strengthen a photograph. While it is true that a sizable percentage of the most admired examples, such as those in magazines and exhibits, are taken by professionals using expensive equipment, many amateurs turn out praiseworthy photographs of miniature subjects with standard lenses and very inexpensive attachments. The scientific term for large pictures of small objects is *macrophotography*.

Flowers and insects are favorite subjects for close-ups, as photographers seem to find them more satisfying than "tabletops" or other indoor still lifes. One of the most interesting indoor projects is making title slides, which is a practical photographic exercise with a built-in purpose. Ordinary copying can also be done with the close-up lenses and other simple accessories discussed in this chapter. While the same equipment can be used to some extent for portraits (see chapter 16), it is well to keep in mind that an average head and shoulders is considerably larger than an average blossom or bug and that distortion is less acceptable in a photograph of a face than in one of a flower. The only way really to know this, of course, is to experiment freely and study the results closely.

BASIC CONSIDERATIONS

Cameras. An optical system that permits the photographer to view the composition through the taking lens is best for extreme

close-ups, since the problem of parallax becomes more critical as depth of field becomes shallower. The single-lens reflex is, therefore, first choice of those whose chief interest is in nature studies or other close-up photography.

Lens interchangeability is a highly important feature if you intend doing much macrophotography, since it permits the use of relatively inexpensive extension tubes or the more costly adjustable bellows. Macro lenses, which allow you to photograph accurately within inches of your subject, are also available for most cameras. They can be used like normal lenses but have an extended focusing range without supplementary attachments.

For a very limited number of cameras there is a reflex bellows housing which adapts the camera for close-up work.

Supplementary Lens Attachments. These are also called "close-up lenses" and—like filters, which they resemble—can be placed in front of any camera lens for close-up photography. For twin-lens reflex cameras, it is possible to buy a pair of matched close-up lenses; in some sets the upper (viewing) lens has a prism factor for parallax correction.

These little accessories are not for use by themselves but are supplementary meniscus lenses whose purpose is to modify the distances at which the camera lens can produce a sharp image. They require no exposure compensation.

Close-up attachments come in a wide variety of magnifications, ranging from +1 to +10 diopters, the higher numbers indicating proportionately greater magnification. Two of these lenses may be combined for increased magnification, but more than two can cause image deterioration. When two are used together, the higher number should be next to the camera lens.

"Portrait lenses" is another name given to these attachments, since they allow a photographer to move closer than normal to his subject and to take portrait shots without distortion. These supplementary lens attachments are widely available for almost all cameras and are known by many trade names, such as "Portra," "Proxar," and others. The manufacturer usually provides a table of working distances.

Size of Field. Most amateur cameras can focus down to about 3½ feet, at which working distance the normal lens of a 35mm camera covers an area, or lens field, of about 27 x 18 inches. By adding a +1 close-up attachment, the working distances can be

reduced to a range of approximately 40 to 20 inches, and a pair of +3 attachments can bring this down to around 6 inches, which would cover a field not much more than 4½ x 3 inches. A 2¼ x 2¼ twin-lens camera with a +3 set of close-up lenses can focus down to around 10 inches to photograph a field approximately 6 inches square. Various printed dialguides contain tables for computing size of field at different working distances, in addition to valuable filter and depth-of-field data.

Focusing for Sharpness. Because depth of field is practically nonexistent in extreme close-ups, there is no margin for error; focusing should be accurate to the fraction of an inch recommended for a specific lens attachment. You may have a camera which shows the image as it will be recorded, as does a single-lens reflex, but if you have a simple camera, you will need some kind of measuring and framing aids along with the lens attachments.

Working distances should be measured from the front of the close-up attachment to the front of the object being photographed. If the camera is on a tripod, a yardstick can be used to position it at a specified distance from the point of focus. For a camera held at less than arm's length from the target, a casual but fairly workable solution is to tape to the camera a piece of string knotted at 14 inches or 10½ inches or whatever distance you plan to work from. With such elementary computers, you will have to estimate the picture size roughly, which is not very satisfactory for ultra-close work. Or you can use a focal frame similar to that in figure 21.3.

Extension Tubes and Bellows. For large images at medium-close working distances, there are small, rigid metal tubes, fixed or focusing types, designed to hold a camera's removable lens at one end. The tube's smaller end is threaded to screw into the camera body or to be combined with other pieces of the set to form a longer tube. By holding the camera lens farther from the film plane, these tubes allow you to come in closer to a small subject in order to obtain large images at comparatively convenient working distances. Bellows extensions, which are bulkier, more versatile, and more expensive than the rigid tubes, are used by advanced photographers who do a lot of close-up work. These units vary greatly and generally fit cameras with focal-plane shutters.

Basic exposure is subject to change with extension tubes or bellows, since they actually alter the lens-to-film distance. Thus, the light-transmitting capacity of a lens aperture diminishes in relation to the length of the tube, necessitating a longer exposure for a given f/stop than the basic lens position requires. This obviously includes a reduction in the maximum "speed" of the lens. Tables of these exposure factors, or times by which exposure must be increased, come with the equipment.

Parallax Compensation. With cameras other than the single-lens reflex, which relays the composition to the film just as you see it in the ground glass, parallax is a tricky problem at close working distances. Some of the best 35mm rangefinder cameras are "fully corrected for parallax" by means of an automatic feature that causes the frame outline to move within the finder as the focus is changed. The "correction" of some other models consists of fixed markings showing, within the regular frame outline, the top boundary for a single close-up distance. Most cameras need to be tilted toward the viewfinder to minimize parallax.

Tilting the camera slightly up for horizontal formats, or to the side for vertical ones, is usually adequate parallax compensation at medium distances, but exact correction by tilting is virtually impossible within the range of close-up lenses. However, the recommended tilt at which to aim is: for a +1 close-up lens, up to about one-eighth of the picture; for a +2 lens, by about one-sixth of the picture; and for a +3, by about one-quarter of the picture.

Camera Steadiness. A rigid camera support is also essential for close-ups, which are usually taken at relatively slow shutter speeds or at time exposures. When using telephoto equipment or a combination of extension tubes, the camera may become front-heavy; this makes it more susceptible to jarring and to vibration from traffic or tramping about, especially during long exposures. Tripod legs should be extended no farther than needed, as longer legs make it less steady; another aid to steadiness is a weight hung from the center of the tripod head.

The blur of an out-of-focus background, resulting from focusing sharply on the main point of interest, is generally desirable. But an action blur, caused by subject motion, or the overall blur caused by camera motion, is a fatal flaw in ultra close-ups.

Backgrounds. Because an extreme close-up is focused concisely on the main idea, in a small area, background simplicity is fairly easy to achieve. In sunlight, backgrounds tend to look after themselves by going softly out of focus. Indoors, a piece of unpatterned material, or the dull-finish paper sold in more than a hundred colors by various artists' supply stores, can be tacked behind the photographic subject when you are shooting by flood or available light. With flash, only the foreground subject usually receives sufficient light to record an image on the film.

In the very broad close-up categories discussed in the next pages, a few specific suggestions for backgrounds are included. Generally speaking, however, for black-and-white photographs the background color should be one that will reproduce as a light gray tone for dark objects and one that will reproduce as a darker gray for light objects. Color photographs are more successful, on the whole, when the background choice is a relatively flat tone which complements without too sharp a contrast the colors of the subject.

FLOWERS AND OTHER NATURE CLOSE-UPS

Nature close-ups comprise an area in which color films are used almost exclusively. Nevertheless, some insects, fungi, ferns, seashells, and other small subjects with distinctive shapes and patterns can be very effective in black and white, as in figure 17.1. Working distances will depend not only on your equipment but on the size of your subject. Some tiny specimens can scarcely be seen without a magnifying glass, while a large flower or a cluster of blooms may fill the picture frame at a distance of two feet or more.

Exposure. Very fine-grain color films, being relatively slow, often require a shutter time too long for hand-held steadiness; in these instances a sturdy tripod and cable release are indispensable. If you do not have a tripod and your camera offers a good range of settings, select a shutter speed no longer than 1/25 second and the corresponding f/stop. If the day or the location is fairly breezy, it is better to shoot at 1/60 and to circumvent subject motion by careful timing.

If a flower, for example, is swaying noticeably, try to trip your

Fig. 17.1. Close-up of spider-web in damp dawn makes interesting pattern in black and white.

shutter between breezes. The base of a swaying stalk can be weighted without injury by means of medical clamps called "hemostats." These clamps, or the flexible plant ties used by gardeners, are useful also for holding back leaves and small branches when you wish to isolate a single plant or blossom.

Another handy little accessory is a mirror, preferably a shaving or makeup mirror which is mounted on a base and can be tilted easily. It can serve as a fill-in light by reflecting daylight into dark shadows where a bulky reflector might be impractical, and it is particularly good for lighting plants or insects in deep shade such as might be encountered under logs or overhanging rocks.

Flower Backgrounds Outdoors. Selective focus at a wide aperture, with consequent shallow depth of field, usually takes care of backgrounds in close-ups, as in figure 17.2. But watch out for

Fig. 17.2. Ultra close-ups of flowers and insects are best with natural, out-of-focus backgrounds. (Courtesy of the Newspaper National Snapshot Awards)

sharp little spots of color, particularly yellows and whites; even when considerably diffused and out of focus, bright spots or specular highlights can mar an otherwise pleasing effect. When your floral subject is in a crowded or busy area, especially in a sunny garden or yard, an artificial backdrop may be needed. If so, a plain sheet of dull-finish art paper can be used, preferably in a light sky blue or subdued foliage color; don't choose an intense color which might overpower the main subject. A less artificial effect can sometimes be achieved by attaching a fern or other appropriate bit of foliage to a stalk or stake right behind the flower.

Live Objects. Insects and other wildlife or small pets, such as kittens and canaries, cannot normally be photographed at shutter settings as slow as you would choose for flowers or still life. Although you may need a comparatively fast shutter time for living things, it is important to *move yourself and your equipment slowly* and smoothly in order to avoid frightening and perhaps losing your subject. Most pets and other animals react in alarm to flash; it is usually better to try for available light with reflector and fill-in and, possibly, to use a faster film. Since live insects are likely to scurry off before a photographer can get set, artificial insects appear in some slides.

Experienced photographers who specialize in apparent close-ups of wildlife frequently employ various remote-control devices for releasing the shutter while watching through binoculars the area on which the camera is focused; or they may have an even more complicated setup in which the subject itself trips the shutter. This is mentioned only so that you will not expect to achieve the impossible with an average small camera and equipment.

TABLETOPS

Although the term is sometimes loosely applied to still-life photographs, *tabletop* is a photographic coinage intended to refer to pictures of small-scale objects which incorporate some sort of theme—in other words, an "idea" carried out in miniature still life. For example, if you place a set of toy soldiers on a table and photograph it, you get a picture of some toy soldiers; if you place an African violet on a table and take its picture, you get a flower portrait. But if you arrange the toy soldiers and a couple of tanks in authentic battle formation on mud-colored fabric, you may get a successful tabletop. And if you place an African violet on some textured paper and arrange a doll of suitable size with a miniature watering can in realistic relation to it, you may get a pleasing tabletop.

Within the framework of the basic definition, anything goes in tabletop photography. It is dependent upon your imagination, resourcefulness, and good taste, without which the results can be pretty awful or just plain dull. When you are not sure about a picture, follow this rule: if in doubt, toss it out.

Backgrounds. A piece of fabric, a sofa, draperies, or a rug can serve as background for tabletops, title slides, and similar close-ups. More often used, however, are the colored papers mentioned earlier—i.e., textured water-color paper or a roll of seamless display paper (sometimes available in half-width). Part of the background material is customarily attached to a large piece of heavy cardboard so that it can be propped vertically against a wall or furniture, and the balance of the paper or fabric is brought forward onto a table or other horizontal surface. When you have arranged the composition on this flat surface, check your viewfinder to be certain that all elements are well within the background boundaries.

Lighting Very Small Objects. The basic lighting arrangements

detailed in the preceding chapter on portraiture are applicable to many inanimate objects; but for photographing really tiny objects only a few inches away, you should have slightly different equipment in order to achieve modeling, texture, or special effects. One reason for this is that the exposure generally calls for the maximum possible illumination. Another is that standard floodlamps placed very near a tiny object are likely to light it too evenly and flatly; furthermore, if the object is perishable, like a flower or fruit, the heat from the floods will be excessive. A more appropriate lamp is a 150-watt miniature spot, which confines the light to a comparatively small area. To the spot can be added a *snoot*, a metal tube designed to funnel the light into a narrow beam. One or more reflectors can further intensify this main light. For fill-in lighting, the mirror previously suggested for small objects in deep shade can furnish sharply focused secondary light. For simply softening shadows, an ordinary white cardboard reflector can be used as in other types of photographs.

TITLE SLIDES

If you plan some showings of color slides for more than small family gatherings, it may enhance your act to include some courtesy slides, like "Good Evening" and "The End," and some transitional slides, such as an airplane takeoff or an area-map close-up for a vacation series.

Titles can be nonverbal; for example, a picture of a confetti-showered car or of a jolly Santa speaks for itself in introducing a pictorial record of wedding or Christmas festivities. And whether you make a few titles occasionally, perhaps to finish a roll of film, or make a larger supply at one time, it is a good idea to keep an interchangeable assortment on hand for putting a slide show together.

Title slides can be made in daylight as well as by artificial light with the basic equipment already described. Sometimes a background of sky or grass or tree bark will blend more harmoniously with other outdoor pictures than will a floodlit colored paper. And words written in sand can last a lifetime when photographed for titles.

Lettering. Words to be arranged against a background can be clipped from magazines or brochures, can be handwritten or typewritten, or can be made up from the letters of games such as Scrabble. They can be finger-painted on a 16 x 24 sheet of clear glass, with white paper back of it for maximum brilliance. Titles of books or brochures can be worked into appropriate settings.

Some stationery and camera stores carry one or more types of ready-to-use letters: individual die-cut letters on gummed colored paper; self-adhesive letters to stick onto the background or, if you wish to reuse them, onto clear cellophane; colored plastic letters that can be placed above any printed matter; small three-dimensional display letters with white matte surfaces. Color tapes from $\frac{1}{16}$ to $\frac{1}{2}$ inch in width can be used for underlining and decoration.

Props for title slides, like those for tabletops, can be anything you consider suitable; cutout figures and shapes, travel folders and postcards, and jewelry and trinkets are all favorites. Watch out for glare from any highly reflective surfaces like silver or polished metal.

Lettering within an Existing Slide. If you wish to add a title to the sky or other light section of a color slide, you can do so by sandwiching a slightly underexposed black-and-white negative with the original slide. Place white letters against a dull black ground, leaving plenty of black space below. Before exposing the film, carefully compare the image in your viewfinder with the existing color slide to be sure that the title is well inside the sky area. Enlargements from these black-and-white negatives can serve as covers for albums of print pictures.

Lighting. For texture and a feeling of depth, use strong side lighting, keeping any fill-in light far enough away so that it does not create double shadows in your composition. If the composition includes a postcard or other picture-within-a-picture, see that the shadows created by your lighting fall in the same direction as those in the postcard.

Title slides, to be effective, should have original arrangements of props, with letters neatly mounted and properly lighted. Perhaps even more important is their mood and message, which should be fitted to the subject matter *and* to the audience with whom you are communicating through the slides.

COPYING

Copying is an aspect of close-up photography and, as such, can be done with the same accessories and equipment. It is also, like portraiture, a highly specialized profession in which specific copying cameras and extensive commercial setups are employed.

The camera preferred by the layman for copy work is the single-lens reflex, for the advantages already noted. Besides eliminating the parallax problem, the SLR's ground-glass focusing reveals any lighting glare which may need correcting and also simplifies measurement of the image size. For serious copying work, microphotography, magnification, or slide copying, there are elaborate attachments, adapters, and various extension bellows designed for individual small cameras. When using any of this special equipment, you should carefully follow the instructions in the booklets provided with the equipment.

For some copying, the normal lens of your camera will be quite satisfactory. If at the lens's minimum focusing distance the original to be copied fills most of the viewfinder, no supplementary lens attachments are needed.

Terminology. *Copying* refers to photographic reproduction of flat, or two-dimensional, subject matter. The material to be copied is called the *original*, or the *copy*. Copy as a noun refers also to the photograph obtained by copying—the *reproduction*. Subject matter that has only two tones, such as printing or line drawings, is a *line original*. Any material having several gray tones, such as a photograph or wash drawing, is a *continuous-tone original*. A photomechanical reproduction, in a pattern of tiny dots, of a continuous-tone original is called a *halftone*.

Basic Copying Setup. Any camera can be used for copying, provided there is some means of holding the subject matter parallel to the film plane and perpendicular to the lens axis. This may be a horizontal or a vertical setup, depending on available equipment, working space, and the condition of the original. The standard *horizontal setup* includes a copying stand to which the camera is mounted, a horizontal board with graph lines for measuring and squaring the original, and clips to hold the original in place. A camera mount without its own board can be used with any sturdy table and special clamps. Some enlargers provide

special equipment for converting the enlarger bellows into a copying camera.

Most *vertical setups* need less working space and are usually less subject to vibration. They require some kind of frame or an easel to hold the original upright and a sturdy tripod for the camera. In either a vertical or horizontal setup, a small bubble level is useful for determining whether the camera and all parts of the setup are perfectly level.

Lighting Equipment. Any light source, like any camera, *can* be used for copying, but it must furnish even lighting. Daylight is generally too variable to be practical; however, it may be used successfully if the original is directly facing the window. Ordinary flash is not recommended because it does not permit a preview of the lighted original.

The most practical lights are photofloods or household lamps of 60 to 150 watts; they should be identical pairs and used in twin reflectors sufficiently large so that from the camera position no part of the bulb is visible. Lampstands which are easy to move and tilt are convenient for copying and for other artificial-light photography.

Low-wattage lamps are often preferred to photofloods for copying. Although they necessitate longer exposures than floods, the entire copying setup—including the original to be photographed—should be rigid enough to make this no problem. A lower intensity is more comfortable to work with and easier on the subject matter if it happens to be something like an old document or print which could be faded or otherwise damaged by too intense illumination.

Even-Lighting Setup. Uniformity of illumination is usually achieved by placing the twin lamps on opposite sides of the copy holder at an angle of 45 degrees to it, as indicated in the standard setup diagram of figure 17.3. When you are using a camera with a lens of longer than normal focal length, the angle of lighting can be narrowed, as shown in the narrow-angle setup diagram. Reduction of the angle of lighting is sometimes a means of counteracting problem reflections in an original.

When the original to be copied has rough surfaces (such as wrinkles in an old document) which cause misplaced highlights, adjust or diffuse the lights to eliminate any glare. If you wish to emphasize rough surfaces (for example, the brush strokes of

246

Fig. 17.3. Lighting arrangements for copying

an oil painting or the texture of a fabric), experiment with a
modified crosslighting.

Filters. For clean black-and-white copies of colored subjects,
a filter is often advisable, and the principles explained in chap-
ters 9 and 10 apply to copying as well as to general photogra-
phy. A brief summary will remind you that a filter lightens its
own color (yellow being red + green), and darkens its comple-
mentaries:

Filter Color	*Lightens*	*Darkens*
YELLOW	reds, greens	blues
RED	reds	blues, greens
GREEN	greens	blues, reds
BLUE	blues	reds, greens

Be sure to check on the filter factor, as accurate exposure is vital
to successful copying.

Blueprints are customarily copied with a red filter, which dark-
ens the blue background and makes the white lines stand out
more sharply. A yellow filter is often used to copy prints or
photographs that have become yellowed or slightly brown. To
"erase" transparent stains, such as ink, use a darker filter of the
same color as the stain.

Films. The finest-grain films should be chosen for most line
copying, since sharp contrast is generally desired. For a con-
tinuous-tone original, where excessive contrast would be un-

desirable, it is better to use a medium-speed film such as you would choose for ordinary snapshots. As an example, for copying a photograph in which your aim is to preserve highlight and shadow detail with several in-between tones, a medium-speed film will give the nearest to normal reproduction. High-speed films produce still lower contrast and are liable to overexposure and loss of detail in the light areas. Of the popular Kodak black-and-white films, for instance, you would pick Panatomic-X for high-contrast line copying, Plus-X for continuous-tone copying, and avoid the very fast Tri-X.

The purpose of most copying is to make black-and-white records, whether the original is in color or not. The basic principles of balanced lighting and fine-grain films apply to copying with color films, but you should not expect exact duplication of the colors being copied; this is a problem even with the most advanced commercial reproduction equipment.

Warning. There are laws regarding the copying of many subjects, such as stamps, money, citizenship papers, and innumerable other documents, as well as any copyrighted subject matter. If you are in doubt, check before you click.

Night Pictures and Trick Shots

Under colorful city lights or brilliant country stars, amateur photographers find challenging opportunities for a hobby within a hobby. Since so many after-dark pictures are taken at longer than a second, some general suggestions regarding time exposures are included in this chapter. Not included are suggestions for sunsets and moonlight (see chapter 13), nor recommendations concerning night photography indoors (see chapters 11 and 17). Since time exposures and a tripod-held camera are also utilized in many trick shots, including multiple exposures which combine night and day lighting, a few of the fairly common tricks you may have seen, or attempted yourself, are also described.

BASIC CONSIDERATIONS

Cameras and Accessories. Any adjustable camera with a setting for bulb or time and a maximum aperture of $f/3.5$ or larger is suitable for taking pictures at night. Simple cameras with no settings for time exposures are likely to be unsatisfactory, except for occasional snapshots in very bright areas such as under a theater marquee; however, today's high-speed films permit almost any camera to record some subjects that a few years ago would have been possible only with time exposures.

If you expect to take long exposures, you will probably want a tripod and cable release. But a tripod, even a fairly heavy model, is no guarantee of absolute steadiness, especially out of doors where there may be gusts of wind, numerous passersby, and darting dogs. Many photographers, refusing to be encum-

bered by extra gear, either look about for a ledge, post, step, car door, windowsill, or wall as a tripod substitute or as a brace for the photographer.

A lens shade is even more important at night than in daytime to minimize glare. And if flash is to be used, it is best to have some provision for using it off the camera. A piece of black cardboard, or some article such as a dark hat with a black lining, should be carried to serve as a mask when you have occasion to interrupt a time exposure; for example, to block out the headlights of a passing car, simply hold the mask in front of the lens for a moment without touching the camera. A small flashlight may be needed to make out camera settings and meter readings.

Films. Fast panchromatic or high-speed color films are usually preferred for night photography in order to reduce the exposure time and perhaps eliminate the necessity of carrying a tripod. A daylight-type color film, recommended previously for sunsets and moonlight, will give more normal sky colors during twilight hours but will render street and building lights rather strongly red and yellow. A color film of the type balanced for artificial light may render early evening skies more blue than normal, but it will probably reproduce the colors of a lighted night scene more nearly as they appear to you. In short, daylight films will render the colors of a night scene somewhat "warmer" than will artificial-light films. But either can create interesting effects, and you should not pass up a good picture possibility just because you have the "wrong" film in your camera.

Time Exposures. Markings for exposures longer than one second are usually indicated by a letter at the slow end of the shutter-speed index. When set at that letter, the shutter is no longer controlled by its timing mechanism but is controlled manually. If the marking is a "T," for *time,* you press the shutter release in the usual way to open it; at this "T" setting the shutter will remain open until pressed a second time to terminate the exposure.

On a "B" (as in *bulb*) setting, the shutter remains open as long as the shutter release is held down; when you let go, the shutter closes. This "bulb" has nothing to do with flash; it's simply a carry-over from days when the photographer had to squeeze a rubber bulb connected with shutter to trip and hold the shutter mechanism.

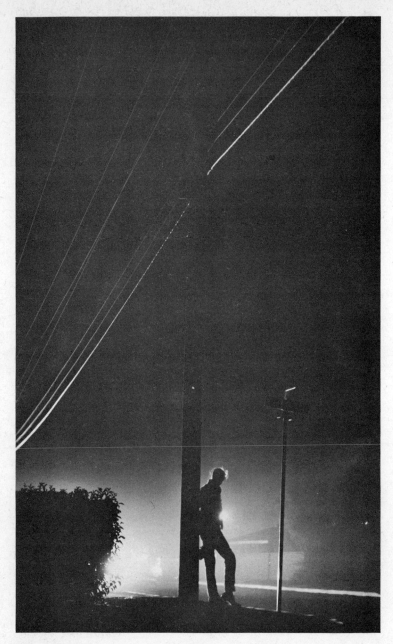

Fig. 18.1. Time exposures are usually needed to capture mood or activity at night. (Courtesy of Scholastic High School Photo Awards)

A cable release is a practical necessity for time exposures, because it is almost impossible not to jar the camera slightly while pressing or holding the shutter button on a tripod-held camera. Always press the plunger of the cable release gently but firmly, and remember to hold the cable in a slack curve; pulling it taut will jar the camera, especially if you are holding a "bulb" exposure.

Flash by Night. If you plan to use fill-in flash for a scene needing more than existing light, try to place the flashgun at an angle that will simulate a high street lamp, a low window light, or some other natural source of illumination. This can be done, of course, only with an off-camera flash arrangement. A statue, a person, or other foreground object in a night scene can be lighted with flash.

Night photographers usually prefer *open flash* (see chapter 11), firing the flash at some time during a time exposure. If there are people in the picture, it is preferable to fire the flash near the end of the exposure, because people are inclined to turn toward the flash or otherwise move when it goes off. During long exposures of at least a minute or two, and if there is not much existing light from windows or street lamps, it is possible to use the painting-with-flash technique outlined in chapter 11. If the situation—and your temperament, experience, and equipment—warrants doing this, you would choose the aperture giving the desired depth of field and proceed as indoors.

Estimating Exposure at Night. The principal problem in night photography is to determine how long the exposure should be; in some instances this is bound to be a wild guess. The variables are far more diverse and unpredictable than by daylight, and the brightness range of most night scenes is too great for any film to reproduce accurately at any exposure. Exposure meters are generally less effective in dim light than in normal illumination, but when there is sufficient light to activate the needle, read your meter in the usual way. Many meters have a switch for low-light readings.

The exposure suggestions which follow are simply starting points, to be modified according to your estimate of specific conditions and the film you are using. If you wish to be reasonably sure of a picture, take at least three shots. After shooting at what you have decided on as the best exposure, bracket this with

another at 4 times the estimated exposure and a third at 1/4 the exposure. A narrower bracket, such as 2 times and 1/2 the exposure, is not likely to produce appreciable differences at night. For a double bracket, on a must-have-now-or-never picture, take two extra shots, one at 8 times and another at 1/8 the key exposure.

Basic Exposure Guides. First of all, there is no *one* correct exposure for pictures at night; at practically any exposure you select, you are bound to get something. Since modern color films offer a wide choice of speeds, the starting-point recommendations in the list which is to follow are based on medium-fast types with speeds a bit above or below Kodachrome-X (ASA 64). If you are using a slower color film (ASA 25 to 50), double the recommended basic exposure; if you are using a high-speed color film (over ASA 125), cut it in half. For very fast black-and-white film, such as Tri-X, reduce exposure by still another stop.

As explained in chapter 4, each *f*/stop, going up the scale, transmits half as much light as the preceding aperture. This principle works in the same way for exposures on time or bulb settings by halving (or doubling) the number of seconds. For example, to decrease a 16-second exposure by three stops, cut 16 to 8 for one stop, 8 to 4 for two stops, and 4 to 2 seconds for fast black-and-white film.

The reason that films of varying ASA indexes or speed values are grouped together for night pictures is that when either illumination or length of exposure is not "normal," the law of reciprocity fails, and thus the exposure estimate can be only approximate.

Reciprocity Failure. Do not be daunted by this formidable little phrase. You may hear it, and you may wish to have some idea why precise exposure guides are not possible except when conditions are more or less average. Basically, the law of reciprocity predicates that decreases in light intensity can be compensated for by corresponding increases in exposure. This theory works fine until the exposures become extremely long or extremely short, which occurs when levels of illumination are very low or very intense. If the light is average, you can expect a doubling of the exposure to double the density of the negative; but if illumination is so low that you need a time exposure of

ten seconds, for example, the negative density will not necessarily be ten times what it would be at one second. Hence the unpredictability of results in night photography.

RECOMMENDED EXPOSURES

The following general guides are based on medium-speed color films, such as Kodachrome-X. Double the basic guide for slower films and halve it for faster ones. (Also, Kodak has a customer-service pamphlet on existing-light pictures which includes a chart of night subjects with suggested exposures for its various films, including Kodachrome II, Kodachrome-X, Plus-X, and others.)

Brightly Lighted Streets. One of the calculated risks of photographing night scenes is that unexpected pedestrians or cars can show up during a long exposure and ruin the picture. By studying the flow of traffic for a while, you can often see a pattern of stopping and starting which will allow you to take your picture when there is the least motion, perhaps when people and vehicles are waiting for a traffic signal to change. If the scene is quiet except for an occasional car or pedestrian, you can cover your lens with a black mask during the movement, and uncover to continue the exposure. Basic recommendation: *1/30 second at f/2.8.*

Neon and Electric Signs. An exposure of *1/2 second at f/11* or, if you are bracing your camera without a tripod, *1/25 second at f/3.5* will record the lighted sign but not much detail outside the display itself. You can get more detail in the area around the sign by increasing the exposure, but then the display lights will be overexposed.

Rain and Fog. Wet pavements often make streets more interesting, keep more pedestrians out of the way, and reflect about as much light as supplementary flash. If you are exposing for highlights, rain will increase their number, and reflections can double the amount of color you get. Fog lends mood to a picture, adds halos to street lamps, and imparts an illusion of depth by swallowing up distant areas and emphasizing near ones. Be sure to protect your camera from rain and excessive dampness by keeping it covered when not in use and by photographing from under some shelter, such as an awning, doorway, or umbrella. De-

Fig. 18.2. Water in foreground of a picture reflects city or roadside lights. (Courtesy of Scholastic High School Photo Awards)

pending on the brightness of street signs, try *4 seconds to 1/2 second at f/8.*

Water Reflections. City lights reflected in a pool or fountain, like those sometimes found in a city square, plaza, or small park

—or even a large puddle—can add color and interest. Try to compose your picture so that the reflections serve, in the same way as flash, to brighten the foreground. Use the same exposure as for bright streets: *1/30 second at f/2.8.*

Store Windows. Some window displays are bright enough to be photographed at *1/30 second at f/2 or f/2.8,* with no exposure increase required for the glass. But most do not have that much illumination and need about two stops more: *1/8 second at f/2 or f/2.8.*

Reflections are the biggest problem and can often be controlled by finding the right camera angle and by standing two or three feet away from the glass. If light levels are high enough or if you use a faster color film (such as High-Speed Ektachrome with special processing), a polarizing filter will usually take care of most reflection problems. Also, occasionally you can turn a problem into a pictorial advantage by making reflections part of your composition. Professional photographs of window displays are generally taken very late, when traffic is at a minimum, and sometimes with assistants holding a large black curtain behind the camera.

Floodlit Buildings and Monuments. Practice will soon tell you how much exposure is needed for monuments and other public buildings in floodlight. A lot depends on the light or dark color of the structure itself, as well as on the intensity of the floodlighting, which often varies considerably. Here again, a hand-held exposure may be possible with fast film and a fast lens. Otherwise, an average basic recommendation is *4 seconds at f/5.6.*

The color of the floodlighting makes quite a difference in exposure. For instance, in photographing an outdoor spectacle such as Niagara Falls, a basic recommendation for white floodlighting would be about 15 seconds at *f/5.6.* Fairly bright colored lighting would require about 30 seconds at *f/5.6,* and darker colors about 30 seconds at *f/4.*

Fireworks and Carnivals. Spectacular color photographs of distant fireworks are usually achieved by aiming the camera up toward the display area, leaving the shutter open while three or four bursts explode, then closing the shutter. Time for this is generally about *8 seconds at f/8.* This multiple-exposure technique can be used for a lighted ride, such as a Ferris wheel; obvi-

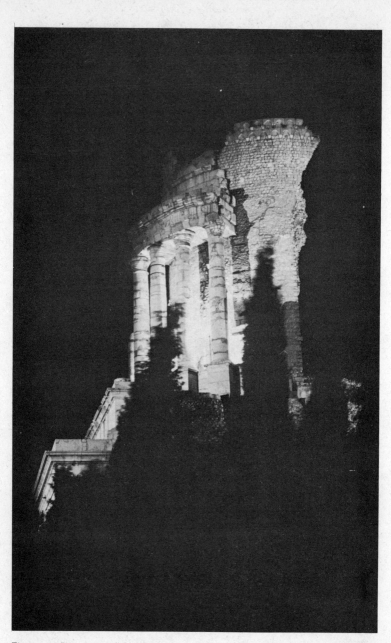

Fig. 18.3. Intensity of floodlighting affects amount of exposure needed for monuments at night. (Courtesy of Scholastic High School Photo Awards)

ously it will not stop the action, but the whirls of color can create interesting patterns. For closer shots at fairs and amusement parks, try a hand-held exposure of *1/15 second at f/2 or f/2.8.*

Campfires. A basic recommendation for recording the flames of the campfire itself would be *1/30 second at f/2.8.* If you are more interested in catching the faces of a group around the campfire, at the expense of blurring the flames, try *1/2 second at f/11;* a supplementary flash on the far side of the campfire will help reveal features.

Burning Buildings and Bonfires. Here you would in all probability be trying first for flames and then for faces. Since flames have a good deal of "action," you would choose a shorter time first: *1/30 second at f/2.8.*

Christmas Trees and House Lighting. For lighted trees outdoors or indoors, or doorways decorated with colored lights, try a basic exposure of *1 second at f/4.* For close-ups of lighted Christmas trees indoors where you can use supplementary flash, *1 second at f/11* should be adequate.

Theaters and Sports. For atmosphere shots in bright theater and nightclub districts, where lots of marquee lights and electric

Fig. 18.4. Flames of fires at night can be recorded at hand-held shutter speed with fast films. (Courtesy of Scholastic High School Photo Awards)

signs are illuminating the scene, you may be able to take a meter reading. If not, try *1/30 second at f/2.8.* The same setting is also recommended for football, boxing, racing, and other night sports events. Use high-speed film for a faster shutter setting.

For spotlighted acts inside, whether a stage show, ice show, or circus, you can use *1/60 at f/2.8*—if you have an unobstructed view and if picture-taking is permitted.

Effect of Distance on Exposure. Some increase over basic exposure is generally recommended for night scenes at relatively great distances. For example, a picture of the New York skyline taken from New Jersey or from a Staten Island ferry should have more exposure than a city scene taken on a New York street.

For a very general basic exposure to use in night photography, try 2 seconds at f/8, or any equivalent combination, depending on whether you need a smaller aperture for greater depth of field or a faster shutter speed because of motion in the scene.

Calendar Considerations. Darkness arrives at different hours in different months, and city scenes have different aspects and moods at various times of the year. On a summer evening you may find more strolling and less bustling, but in winter there will be more dazzle and more lighted office buildings. Buildings silhouetted against the sky will show up best if photographed after sunset but before it is really dark. During December this twilight zone comes early, before the closing time of most offices, making it possible to get many lighted windows in your night scenes at the end of the year.

But December need not confine you to business sections or Christmas lights. In residential areas a snowy night scene can evoke a variety of moods and emotions. Street lamps reflecting on white-blanketed shrubbery or ice-coated trees, dark shapes cast on snow-covered walks, silhouettes of a homebound couple or a late shoveler, friendly lights in a living-room window offer right-at-home opportunities for anyone with an observant eye and a ready camera.

MULTIPLE EXPOSURES

When you see a photograph that looks like a lighted city scene against an early sunset sky, a woman conversing with her

own image, a person recoiling before a ghost, or a man balancing a girl in the palm of his hand, you know that things are not what they seem. But what are they? The apparently single photograph usually turns out to be more than one exposure on the same negative; sometimes it turns out to be two negatives sandwiched together.

Many modern cameras have a lever to advance the film and cock the shutter in one easy operation—a device designed not only for speed but also to prevent unintentional double exposures. Check your camera booklet to ascertain if and how your film-advance mechanism works to permit double exposures.

Atmosphere à la Carte. Unusual effects can be obtained by combining daylight and evening exposures on a single negative. As an example, suppose that while you are vacationing in a large city you observe from your hotel window that the view takes on a special magic as lights and more lights come on after dusk. To capture this scene, place your camera on a tripod or other support where it can remain focused on the view for a few hours. Make a daylight underexposure of the general scene, using about two stops below normal. When the after-dark scene is the way you want to photograph it, make a time exposure on the same negative. In a similar manner a double-exposure photograph of a lighted city scene silhouetted against a sunset sky can be obtained: take a picture of the sky at a slight underexposure; keep your tripod unmoved until the lights appear; then take a second exposure against the darker sky.

With planning, practice, and patience, you can use this technique to record three or four exposures as one picture. This is done by building up the composition with progressive underexposures, putting the background and secondary elements in first and superimposing the main interest on them. Similar effects can be achieved by sandwiching negatives or color slides together.

Double Take. The first secret of shots such as that of a woman conversing with herself or that of a man beating himself at chess is a black background which, by itself, does not affect the film during exposure. For a hand-held camera, you can have your subject chalkmark the black ground to correspond to the frame corners in your viewfinder before your two-way conversationalist steps into the picture. Pose her talking on one side of the pic-

ture area and make an exposure but don't advance the film; then pose her for listening on the facing side and make another exposure on the same negative.

If your plan calls for something in the center of the picture, such as an unfinished chess game on a table, the central object will be exposed twice. This usually does not matter, provided you have your camera on a firm tripod so that the chess game is in exactly the same position during both exposures, but try to keep the setup simple. Pose your subject on one side of the table puzzling over a beleaguered bishop, make the first exposure, then put the same man on the opposite side with the complacent expression of a player about to capture an opponent's queen.

These half-and-half photographs are sometimes made by masking one side of the lens for the first exposure, then shifting mask and subject to the opposite side for the second exposure. However, unless you get the mask exactly the right size, there will probably be a vertical line in the center of the picture where the exposures did not quite meet or overlapped slightly.

Exposing a Ghost. This time not only should your camera be stationary for two exposures, but your subject should be ready, willing, and able to remain fixed during both takes. Seat him in a reading chair with a lamp and arrange the ghost character opposite the live character. Place an open magazine or newspaper as if it had just fallen from the hands of the suddenly affrighted subject. When the setup and pose are as you want them, take one shot very underexposed (about one-fourth normal), tell your subject to "Hold it" while the ghost exits and you reset your camera to normal exposure, then take another picture on the same negative.

Or you can do it the other way around, using one actor instead of two. Photograph a pseudo-terrified boy against the black background, and don't advance the film. Now the boy exits, to be set up as the spook with something light behind him instead of the black background. This, and a half-normal second exposure, should make the subject somewhat translucent, as a proper ghost should be.

Offbeat Balance. A very simple version of man balancing girl in palm of hand can be done outdoors in a single exposure by posing the man as close as your equipment permits, and posing

the girl far enough back so that it appears in your viewfinder as if she were standing on the outstretched palm. Focus about halfway into the double subject and make the exposure.

The balancing act is easier if you have a ground-glass viewfinder, on which you can mark the hand position, and the camera on a tripod for an accurate double exposure. Pose the man with his hand stretched out to one side in the foreground of your finder, mark the hand on the ground glass, and expose against a black background. Now move your camera back until you get a small image of the girl standing on the hand line and make a second exposure on the same negative.

Paste-ups. While not strictly a multiple exposure, a composite photograph can be made up of multiple elements in the standard way illustrations and text are pasted up to be reproduced as an advertising page. Amateur photographers, with less serious intent, sometimes use this method for trick pictures by rubber-cementing a cutout from one photograph onto another, or several cutouts onto a white cardboard. The result may be simply a pair of odd-scale figures, like the balancing act, or a pretty girl looking into a mirror which startlingly reflects a cutout crone; or it can be a more original and fanciful concoction of your own making.

PHOTOGRAMS

Look, No Camera! Photogram techniques are based on the fact that light can produce an image without a lens. (See the description of the "pinhole principle" in chapter 3.) By arranging small objects on sensitized paper, exposing the composition to light, and developing the print by standard methods, you can produce a black-and-white photograph known as a *photogram*. (Do not confuse this term with "photogrammetry," which is the science of making maps and surveys through measurements obtained from photographs—generally aerial views.)

Any objects that will fit the photographic paper size may be used. Tiny objects strewed in some pleasing pattern are the most popular "subjects"—for example, grain kernels, seeds, marbles, beads, buttons, tacks, nuts, petals, pods, pebbles, toys, and jewelry. Even with no objects at all, a photogram can be made by "painting" a design with the light (see chapter 11).

Exposure. Because the sensitized paper should be used by safelight (see chapter 19), it is advisable to experiment with your designs first on plain paper. Theoretically, sunlight can be used for photograms, but such a method makes it very difficult to protect the photographic paper before exposure.

Place the composition to be photographed under an ordinary light bulb, and turn the lamp on for a few seconds—much as you would for making a contact print with a printing frame. Wattage and distance will largely determine the length of exposure, which is not critical and is generally done by test.

Shadow or Substance. The customary goal of photograms is a print showing opaque objects as sharp black shapes on a white ground, so overexposure is no problem. However, you may wish to render a particular design in pale, shadowy silhouette, which is done by underexposure. Or you can try for middle tones by using translucent rather than opaque objects. A pattern within a pattern, such as the vein structure of a leaf or the motif of a thin fabric, can be reproduced by experimenting with the length of exposure.

Photograms offer interesting and useful practice in composition and printing to photographers, even those who may not be planning to do any darkroom work—the fundamentals of which are described in the following chapter.

Darkroom Fundamentals

Photographic chemistry as known today dates back to 1839, when a French painter named Daguerre, after years of experimenting, happened upon the discovery of a *latent image* which could be developed and fixed. From the unprosperous state produced by his neglect of painting commissions, Daguerre's fortunes reversed when his long experimentation made him the recipient of sudden wealth and fame.

Although modern scientists generally agree that the silver halides in a photographic emulsion form an invisible image when correctly exposed to light, there are still many theories as to exactly how the latent-image reaction occurs. But occur it does, allowing the affected halides to be reduced to metallic silver and subsequently to be reproduced as a photograph.

DEVELOPMENT THEORY

The Developing Solution. To convert a latent image into a photographic image, a *developer* is used. It is compounded of several chemicals, all having specific functions. These generally include (1) a developing agent, (2) an accelerator, (3) a preservative, and (4) a restrainer. The most important element is the developing agent, which combines with oxygen to react on the silver halides and thus reduce, or separate, the silver.

The water in which the dry chemicals are dissolved softens the gelatin of the emulsion, permitting the solution to penetrate it. To energize, or activate, the developing agent, an alkali (the accelerator) is usually added, and since the developing agent will attack all the silver on the negative unless its action is slowed

down, a restrainer is added to make the developer more selective. As a result of this step, the silver halide particles of the latent image are developed first, thus preventing the premature development of the unexposed particles, which would produce fogging of the image. Lastly, because rapid oxidation in the developing solution can cause stains and streaks on the negative, a preservative is added to retard the oxidation process; this prolongs the life of the developer and lessens staining.

Combinations of developing agents are used to form a balanced, all-around developer, usually one that has soft action and good detail ability for medium-contrast work.

Rinse Bath. When the film is removed from the developing solution, it must be rinsed before being placed in the *fixing bath;* otherwise, the surplus developer would continue to react on the emulsion. Even a very small amount of developer in the fixer can cause stains.

Rinsing can be by plain water or by a chemical *stop bath* (also called *shortstop*). A water rinse is normally sufficient to remove excess developer and prevent contamination of the fixing bath. When an acid stop bath is used, it not only neutralizes any excess developer but also lengthens the useful life of the fixer.

The Fixing Bath. Photographic emulsions, when removed from the developer and rinsed, still contain some light-sensitive silver halides unaffected by the developer. To prevent eventual darkening and discoloration, these residual halides must be eliminated from the negative by a fixing bath. To do a good job, a fixer must dissolve the excess silver without affecting the image and must form soluble compounds which can be removed. The chemical most commonly used is sodium thiosulfate, which has another name, hyposulfite, from which comes the familiar abbreviation "hypo."

Because strong acids in quantity can cause the fixer to decompose, a preservative, usually sodium sulfite, is added to the hypo solution. An *anti-stain neutralizer,* usually acetic acid, added to the fixing bath stops the alkaline developer's activity more completely than a rinse can and prevents staining. Without a *hardener,* swelling and softening of the gelatin during development would leave the emulsion vulnerable to scratches and other defects; therefore, a hardening agent is added to the fixing formula.

RAPID FIXERS. Increasing the amount of ordinary hypo in a standard solution will *not* increase the rate of fixation; in fact, it can decrease it. When speed is vital—as in printing news, medical, or tactical photographs—a concentrated solution of other, special hypo forms can be used to fix film in about three minutes and paper in about half that time. These special chemicals are unstable in powder form and are therefore sold in concentrated solutions costing slightly more than ordinary fixers.

EXHAUSTION SYMPTOMS. The manufacturer's directions will explain how much film or printing paper a specific amount of solution, such as one quart, can be expected to fix satisfactorily under average conditions when temperature and other recommendations are adhered to. Fresh solutions, which are characterized by the sharp odor of acetic acid, a grippy feel, and very temporary bubbles, will clear film in about five minutes and fix it in about ten; older solutions take slightly longer. If the fixing time runs very much longer, the bath should be replaced. Among the symptoms of an exhausted fixing bath are a sulfurous odor, a slippery feel, a milky look or other discoloration, and persistent bubbles.

Replenishing Solutions. Because the chemicals in developing and fixing baths are used up at different rates, a special solution called a *replenisher* can be added according to directions. If a developing solution has a self-replenishment recommendation, then more of the regular developer can be added instead of a special replenisher. Since replenished developers and fixers do not give quite the same quality as fresh chemicals, some photographers prefer not to use replenishers at all but to work with new solutions each time. Many also like the "one shot" solutions, which are used once and discarded after developing a specified amount of film.

WHERE AND HOW TO WORK

Makeshift Darkrooms. Any lighttight space can serve as an occasional darkroom. To be efficient, however, it should have running water, electricity, and a reasonable amount of ventilation. If there is no running water, solutions can be mixed, and negatives and prints washed, outside of the darkroom. But the disadvantage of this, besides the inconvenience, is that without

water at hand there is less control of temperatures during the actual processing.

Kitchens and bathrooms, therefore, are the favored choice. A counter top or table beside the kitchen sink, or a piece of plywood across the top of the bathtub, provides work space. Processing chemicals stain, so floors, walls, and counters should be protected by oilcloth or newspapers.

If you are mixing solutions and washing prints outside the darkroom—and especially if you are sharing the setup—it is very convenient to have a *changing bag* for loading roll-film tanks for developing. A changing bag is a large, lighttight pouch with two thicknesses of black cloth double-zippered along one side and snugly sleeved on the opposite side. The camera and tank are placed inside the bag, which should be on a table or other convenient working surface. The bag is then zipped shut and the hands inserted in its sleeves. When the hands, working blindly inside the bag, have transferred the exposed film to the tank and replaced the tank's lightproof lid, the remaining development steps can be completed in a normally lighted room.

Darkness Check. In kitchens or bathrooms you will probably need some black twill or felt for the windows. To check any darkroom for light leakage, simply remain in the closed area for four or five minutes; then if you cannot see your hand or a sheet of white paper on the work table, the room can be considered adequately dark. A common source of leaking light is the crack beneath the darkroom door; a dark towel or a length of weather-stripping will usually be sufficient to make the doorway light-tight.

Permanent Darkrooms. Makeshift darkrooms require a lot of setting up and putting away, so if you can snare a corner for your very own, that will be more satisfactory. Home darkrooms are often constructed in basements or utility rooms, where water and electricity are readily available; any excessive dampness or seasonal temperature extremes should be avoided or controlled. All you need for a one-man operation is a space approximately five or six feet square. When space is no problem, amateur darkrooms average at least 8 x 10 feet. Sometimes a camera club or a group of friends undertakes to share the expense, maintenance, and housekeeping of a darkroom. Walls should be painted white, and work surfaces should be about three feet high. For

new darkrooms there are stainless-steel sinks especially designed to resist processing chemicals. There are a number of books about darkrooms which include directions for building them and suggestions for working arrangements.

Basic Equipment. Besides the appropriate chemicals and paper, these are most of the needed items for black-and-white developing and printing:

Trays, three, preferably large enough for 8 x 10 sheets
Graduate, or pitcher, for measuring liquids
Thermometer, accurate, for liquids
Tongs, two
Stirrers, two
Spring clips
Funnel
Timer
Safelight
Roll-film tank
Printer and/or Enlarger

Since metallic substances, except stainless steel, are generally prone to contaminate photographic chemicals, it is best to acquire the items in a photographic store after conferring, if possible, with friends who have used some of them. Smaller trays can help economize on developer and shortstop solutions, but fixing solutions, which can be saved for reuse, perform better in larger trays. A fourth tray, fairly large, is handy for washing and for holding several prints about to be washed. You will also want to have on hand a heavy apron, towels, absorbent cotton, and possibly rubber gloves—although some photographers use neither tongs nor gloves. You should remember that the different solutions contaminate each other and must be kept separate.

Darkroom kits of various sizes, available from photographic dealers, may contain all or part of the foregoing list, along with developing or printing chemicals, or both. A kit should contain general instructions, as well as directions for the use of its individual components.

Emergency Substitutes. If you are short on trays, nonmetallic cooking or serving dishes can be used. A safelight substitute can be either a 15-watt bulb in a desk lamp, with red cellophane or plastic used as a filter, or a yellow "bug light." If you need to

make a contact print and have no printer, you can use a piece of plate glass on a flat board or table; put the negative and paper, emulsion sides face to face, inside the board-glass sandwich and expose as with a printing frame.

Basic Darkroom Cautions and Tips. A few important darkroom habits should be learned so thoroughly that they become automatic.

Read the directions. This injunction cannot be overemphasized.

Keep trays, tanks, and other equipment *clean* to avoid contaminating the solutions.

Rinse funnel, graduate, and other equipment in cool water promptly after each measuring and pouring of liquids.

Pour chemicals *away* from you to keep any spillage from skin and clothing.

Hold funnel slightly *above* bottle neck to admit air and lessen chance of spilling.

Mix chemicals *gently*, pour *slowly*, to keep air bubbles from forming.

Use gentle, *uniform* motions when agitating trays or tanks. Observe carefully all *time* and *temperature* recommendations.

Label all storage bottles and *make notations of each use* on the label to avoid using exhausted solutions.

If you are sharing a darkroom, *do not open the door* to go in or out without asking if it is all right to do so.

Agitation. If a negative or print is placed in a developing or fixing solution and left there without any movement, the solution in direct contact with the emulsion, especially with the highlight areas, will soon lose its power. Agitation of the tray in printing or the tank in developing is therefore necessary to bring fresh solution continuously to the emulsion.

A key word in photographic processing directions, *agitation* is sometimes qualified by "intermittent" or "constant" or "gentle" or "uniform." Constant agitation often applies to mechanical methods not usual for home processing. Intermittent agitation is recommended for most amateur work. For *tray* development, this generally means a gentle rocking of the tray for about five seconds every minute or half-minute. For *tank* development, it

means a gentle twisting or slight shaking of the tank almost constantly for the first minute or two, then for about five seconds every one or two minutes of the remaining time. Lack of agitation can cause underdevelopment; excessive or vehement agitation can cause frothing and relative overdevelopment of some areas.

DEVELOPING FILM

When choosing chemicals for developing films, most photographers prefer to use one of the many convenient and economical prepared developers to mixing their own formulas. Ready-mixed liquids and mixed powders ready to be dissolved in water come in practically any quantity desired; they are accurate, clean, and space-saving. On the packages, bottles, or cans, you will find detailed directions which should be read carefully and followed exactly. Unless you are using the materials with professional frequency and proficiency, the manufacturer's instructions should be referred to each time the product is used. Any reference to "cool" water usually means about 68° F.

Single-Solution Processing. Also on the market are "monobath" formulas, which combine developer, shortstop, and fixer in one solution. This all-in-one processing does not permit much control over the results, but, like a simple camera, it is easy to use and a boon to beginners. When buying a monobath product, be sure to get the formula recommended for the ASA rating of the black-and-white film you are working with.

Small Tank Development. A roll-film tank is generally used for developing 35mm and roll films. It is not only convenient but is the only practical way to handle these sizes. Small tanks, when correctly used, are economical of solutions and spill very little. They are easier on the film because it need not be handled while it is in solution, and they help keep chemical stains from hands and clothing. Only the first step, inserting the exposed film into the tank, requires total darkness.

Roll-film tanks are essentially simple equipment as shown in figure 19.1. The round metal or plastic tank has a lid containing lightproof pouring holes which allow liquids to be added or removed while the lid remains tightly in place. To support the film, there is a reel (as illustrated) or a plastic apron, onto which

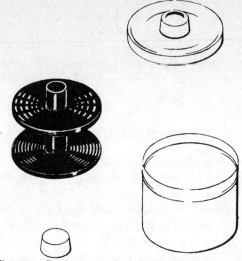

Fig. 19.1. Components of a roll-film developing tank

the film is wound. Popular tank models have adjustable reels (or aprons of different widths) which accommodate different sizes of film; two rolls of 35mm film can be developed at one time on a double reel.

Loading the Film. Rehearse tank loading in daylight with a practice strip of developed film before attempting to load the exposed film you wish to develop. Another practice step, in the interests of economy and efficiency, is to measure the amount of liquid needed to cover the film size you are processing. Note also the time you take to pour the liquid into and out of the tank, in case you want to adjust the development time later on. Be sure that the reel is perfectly dry before loading; otherwise the film may stick. Have scissors handy to snip film leaders. For 35mm film, you should also have a small prying tool, such as a screwdriver or soda-can opener, in case the end of the cassette does not come off with a sharp tap on a hard surface. From time to time slight changes in the design of the cassettes may make them more difficult to open.

In a darkroom or changing bag, remove the end of the metal cassette and snip the film leader to start 35mm film at its full width onto the reel; after reeling, remove the sticker from the end of the film. For roll films, remove the paper backing before

loading (or as you load) the film onto the reel or apron. When the film is in place, insert the reel in the tank, replace the light-proof tank lid, and continue the processing in normal light.

Conventional Tank Processing. Film should be developed according to the times and temperatures recommended by the manufacturer of the product used. Some developing solutions allow a substantial temperature latitude and are easier to use than others; ask your dealer about current products. The basic steps for *time-and-temperature* development are these:

(1) Read directions on bottle or package.

(2) Load film into lightproof tank in total darkness.

(3) Fill tank with cool water, shake gently, pour off all water.

(4) Pour developing solution into tank and . . .

(5) . . . start the timer as you start pouring.

(6) Agitate gently according to directions.

(7) At the end of development time, pour solution into graduate for transfer to stock bottle—unless you are using a one-shot developer, which can be discarded.

(8) Fill tank with clear water the same temperature as developer. Agitate gently for about thirty seconds, then pour out. If a shortstop is used for this step, follow the manufacturer's directions.

(9) Pour hypo or fixer into tank, timing according to directions.

(10) At end of fixing time, pour solution into graduate.

(11) Remove tank lid and, with film on reel, fill tank with cool water and empty it two or three times; then place tank with reeled film under cool running water, with intermittent agitation, for at least twenty minutes.

(12) Hang film to dry.

If you are not using a one-shot developer, *replenishers* can be added to the solutions, according to manufacturer's directions, during the fixing and washing intervals. However, most photographers prefer to use fresh chemicals. Another possible step is to use a *hypo neutralizer* to shorten the standard washing times for negatives or prints.

Washing Films. All negatives should be washed in cool *running* water for about half an hour. Roll films can be washed right

in the tank or in a tray. Single negatives (or prints) can be washed in a large tray with a siphon attachment on the sink, or in the sink itself. Always keep the water running in a gentle stream, just enough to maintain circulation in the tank, tray, or sink. Check at intervals to be sure the temperature remains fairly near 68° F.

Drying Films. After the negatives have been washed, hang them where there is good circulation of air—not in a closet or any other unventilated area. For films which come in strips, such as 35mm and roll films, an easy way to hang them is to attach one end of the film to a clothes hanger with a spring clip. Hang it up (the shower rod is a favorite rack), and attach another spring clip or some paper clips to the bottom of the strip to keep it from curling. Single, larger negatives should also be hung by film clips and the negatives handled carefully by the edges.

Drying time, usually a half hour to two hours, depends on room temperature, humidity, and circulation of air. Dipping the negative in a wetting solution before hanging it up will speed the drying process by reducing the surface tension of the water so that it will run off faster. The wetting agent also will practically eliminate the possibility of water spots.

Surplus moisture, which might spot the negative, can be removed even faster by another simple method: take two swabs of absorbent cotton, as large as the film width, and squeeze them out in cool water. Then, with one swab on each side of the film, wipe *slowly* down from top to bottom. If you hold the two swabs of cotton at the outer edges of the film strip, there will be no pressure on the emulsion. Viscose sponges are easy and popular for drying; however, chemicals and grit tend to cling to them and unless they are absolutely clean, they can damage negatives irreparably.

Do not turn the film around while it is drying, as this can adversely affect the emulsion. Leave it alone. You will note that negatives curl slightly along the edges while still wet; don't worry, for they flatten out as they become dry.

Filing Dry Negatives. Roll films are usually cut into strips of three or four pictures each and kept flat in transparent glassine envelopes; if you happen to cut a single picture or a pair, the 2¼ size is large enough to handle for printing.

Smaller negatives such as 35mm are cut by most photographers and processors into strips of five or six frames each and kept flat in glassine "sleeves." Processing labs will return these negatives uncut by request; some do it routinely, winding the strip loosely on a cardboard oval with a strip of protective paper separating the layers of negative. If you roll your own uncut negative, be sure to keep it in a loose circle with a strip of paper to prevent the layers from touching each other. Never keep negatives in tight rolls, as this could damage the emulsion surfaces.

Keeping some record of subject matter, technical data, location, and date right on the filing envelopes can be a great convenience whenever you are using the negatives.

PRINTING BASICS

Photographic printing is the process of transmitting light through a *negative* to form a corresponding *positive* image. The basic steps for transforming a negative image into a positive print are the same as those for transforming an exposed film into a negative: (1) exposure, (2) development, (3) stop bath, (4) fixing, and (5) washing.

Printing Papers. Although printing papers look quite different from films, both have light-sensitive emulsions, that of papers being extremely thin with far less concentration of silver halides than in negative emulsions. The sensitivity of the emulsion varies; enlarging papers, for instance, are generally more sensitive than contact papers, because the light reaching them must pass through a lens and be spread over a relatively large area. Photographic papers are considerably less sensitive than film and, while a crack of light under a door might not fog them, they should always be handled carefully and guarded from unintentional exposure. Keep papers in their protective packages, or well covered, withdrawing each sheet in darkness as it is required and then promptly closing the package.

Papers come in a wide choice of weight, texture, contrast, and tone. Single weights are used for most contact prints, double weights for enlargements, and extra-thin papers for printed matter to be folded. Glossy textures are chosen for retaining maximum detail, and semimatte textures for subduing detail and

grain. Papers also vary in degree of contrast: low-contrast papers counteract excessive contrast in a negative; high-contrast papers help to bring out the most in a flat negative.

Average negatives can be printed on paper of grades 2 or 3. For negatives of *higher-than-normal contrast*, use paper of grades 0 or 1. For negatives of *lower-than-normal contrast*, there are printing papers available in grades 4, 5, and 6.

Photographers who do not like to buy different kinds of expensive enlarging papers often prefer to use one variable-contrast type of paper with filters in the enlarger. These filters come in sets of graduated densities and can be placed in the enlarger as needed to increase or decrease the contrast quality of the paper. The tone of papers may be warm for brownish blacks or cool for bluish blacks.

Preparations for Printing. Arrange all the printing materials and equipment, with the three trays containing solutions of developer, stop bath, and fixer, in a lineup similar to that shown below. If you have a sink or a wash tray, it should be next to the fixer. Place the printer or enlarger at the left of the trays and the covered-up printing paper on a perfectly dry surface at the left of the printer. Place the timer where you can see and reach it easily. Place one pair of your print tongs between developer and stop bath, the other between stop bath and fixer. When not in actual use, the tongs should remain between those trays to avoid any mix-up, which might contaminate the solutions. This, then, is the basic arrangement:

PAPER	PRINTER								
on dry	or	TIMER	Tray 1	Tongs	Tray 2	Tongs	Tray 3	WASHING	
surface	ENLARGER		DEVELOPER		STOP BATH		FIXER		

If you use fingers instead of tongs, keep your left hand for the developer and your right hand for the fixer. Remember also that clean negatives are essential to good prints, especially in projection printing, which enlarges specks as well as image. To remove loose dirt or lint, dust the negative gently with a camel's-hair brush.

Printing Methods. There are two general classifications of photographic printing: *contact* and *projection*. The basic procedure to be outlined for contact printing applies also to projection printing, except that for projection an enlarger instead of a small

printer is used, and larger trays may be needed to accommodate the blown-up prints.

In *contact printing* the emulsion side of the negative is in direct contact with the emulsion of the paper to produce a positive image the same size as the negative image. This contact can be effected by various methods, including a printing frame, a piece of plate glass, a film proofer, and, infrequently, a contact printing box.

In *projection printing*, usually referred to as *enlarging*, there is a space between negative and paper, and a lens projects an enlarged image onto the sensitized paper. This is effected by an enlarger, whose lens vertically projects an image down onto an easel (rather than horizontally onto a screen, as a slide projector does).

Contact Printing. Before the advent of the 35mm camera, the larger formats of 4 x 5 and 8 x 10 cameras lent themselves to useful contact prints. There was less necessity for enlargements, and the direct-contact prints were of a quality superior to projected prints. However, with the advent of the small-negative era and the development of new sizes, enlarging has become more usual for obtaining prints of a viewable size, and contact prints are used primarily as proof sheets.

The Printer. Rather elaborate printing boxes were developed for contact printing, with individually rheostated bulbs on the inside for controlling print density and contrast. Also used was a much simpler device, the printing frame, which is essentially like a picture frame but designed to hold the inserted paper and negatives in complete contact. This kind of direct print still gives

Fig. 19.2. A simple printing box (*left*) and a printing frame (*right*)

the best quality in terms of resolution, sharpness, gray scale, and *acutance* (which is the physical measure of image sharpness).

Contact prints or proof sheets can be made quite easily with a piece of good plate glass, approximately 11 x 11 inches, as well as with a printing frame or printing box. When you buy the glass, have the glazier smooth off any sharp edges; if it needs additional smoothing, use sandpaper.

Before using the printer, have your trays lined up for processing. Then turn off the room lights and turn on the safelight. Open the package of photographic paper, remove one sheet, and close the package. Place the sheet of paper on your working surface with the paper's shiny *emulsion side up*. Next, lay the strips of negatives on the paper with their dull *emulsion sides down*. Now carefully place the piece of plate glass on the negatives. The weight of the glass will hold the negatives flat so that they are in complete contact with the paper. Additional weights can be placed on the borders of the glass if you make certain that the weights do not cover any of the negatives.

Exposure. The length of exposure needed for a good contact sheet depends on the density of the negatives, the type of paper, the wattage of the bulb, and the distance of the paper from the bulb. Normal negatives should print in about five seconds with a 40-watt bulb held three feet from the paper, but the correct time can be determined only by experiment.

Test strips can be made by cutting a sheet of unexposed paper into narrow lengths and giving them a series of slightly different exposures. If you do this, try to place each strip over a section of the negative that includes a good range of highlights and shadows.

If the images on the paper come up too fast in the developer, less exposure is needed; if too slow, more exposure is needed. A normally exposed contact sheet should be fully developed in one-and-a-half to two minutes. If a different change in exposure is indicated, it can be controlled by changing the length of the exposure, the wattage of the bulb, or the distance of the paper from the bulb. But your photographic life will be much easier if you try to establish a standard procedure so that you don't have to experiment every time.

Print Development. After making the exposure, lift the plate

glass (or open the printing frame or printing box) and carefully put it aside. Pick up the negatives by the edges to avoid getting finger marks on the emulsion and place them gently to the side. Then promptly slip the paper into the developer, emulsion side down. Hold the print by the edges as you slide it gently down into the solution, and wipe any solution from your hand. Agitate by a slight rocking of the tray, and with the first tongs pat the back of the print or test strips to keep them well covered by the solution.

After about half a minute, turn the print face up to see how the image is coming along, then either turn it face down for the balance of development or leave it face up if well covered by solution. Full development time will probably be one-and-one-half to two minutes. At the end of development time, use the first tongs to transfer the print to the stop bath for about ten seconds, and then replace the tongs.

Print Fixing. With the second tongs transfer the print from stop bath to fixer, draining excess liquid from the print momentarily during each transfer, then sliding it into the solution gently. Keep prints face down in the hypo, completely immersed, turning them up briefly for periodic inspection. Keep agitating the hypo gently for the first minute, then agitate the solution every three or four minutes until each print is properly fixed. After half the required fixing time, the prints may be inspected by room light. Normal fixing time is about ten minutes, depending on the type of fixer, after which the prints are ready for washing.

Group Processing. After processing a few tests to check results, you can make several prints at one time. Do not attempt a greater number than you can keep track of, as each print should be put into the developer separately and at regular intervals. Agitation during development should include rotating the prints by transferring the bottom one to the top of the pile and seeing that they do not stick together. Transfer each print to the stop bath in the same order in which it reached the developer, so that each print gets its full developing time. After ten to twenty seconds in the stop bath, transfer the prints to the hypo, sliding each in turn under the others to insure its getting fresh solution. Edging the prints in sideways helps prevent air bubbles from forming under the emulsion. Agitate the prints being fixed

frequently and keep them separated. After a couple of minutes in the hypo they can be inspected by room lighting, and as they are fixed they can be transferred one by one to a large tray of clear water until all are ready for a thorough washing.

Washing Prints. Because paper absorbs more of the processing solutions than film does, prints need more extensive washing than negatives to avoid fading and discolorations. The simplest way is to place the prints in cool (approximately 70°) running water. They should be washed in plain water for at least thirty minutes but not more than an hour, and they should be moved about in the tray or sink at intervals during the washing. The use of hypo eliminators or neutralizers can reduce the washing time to less than ten minutes.

Drying Prints. Special photographic blotters are sometimes used to dry prints, but a clean, absorbent cloth such as lint-free sheeting may be substituted. (There are also blotter books, which are convenient for carrying wet prints home from an outside darkroom.) First, drain as much water as possible from the washed prints before laying them on the blotter face down. Blot to remove excess water, then roll up the prints in the blotter for drying, or leave each one between the sheets of a blotter book.

If you have enough space, leave the prints flat between blotters with some large books or magazines weighting them down while they dry. Prints tend to curl when drying, but they can be flattened later. Electric dryers are often used for club groups or schools; the blotted prints are placed face up, with a taut cover of heavy fabric which shows wet patches as the prints dry. Do not allow prints to become bone dry; remove them while the cover is still slightly damp.

Ferrotyping Glossy Prints. The high gloss characteristic of prints returned by photofinishers results from compression in the emulsion gelatin during drying. In the step referred to as *ferrotyping*, the wet print is placed face down on a polished metal plate, usually called a "ferrotype tin," squeegeed or rollered into firm contact, and then left to dry until it peels off by itself. If you try this process, use only printing papers designated as suitable for ferrotyping; wash the tin occasionally in warm water with mild soap to prevent sticking, and store it carefully to avoid scratches.

ENLARGING

Since it is designed to project an image rather than receive one, an enlarger is fundamentally a camera in reverse; it transmits a cone of light which expands toward the paper instead of contracting toward a pinpoint focus. A unit housing the lens, lamp, and negative carrier is attached to a rigid vertical standard; a base with a masking easel holds the paper to receive the projected image. The advantages of projection printing over contact printing, besides the enlarged print sizes, are the opportunities for special effects, for localized controls, and for composition improvements.

Enlargers. The system by which the light is spread uniformly over a negative, with no uneven hot spots, may be either *condenser* or *diffusion*; there are innumerable combinations of the two systems among today's enlargers. Ask about the different kinds available and about each one's lens quality and focusing mechanisms, as you would in choosing a camera, to decide on one that will suit your purse and purposes.

Diffusion enlargers have ground or opal glass plates between the negative carrier and the projection lamp in a housing shaped

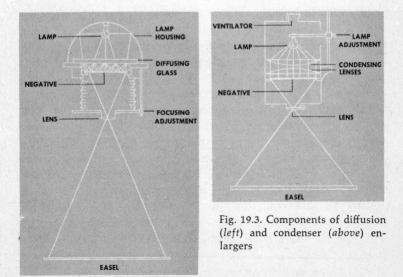

Fig. 19.3. Components of diffusion (*left*) and condenser (*above*) enlargers

se diffusion. The result is a softened image, minimizing
d negative defects. Because of the lessened light inten-
sity, diffusion enlargers generally require longer exposure times
than condenser types.

Condenser enlargers, in principle, have no diffusion between
negative carrier and projection lamp. Optically the most efficient,
this type can produce brilliant images with great contrast; un-
modified, however, such sharpness can be a disadvantage since
it shows up minor negative imperfections which might other-
wise pass unnoticed in the print. The chief usefulness of these
enlargers, consequently, is in technical work.

Most of the popular enlargers are a combination of these two
basic types. Some offer considerable versatility by providing in-
terchangeable clear and opal bulbs and removable diffusion plates.

Enlarger lenses do not have automatic shutters, since expo-
sures are timed in seconds; a light switch controls the exposure
time. "Click stops" to count off when stopping down the lens
make it unnecessary to read the aperture markings by safe-
light. The easel of the enlarger, on which the printing paper is
placed, is usually adjustable, with masking strips to regulate the
print borders. Lens-to-easel distance governs the image size: the
farther the enlarger head is from the paper, the larger the image
will be.

Enlarging Procedure. Arrange the printing setup in the manner
outlined for contact printing and be sure your trays are large
enough; also mix larger quantities of the solutions. Handle
negatives carefully by the edges and see that they and your
equipment are clean.

Place the negative in the carrier, emulsion side down toward
the lens and shiny side up toward the lamp house. Place a sheet
of plain white paper (or the back of a finished print) on the easel
and set the masking guides for the desired print size. Open the
lens to maximum aperture (lowest f/number), turn off the room
lights, and switch on the enlarger lamp. Start focusing with the
enlarger head farthest from the easel, bringing it gradually down
toward the paper and adjusting the distance until the image is
exactly the right size. Adjust the focusing knob until you get
the sharpest image obtainable, concentrating on eyes or some
important detail.

This is the time for cropping and compositional corrections.

Now you can determine whether a horizontal or vertical format is better, you can eliminate superfluous background, and you can straighten a horizon line, a tree, or a building by moving the easel and adjusting the masking strips. When you are satisfied with sharpness and general composition, stop down the lens to its most effective aperture (usually $f/8$) and turn off the enlarger lamp. By safelight replace the sheet of plain paper with a sheet of enlarging paper, emulsion side up, and proceed with a test print.

Fig. 19.4. Printing paper, emulsion side up, slides under masking strips of easel.

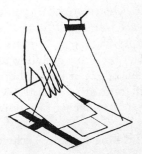

Fig. 19.5. Use cardboard to cover part of printing paper when exposing successive test strips.

Test strips for enlarging differ from those for contact printing in that a series of four or five exposures can be made on a single strip; an 8 x 10 sheet may be cut into ten or twelve strips. A standard method is to expose the strip, section by section, in four to six steps, giving the same exposure time to each section; some photographers prefer to start off with 2-second exposures, some with 5 seconds, and some with 10 seconds. As an example, you might decide to make five tests at 5 seconds each: cover four-fifths of the strip with the cardboard and expose the remaining fifth for 5 seconds; then move the cardboard so that it covers only three-fifths of the strip and expose another 5 seconds. When you have done this five times, the first section will have received a total exposure of 25 seconds and the last section only 5 seconds.

Develop the test strip for the full recommended time. After it

has been in the hypo for a couple of minutes, turn on the room lights and inspect the strip. If none of the exposures looks right, make another test strip. In adjusting your exposure time, try to avoid extremely short exposures, which are impractical both for accurate timing and for the manipulations to be described, and overlong exposures, which subject the negative to excessive heat. When one of the exposures, or halfway between two exposures, seems about right to you, go ahead and make a straight print.

The *straight print* is a full-size enlargement exposed according to your evaluation of the test strip. Develop, rinse, and fix the exposed sheet of enlarging paper. If you are doubtful about your choice of paper, you can treat the straight print as an additional test. Rinse it in clear water, flatten it face down in an empty tray or on a blotter to sponge off surplus water, and inspect the print minutely under white light. You may then wish to make one or two additional straight prints on papers of different contrast or texture. Wash them for the full time and place the enlargements face down on a photographic blotter for drying.

Printing Control Techniques. Examination of a straight print generally suggests some improvements which can be effected by further manipulations during exposure. Besides cropping and straightening, there are several commonly used methods.

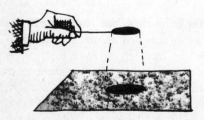

Fig. 19.6. Dodging (*left*) holds back exposure from area that needs lightening.

Dodging refers to holding back some of the enlarger light from certain areas of the image which need to be lighter in relation to the shadows. The dodging tool may be simply a cardboard disk, usually about the size of a half-dollar, attached to a rigid wire about a foot long, or you can use one of the mounted plastic disks available in stores. A favorite—certainly the most convenient—dodging tool is a hand. It is used to shade an area to be lightened—something like a parasol against the burning

sun. Hold the tool a few inches above the paper and keep it moving slightly to prevent its forming a sharp shadow line.

Fig. 19.7. Burning-in (*right*) gives more exposure to area that needs darkening.

Burning-in, or *printing-in*, is dodging in reverse; to darken certain areas of the image by giving them more exposure than the other areas, use a large piece of dark cardboard with a half-dollar-size hole. During part of the exposure, hold the cardboard over the image so that the hole is above the area to be darkened while the cardboard shades the rest of the image. Again, use a constant, gentle motion to blend the areas.

If you want to darken a large irregular section of a picture, you can focus the image on a cardboard (instead of on plain white paper) and pencil the shape to be cut out before starting the actual enlargement.

Vignetting is a combination cropping-and-shading technique for printing only the main feature of an image; it is used mostly to abstract a single portrait from a group or a busy background. A cardboard with a cutout corresponding to the area to be retained is handled in a manner similar to that described for burning-in.

Diffusing in printing is a softening of the image in much the same way that harsh illumination is diffused for photographing. Various informal diffusers serve quite satisfactorily, such as crumpled tissue paper or a handful of cheesecloth or other netting, which are moved about between enlarger and image during exposure. However, there are also special *diffusion disks* of glass, designed to be held next to the lens during approximately half the exposure time.

There are a number of other more advanced methods for altering the contrast, tone, or general quality of an unsatisfactory print or negative. Some of these methods are briefly defined here. *Intensification* is a chemical process for increasing the

density of an overthin, light negative; its opposite process, *reduction,* decreases the density of a negative that is too dark. *Toning* involves changing the overall tone of a black-and-white print by a chemical bath; a sepia toner is used for a warmer effect, and a blue toner for a cooler effect. *Redevelopment* is a step in the process of intensifying or toning when the negative image is bleached and then redeveloped in order to produce a specific effect. *Solarization* is a technique for getting positive and negative effects in the same photograph, usually by exposing the negative briefly to light when it is partially developed, then continuing the development. *Spotting* is a kind of retouching to remove tiny spots from a negative or print.

However, far better than a closetful of remedies is the healthy photographic habit of exercising care and judgment in taking the picture in the first place.

Showing Your Prints and Slides

There are a number of ways in which black-and-white or color prints can be enjoyed besides putting them in albums. They can be mounted on display mats, put in picture frames, reproduced as greeting cards or announcements, and used for bookplates, or to decorate a plain folding screen. Color slides can be shown to advantage in projection, either by putting together your own private slide show or submitting individual slides to competitions. Prints, either black-and-white or color, can be made from slides to fill in album collections but, of course, this is more expensive than taking photographs for prints.

DISPLAYING PRINTS

Albums. Picture albums have grown up with photography and no longer does one have *a* family album containing a chronological and intermittent record of domestic events. Modern albums are colorful and various as to bindings, sizes, and formats —as you can see in photo and stationery stores. Although you can still find gummed corners to paste a print down on a plain page, more commonly used now are transparent acetate pages which hold pictures where you place them, flip-over acetate envelopes for different print sizes, and other quick and versatile variations on the scrapbook theme.

Albums of pictures can be edited like slide shows or home movies to present travel stories in book form, high spots of school years, and interesting phases of family life in separate albums of suitable size. Any editing can advantageously include omissions: arrange albums of your better pictures while they are

fresh and of immediate interest, keeping the weeded-out ones in labeled envelopes for later discard or change of mind. Dates, places, and names can be penciled lightly on the backs of prints until they go into albums. Consider a black-and-white enlargement, protected by clear plastic, for a personal and provocative album cover.

Dry Mounting. An enlargement for display can be mounted flat on a single mounting board or mat. This is usually white, sometimes black or gray, and may even be colored, if the color frame enhances your picture. Besides the enlargement and mat, you will need a cutting board (or equivalent), a welding iron, dry-mount tissue, and plain paper; then proceed step by step:

(1) Trim the print accurately to the size wanted on a cutting board (or use a razor-blade-and-straightedge substitute). Then cut the most important edge first. The border of the print is seldom left on, unless it is part of the pattern.

(2) Try the cropped print on the mounting board to determine the overall mat size. A standard board is 16 x 20, which is generally appropriate for an 11 x 14 enlargement; for an 8 x 10 print, you will probably want to cut the mat down to about 12 x 15, and reduce it proportionately for small prints. It is conventional but not at all mandatory to have the bottom of the mat slightly larger than the top, and the sides about equal to the top. After deciding on the placement of the print, lightly pencil in the position of the top corners.

(3) Heat a photo-welding iron, which is thermostatically controlled, or put a household iron on the lowest heat setting. Cut a sheet of dry-mount tissue the exact size of the print, or just slightly smaller. The tissue is sticky on both sides and has some separating sheets in the package. With the warm iron, tack the tissue to the back of the print, using single firm pressures at the center, corners, and edges. Do not use back-and-forth ironing strokes.

(4) Now place the print in position on the mount. Over the print place a piece of fairly heavy plain paper and press down with the iron. Go over the print, especially the corners and edges, with hard downward pressures until

it is welded to the mat. Place a heavy book on both print and paper for a few minutes.

Enlargements for portfolios are usually dry-mounted without a mat border. In cutting the mounting board to print size, it is best to err on the skimpy side, to be sure that the enlargement covers the mount completely.

Cutout Mounts. Enlargements may also be mounted between double boards with a frame cutout in the top mat. When buying double mounts, be sure to specify your print size and whether the print is horizontal or vertical. Indicate also whether you prefer a wider base, as some stores sell centered cutouts for horizontal or vertical use. Cutout mounts cost slightly more than single mounts but they can be reused for different enlargements.

For cutout mounting you will need only a small roll of "double-stick" transparent tape, about ½-inch wide. On the back of the print, place a strip of sticky tape (about 3 inches for an 8 x 10 print) along each of the four sides, place the print in position on the underneath mat, and press down so that the print adheres to the mat. Or you can mark where the print is to be placed, put the four strips of double-stick tape on the bottom board, then place the print on the tapes. Leave a heavy book on it for a few minutes.

Black-and-white mounted prints for exhibition are usually 8 x 10 or larger, but the rules vary, and individual exhibits often accept various sizes. A title and the photographer's name are generally written lightly in pencil on the mat just underneath the print, the title flush with the left edge and the name flush with the right edge. Your address and any technical data should be on the back of the mount. If the exhibit accepts flush-mounted prints, the title may be on a separate card as well as on the back of the mount.

VIEWING SLIDES

Color transparencies returned from the processor are usually masked in cardboard mounts and may be viewed in three ways: by using normal light, a viewer, or a projector. The simplest and least satisfactory way is to hold a slide up to a lamp or window. This method not only gives no magnification, but the illumination passing through the transparency also may distort the color

balance of the picture. To minimize this disadvantage, aim an adjustable desk lamp at a sheet of white paper, then look at the slide by the light reflected up to it from the paper. If you like, you can hold the slide in one hand and a magnifying glass in the other. Even if you have a projector, this is a good way to preview and sort slides.

Thumb Spotting. While you are having a first look at a new batch of slides is the best time to "spot" them, perhaps roughly, for later viewing. This term refers to a corner mark which indicates how the slide should go into a projector, and there is a standard procedure: hold the slide up so that you are looking at the scene as you photographed it. Now with a red or black pencil make a large dot or a small circle in the *lower left corner* of the mount. This is the way the slide goes upside down into a projector, the red dot will be in the upper right corner under your right thumb.

Even if you are going to discard quite a number of slides, a prompt mark in the lower left corner will cut down on subsequent handling until more positive spots are put on the slides you decide to keep. A thumb spot does not have to be red, but it should be large enough for a projectionist to see easily in dim light. Self-stick spots are available in some stores.

Small Viewers. There are many types of small hand viewers which vary in size, degree of magnification, and price. Some are pocket-size folding viewers without illumination; some operate on batteries or by electrical connection, or both. A majority of models are designed to accept only the 2 x 2 mounts of 35mm and 126 slides. The pocket-size viewers, which must be held up to a lamp or bright window, are very convenient if you are carrying a few slides to show someone; otherwise, it is more satisfactory to have an illuminated viewer.

Basically, an illuminated hand viewer is a plastic case with a magnifying glass and a tiny lamp, between which is a slot for the slide. The slight fingertip pressure that illuminates the slide can bend the cardboard if it does not go in straight. Some viewers need to be held fairly close; others are large enough to be positioned on a table for three or four persons to look at simultaneously. Whatever the type, the viewer should be used in fairly low room light, and the slide should be inserted carefully.

Preview projectors are often used by photographers who want a larger look at slides than hand viewers provide. These throw an illuminated image onto a small screen and are helpful in predicting how effective a slide will be on a large screen or in reproduction. Some of these previewers come in carrying cases, complete with screen and slide holders, for showing samples to editors or other potential buyers of photographs.

Slide Projectors. For showing color slides or home movies, a projector is a kind of enlarger which throws a greatly magnified and illuminated image on a viewing screen. Projection is much the best way to appreciate the brilliance and quality of color transparencies. The focal length of lenses for slide projectors is considerably longer than for movies, an average being about 5 inches. The projector lamp for slides is also larger, usually 500 watts. Follow the manufacturer's recommendations for projector-to-screen distances.

The carrier in which the transparency is advanced and withdrawn in front of the lens is called a *slide changer*. Some are operated manually, some automatically; some accept only single slides, but most accommodate a tray of thirty or more slides or a circular holder of about a hundred slides. All standard projectors accept 35mm or slightly larger transparencies which fit the usual 2-inch mounts; some projectors are equipped also with changers to accommodate larger mounts of roll-film transparencies, such as the 2¼ size of twin-lens reflex cameras.

Cropping and Remounting. The small size of 35mm transparencies limits to some degree their cropping possibilities. For informal viewing, a slide that needs only straight-line masking— eliminating some dull foreground or sky, for example—can often be cropped with black photographic tape. See that the new mask remains parallel to the edge of the mount so that the projected picture will not appear tilted. Notice, too, whether the masking would result in unmatched square or rounded corners, which would be undesirable.

Cropping is usually done by removing transparencies from the processor's mounts and inserting them in new mounts, which are available in various sizes, shapes, and materials. It is necessary to have some kind of light box on which the slide can be studied carefully in different masks to be sure that the intended revision will improve the composition as a whole. By this method a tilting

tree or slanting horizon can sometimes be straightened in a smaller mask, or a scene dramatized in a narrow panel. The dramatic impact of a larger slide can be increased by cropping a roll-film transparency and putting it in a 2-inch mount with a very narrow mask. When you have cropped and positioned your transparency, tape one edge of it to the inside of the new mount, and press the self-sealing edges of the mount together smoothly.

Glass mounts are preferred for slides which are to be shown often or submitted to numerous competitions. They protect transparencies from dust, finger marks, and scratches, and from buckling, or "popping," in the heat of a projector lamp. Various makes of thin 2-inch glass covers and pressure tapes for binding them together are available. There are also metal frames which hold glass covers without taping, as well as other metal and plastic types. The process is a basically simple one, done differently by different people; but because slides and glasses must be spotlessly clean and taped borders smooth, it is well to practice a few times before subjecting your best slides to possible mishandling.

Glass covers are also preferred for sandwiching two or even three slides into a single picture called a *montage;* in fact, it is difficult to keep a montage flat and in focus without glasses. This technique is frequently used to add clouds to an otherwise drab sky, to insert a full moon in a night scene, or to place a figure in an empty foreground. Abstract patterns are often superimposed on the transparency according to the whim and ingenuity of the photographer.

Newton rings is the term commonly given to the color spots that occasionally appear on remounted slides, sometimes along with condensation spots. This problem is generally caused by contact of the smooth surface of the glass with the base (shiny side) of the film. One of the most effective ways of overcoming this difficulty is to give a matte surface to one side of the glass. If the glass surface in contact with the shiny side of the film is lightly etched with acid, the problem can be eliminated.

Always store slides in a relatively dry place, away from dampness and humidity, and away from excessive heat.

Color Modification. Color-compensating (CC) filters, usually referred to as *gels*, come in gelatin sheets of various colors and sizes and are used to counteract an overall color cast or create

a special effect. Clean, colored cellophane can be substituted, if necessary. If a transparency is too blue, or too much on the orange side, for instance, a compensating gel may correct or improve this. Hold the slide over a light box and study the effect different gels have on it; if one pleases you, sandwich that filter into the mount.

As a rule, the color quality of slides is not impaired by frequent brief projection. However, because prolonged projection with lamps of maximum wattage may in time cause some deterioration, it is advisable to keep single projections under one minute. Many photographers like to coat new slides with Permafilm to protect them from marring and other damage. It is also possible to change color areas of a slide completely by retouching with quite simple materials. However, the process itself is not so simple, nor feasible to attempt from written directions; it should be learned from a workshop or from a private demonstration by someone experienced in this technique.

Cleaning Slides. Cleanliness is always a requisite for good slides, as specks or smudges are magnified along with the subject itself. Use a fine camel's-hair brush to remove dust and lint, and a recommended film cleaner sparingly if necessary. Handle slides carefully by the edges of the mount, and keep them protected between showings. Individual glassine envelopes are sometimes used to protect slides which are handled frequently.

If the surface lacquer of a transparency has noticeable scratches and must be refinished, the marred lacquer should be removed first. Ask a reliable darkroom-supply dealer for specific instructions, or write to Eastman Kodak Company, Rochester, New York 14650, for their pamphlet about the care of color films.

Labeling Slides. Slides to be submitted to competitions or photographic markets should have a thumb spot, a title, and your name as minimum information. Labeling is less uniform than spotting and can be on any part of the mount. An acceptable method is to print the title (or subject) across the top of the mount the way it goes in the projector—that is, with the spot in the upper right corner. Your name (and address) can go across the bottom or on the back of the mount, and any technical data and the date can go on the sides. Small printed return-address stickers make convenient and neat nameplates.

Careful labeling and cross-referencing of your slide collection

is especially important when putting together a number of shows for different audiences. Interchangeable courtesy titles and transitional slides (see chapter 17) can be numbered and indexed according to locales, seasons, subjects—whatever is practical for your own purposes. Photographers who have occasion to plan frequent shows from a large collection sometimes key their slides with numbers or letters in different colors. Some photographers collect sunsets or doorways or bridges or interesting characters, and a private indexing system should be worked out to make the collection flexible.

Showing Slides. The general suggestions in chapter 21 about appropriate music, discriminating commentary, and a fitting regard for individual audiences apply to slide shows as well as to home movies. Consider whether you are showing as-is slides to your family, submitting single slides to competitions, or putting together a travelogue or other pictorial essay to be viewed by a group.

Primary slide editing is a matter of sorting, omitting, and rearranging; it requires no special equipment, although it is convenient to have a slide sorter—a plastic rack to hold rows of slides illuminated by a small light bulb. In any case, the editing deserves to be done critically. Are you including a slide out of sentimental attachment or because it was a difficult shot, and will it really contribute to the audience's enjoyment and understanding of your story?

Slide shows can be given a change of pace by interspersing relevant close-ups with general and atmospheric pictures, as in movies, and by varying the color emphasis. Follow predominantly red subjects with green ones, for instance, or mainly blue subjects with yellow ones. Try to keep related subjects in some logical sequence, whether or not it is the order in which the pictures were taken, but avoid dwelling overlong on one theme or on different views of the same scene; it is preferable to come back to it if necessary. Travel shows should generally have sufficient commentary to let the audience know rather than guess where the scene is; even very famous landmarks are numerous enough to be confusing, so they usually need a brief mention.

The following chapter contains some suggestions for showing home movies which you might find pertinent to your slide shows.

Introduction to Home Movies

Home-movie photography is too large and complex a subject to be covered adequately in this basic handbook; only a brief preview is included here. If you plan to shoot any movies and want more guidance than your camera's manual provides, there are many books devoted solely to home movies. Some fundamental principles which apply to making home movies but not to still photography and the characteristics of movie equipment will be discussed in this chapter.

Pictures in motion benefit from observance of the principles pertaining to photography generally—the principles of composition, background, lighting, types of films and filters, angle and speed of action, camera steadiness, and selection of subject matter still hold. Most important, to restate a primary instruction, *study the manual that comes with your equipment* for a thorough knowledge of your own camera and projector.

PRELIMINARY CONSIDERATIONS

"Motion" and "Still" Pictures. It is easy to see why the fundamentals of good photography apply to movies when you realize that "motion pictures" are actually "still pictures" caught on a series of frames much smaller than those of films for other cameras and shown in motion. If you were to photograph a sequence of still pictures with a camera using 35mm film, for instance, and could project those pictures with excessive rapidity, you would see a "movie."

The reverse is also true: individual frames of movie film can be printed as still pictures, but the extreme magnification re-

quired by such a tiny negative does not make this very practical. For one thing, a lack of sharpness that might not be noticeable in a speeding movie could be glaringly evident in a still print.

Persistence of Vision. The principle on which the illusion of motion in a picture sequence is based is the power of the optic nervous system to retain an image after the eye has closed or the image has been otherwise occluded. For example, if you are looking at a brightly lighted subject which is suddenly blacked out so that the image is no longer visible, your eye-brain mechanism will continue to retain that image for a fraction of a second. The normal limit of a person's image-retaining power is considered to be 1/50 of a second.

Without this natural follow-through, the eyes would see merely a rapid succession of still pictures. But because of persistence of vision, the successive individual images of a movie strip are carried through the momentary pause between each frame, making possible the visual illusion of motion pictures.

Essential Equipment. For motion pictures, a projector and screen are as necessary as a camera and film: movies must be shown "moving" on a viewing screen. Consequently, it is important for a movie photographer to understand the operation not only of his camera, which records the action, but also of his projector, which returns the action to a screen.

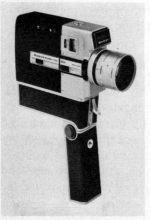
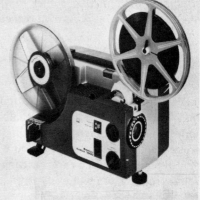

Fig. 21.1. A Super-8 movie camera Fig. 21.2. An 8mm movie projector

Some editing is also essential to most movies. Color slides for projection can be "edited" simply by tossing out some and re-arranging the order of others. But motion-picture footage usually needs to be cut and spliced and arranged in understandable sequence if it is to be an acceptable movie. Therefore, some editing equipment, even if it is only scissors and splicing material, is a must for moviemakers.

CAMERA BASICS

Home-movie cameras, though different in shape, have much the same essential parts as any other cameras. They must have four primary components: lighttight housing, lens, shutter, and a film-transport mechanism. Except for the shutter, these parts have a basic similarity in movie or still cameras.

Shutters. The usual shutter of movie cameras is a rotary disk from which a segment has been cut to create a light cycle and a dark cycle. During the light cycle the film is exposed, and during the dark cycle the film is advanced. Instead of the shutter settings of still cameras, movie cameras have "camera speeds" to indicate the rate at which the film is being exposed.

Camera Speeds. The speed at which a movie camera (or projector) is operated is identified in frames per second, abbreviated *fps*, and indicates how many individual pictures, or frames, reach the film (or screen) during each second of operation. Standard speed for the Super-8 cameras used for most home movies is 18 fps. This covers backgrounds and the everyday activities usually taken by casual photographers.

For serious filmmakers who want correct sound synchronization with motion pictures, 24 fps is the standard speed. Other speeds are used for catching faster than average action and for special effects. Variations in the speed subject action on the screen should be effected by changing the camera speed, not by varying the projector speed.

Slow-motion movies can be made by shooting at faster than standard fps if your camera provides a choice of operating speeds. A sports action taken at 32 fps, for example, and projected at the standard 18 fps will seem to be occurring at an unnaturally slow pace, mainly because it has been split into more than the normal number of pictures per second. In other words,

if you take two minutes to expose the film at 32 fps, it will take about four minutes to project it at 18 fps, making the screened action appear to be in relatively slow motion. An even faster shooting speed will further decrease the apparent pace and is especially useful for checking on sports form, such as a golf swing or a ski jump. In laboratories and test centers, camera speeds may run to thousands of frames per second for studying in measurable slow motion such "action" as the fall of liquids or the flight of aerial objects.

The opposite of slow motion has very limited use for special effects, as in the jerkily speeded-up style of an old Keystone Cops routine. The earliest Hollywood productions, colloquially called "flickers," were photographed at 12 or 8 fps in the days of hand-cranked cameras and were projected at 16 fps. The slow shooting speed increased the time lag between frames and caused the flicker on the screen.

Single-frame exposures, as well as continuous-run operation, can be made by most movie cameras. Setting the single-frame release according to the instruction manual and the speed indicator at the recommended fps allows you to make one-at-a-time pictures for titles or for close-ups of objects you might like to splice into your film.

Animation, which refers to the apparent action of subjects not capable of live motion, is also produced by separate exposures of one or two frames. The subject might be a series of cartoon drawings, such as Mickey Mouse, or it could be some inanimate object which is moved slightly between each exposure.

Exposure compensation is required when using speeds other than the standard operating speed on which normal exposure is based. Since a slow-motion sequence shot at a fast 32 fps, for example, would allow each frame about half as much light as when shot at a standard 18 fps, the picture could turn out rather dim. To avoid underexposure in this instance, use the next largest aperture, and open up the lens proportionately for other speeds.

Lenses. "Zoom" lenses with continuously variable focal lengths are standard on most movie cameras. As in other photography, there are "simple" movie cameras which have fixed-focus lenses. The earliest hand cameras for movies had a turret which could hold three different lenses. Now one zoom lens can

shoot wide-angle, normal, and telephoto without changing the camera position.

The range of a zoom lens varies in different camera makes and models. A zoom lens may extend, for instance, from 13mm to 28mm in some Super-8 cameras. Others may have a 3-to-1 power zoom extending from about 10mm to 30mm, while still another will have a 10-to-1 power zoom ranging from extremes of 7mm (wide-angle) to 70mm (telephoto).

Apertures of lenses for home-movie cameras have the same scale of *f*/stops as still cameras. The sharpness range on all extends to infinity, but the near limit varies. Close-up shooting is generally not recommended for a movie camera with a fixed-focus lens.

Film Drive. The film-transport mechanism of a movie camera, called the *film drive,* advances the narrow strip of film continuously from the supply spool to the take-up spool. This mechanism is nearly always electrically driven, battery power having long ago supplanted the spring motor which used to require manual windups.

The operating principle is this: as the film advances, the claws (sprocket teeth) of the drive engage the perforations (sprocket holes) along the film's edge. The mechanism also has a stop-and-go action which repeatedly pulls the film down one frame at a time, then disengages the sprocket holes at the *film gate,* a small pressure plate back of the lens. During actual exposure the individual frame of film is held in place by the gate; during the advance of the film, pressure is released each time the claws reengage the sprocket holes.

Super-8. Since the introduction of Kodak's preloaded movie-film cartridge in 1965, drop-in loading has become characteristic of virtually all 8mm movie cameras. The Super-8 camera is one of the marvels of automation. With it the photographer (or, more specifically, cinematographer) has little to do except drop the cartridge into place and close the camera cover before he is free to concentrate on his subject. The press of a button does the rest. Features to look for include electronic light meters that govern exposure; automatic signals that appear in the viewfinder to warn of insufficient light, the end of the film, and low battery power; and footage counters that reset themselves automatically when the camera is reloaded. All except the most inex-

pensive models have a zoom lens, "pistol" grips which usually fold compactly, and numerous accessories.

The major advantage of Super-8 over Regular 8mm film is its super-size image area, which is about 50 percent larger than standard, and results in bigger, brighter, and sharper pictures. This was accomplished by reducing the size of the sprocket holes, placing them along only one edge of the film, and increasing the connective distances between the holes. This allows the frame to be placed nearer the center and a sound stripe to be placed along the edge opposite the sprocket holes instead of next to them.

Besides its convenience and improved film, the lighttight Super-8 cartridge not only protects the film against fogging during loading and removing, but no midpoint turnover is needed. This latter advantage also helps the continuity of the movie.

There is also a Single-8mm camera which uses the same film as Super-8 cameras, but for this camera the film is spooled in a differently constructed cartridge. By a different placement of the spools in the cartridge, the film run can be reversed, so that fades and dissolves, as well as single-frame titles, can be made during shooting. This distinct advantage allows the more serious filmmaker to do his editing in the camera without a lot of later cutting and splicing. However, this type of camera is more expensive and not widely available.

Regular 8mm Cameras. Although home-movie cameras might seem to be all Super-8, some photographers of home movies are still using the standard 8mm type. And because of trade-ins by many who switched to Super-8 equipment, there are often good buys in Regular (standard) 8mm cameras, projectors, and accessories for those willing to shop around. In spite of its smaller image area, the standard 8mm is in some instances a more versatile camera than the Super-8 and capable of quite sophisticated moviemaking. A disadvantage of the standard reel of "double-8" film is that it is susceptible to fogging during loading and midpoint turnover, especially in daylight.

PROJECTOR BASICS

A projector, like an enlarger, is fundamentally a camera in reverse: instead of receiving an image through a cone of light

contracted to a pinpoint within the camera, a projector lens is designed to send an image out through an expanding cone of light. To create apparent motion on a screen, this beam of light is interrupted by the shutter action to produce a light cycle of individual pictures all separated by an alternating dark cycle. At standard projection speeds the transmitted images are well within the persistence-of-vision norm, and thus the subjects appear to be in motion.

Essential Projector Parts. Besides the lens and shutter, a projector body must have places for the feed reel of exposed and processed film and for the take-up reel, which receives the film during projection. There must be a power mechanism to transport the film past the aperture through which the successive images reach the screen. The projector must also contain a lamp, along with switches, controls, and cord, and a blower for cooling the machine.

All 8mm projectors accommodate at least 200 feet of film, and nearly all Super-8 projectors take up to 400 feet, which will make a half-hour movie. While it is quite possible to project your footage "as is," in the lengths returned by the processor, this is hardly the way to show your movies to advantage. If you are using the 50-foot lengths of Regular 8mm, this would mean changing film every four or five minutes, which is hard on the audience and the projectionist. Furthermore, it is a rare film indeed that does not cry out for a bit of editing. Some kind of splicer for joining the ends of cut lengths of film into one long strip and at least one large reel onto which you can rewind your spliced film should therefore be considered part of your basic equipment.

Modern Projector Features. Variations and refinements in the different makes of projectors are about as numerous and fast-changing as those in cameras, and no operating instructions could encompass all types. In fact, detailed explanations here for handling and operating could very easily confuse rather than enlighten; it is necessary to study the manufacturer's manual carefully, to refer to the step-by-step instructions during practice runs, and to ask a dealer or other qualified representative to demonstrate any points that may not be entirely clear.

Some of the ways in which projectors vary are in the quality of the lens and in the relative convenience of the automatic

threading mechanisms. Some projectors feature automatic stopping in the event of film breakage; some have smoother control of forward, still, and reverse operation. The automation principle is even carried into such niceties as the turning off of room lamps when the projector lamp is turned on and their automatically relighting when the projector lamp is turned off.

Sound Accompaniments. Another variation stems from the increasing availability of sound projectors—a far cry from the earliest home movies, which were usually accompanied by the halting commentary of the moviemaker and the noisy whirr of the projection machinery. Since then there have been countless developments in stereo records, magnetic tapes and recorders, film striping, and projectors complete with built-in speakers and the equipment for adding your own synchronized words and music.

Musical records and tapes are in overabundant supply, but it is not always easy to find just the right background sound that will enhance your movie and not compete with it for the attention of the audience. Tape recorders are widely used to coordinate the moviemaker's own choice of sound with a specific mood.

If you own a sound projector, you can have a *sound stripe,* the exceedingly narrow magnetic track for recording sound, added to old (or new) movie films. Your music or commentary is recorded while you project the striped film; then when you project the film again, the sound is played back. As with magnetic tapes, a sound track can be erased if you want to make changes in it.

Image Size and Brightness. Three factors affect the satisfactory reproduction of pictures on a home-movie screen: the wattage of the projector lamp, the focal length of the projector lens, and the distance from projector to screen.

PROJECTOR LAMP. The brighter the lamp in a projector, the brighter and farther it will throw an image. However, there is a safe and sane wattage, usually betwen 50 and 150 watts for 8mm projectors, and the manufacturer's recommendation should be observed. Brighter lamps than the recommended maximum may be more than the cooling fan can cope with, subjecting both film and equipment to possible damage.

EFFECT OF FOCAL LENGTH. The projector-to-screen distance required for a satisfactory image depends on the focal length of

the lens; shorter lenses will fill the screen at shorter distances than longer lenses. Some 8mm projectors have substandard focal lengths for showing movies in quite small rooms. If the projector has a zoom lens, variable from 10mm to 25mm, for example, it can adapt focal length to the distance and screen you wish to use.

SCREEN DISTANCE FROM PROJECTOR. An increase in the projector-to-screen distance will increase the image size but decrease its brilliance. You can experiment with this by moving your projector backward or forward, but the instruction booklet of your projector should be consulted for the effective distance at which its lens should be used.

Projection Screens. Screens for viewing home movies or color slides are classified according to their degree of surface brilliance and generally should be suited to the size of the room and the long-and-narrow or shallow-and-wide arrangement of the viewers' seats. Sparkly, beaded screens give the best and brightest image when the audience is close to the projection axis—to the center aisle, as it were; from a side-aisle seat the image is less satisfactory.

If your audience is to sit in a rather spread-out formation, it is preferable to choose a matte screen with a less brilliant surface. There is also an in-between, lenticular screen whose surface yields a brighter image than matte screens but less bright than beaded screens.

A reasonably good screen can be made by covering a section of wallboard or heavy mounting board with flat white paint and hanging it on a wall. A wall itself as a screen substitute is almost certain to distort the color quality of the image. Other make-shifts, such as white sheets or window shades, are not really opaque, so the projected light will pass through them with some loss of brightness.

Well—now that you have camera, projector, screen, and sound possibilities, how about making a movie?

MOVIEMAKING

Home movies can be free-style footage just for the family, like still pictures of the snapshot variety, or they can be more like exhibition prints and slides, the result of planning, patience,

and practice. If you are a beginner, don't accumulate all the accessories and gadgets on the market at once—costly equipment is not a guarantee of good pictures. By the time you have familiarized yourself with camera and projector, you will have a better idea of which additional tools will be most helpful to you in making better movies.

The everyday home activities that suggest themselves for action effects in still pictures (see chapter 14) make good starting subjects for the movie camera: children at their busy games, a day at the zoo, a boy on a bike headed for a spill, preparations for a wedding or vacation, a birthday party, or a backyard cookout. Instead of trying to stop motion at its peak, to catch a fleeting smile, or to pan with the cycling boy, you should photograph the more or less complete motion as it occurs.

The Story. A motion picture should tell a story naturally, with logical continuity; it should show genuine activity—people doing something, things happening—not static scenery. Study the possibilities and watch for filming opportunities, but don't force them; avoid the "Smile please" or "Look at the birdie" business: it results in artificiality, whether the pictures are still photographs or home movies.

The word *continuity* is longer than *story* but really refers to the same idea—in a longer way, since it may imply more extensive planning and a shooting script to detail the order of scenes. Home movies are usually more casual and can be reorganized by editing. However, it is preferable to do your editing in the camera as far as practicable; this means shooting scenes in the right order so that the film will be presentable with a minimum of post-processing work on your part.

Subject Distances. The relative distances of your subject from the camera determine whether you call your shots long, medium, or close-up. A long shot is frequently used to set the scene for the activity to follow and to establish the relationship of objects to it. The distance depends on how much needs to be included; between 20 and 30 feet could be considered an average long-shot distance.

A medium shot brings the photographer in closer, so that the principal subject—a person shown full-length, for example, or a child on a swing—is more or less isolated from the surrounding scene. For a close-up shot, the camera might concentrate on

only a part of the subject, such as the head and shoulders of an adult or the face of a child on a swing.

With a zoom lens, these changes in framing the subject can be made without changing the camera position. With a fixed-focus lens or interchangeable lenses, it is necessary to move closer or farther.

A movie *sequence*, which is a series of related scenes, might begin with a long shot to establish a locale or a mood, then move to some medium shots to show what action is happening, and finally close in on the climax or main interest of the sequence. Shots do not have to be in any fixed order, but they should be varied and should include fairly frequent close-ups. If there is a rule, it is simply to shoot from the distance that gets in the pertinent subject matter and gives you a good composition.

Scene Length. An average scene is about 10 seconds, but this does not mean that all scenes should be that length. To avoid monotony, scene lengths should be varied, like subject distances, and the subject matter itself should be your guide as to whether it needs 3 or 8 seconds' worth of film, or perhaps 12 to 20 seconds. With practice you will often know approximately how many seconds you have ticked off without even looking at the footage indicator.

Action on the screen is seldom as long as the actual happening. There is a tendency at first to shoot too much in each scene, to try to get in every detail. By studying your own results and motion pictures in general—as one does with still pictures—you can learn to condense less important scenes and emphasize key ones.

Handling the Camera. Holding the camera close to your eye will not only help keep it steady but will also show you more accurately the area your lens is taking in; otherwise, the subject may turn out smaller and more distant than you had expected.

Panning, which is moving the camera horizontally to follow a moving subject or to record a panoramic sequence, can be a useful home-movie technique if used with care and restraint. Hold the pistol grip firmly without clutching it tensely and turn your body smoothly at the waist, keeping your feet in a balanced stance. Practice panning with no film in the camera, swinging it very, very slowly until you can do it with a smooth motion—with no jerks and no sudden stops or starts. When you do use this tech-

nique in actual shooting, pan no more than necessary; it is better to have the movement in the scene you are shooting than in your camera.

Experienced home-movie makers often use a tripod for camera steadiness and for better planning of shots. A tripod-held camera allows you to study the scene more carefully, choose a different angle before shooting, check on your lighting and exposure, and even set the self-timer so you can slip into the scene yourself. It also restrains any panning impulses. A tripod is almost essential for steadiness when using a telephoto lens or a zoom lens at its longest focal position.

The impulse to zoom wildly needs restraint, too. Like panning rapidly or unevenly, zooming in and out on scene after scene can result in footage too dizzying to inflict on even your most lenient friends. Zoom sparingly and purposefully, the way you would use separate lenses of different focal lengths, to gain an effect of going in close or backing off for a wider view.

Lighting. The principles of good lighting explained at length in chapters 7 and 8 pertain to motion pictures as well as stills. Learn to recognize basic light conditions outdoors and the direction of the light, using a light meter as a guide. Because motion is involved, it is generally impractical to use portable reflectors, although you may be able to take advantage of natural reflectors.

For shooting indoors, additional room lighting can be arranged in advance. Most cameras have an electronic signal for unsatisfactory light levels. Some have an electronic control for back-lighted subjects, indoors or out. When a movie light is mounted on a camera, it automatically removes the built-in filter. A movie light is useful for fill-in, in much the same way that flash is used with still cameras. Since the introduction of Kodak high-speed Ektachrome to the Super-8 cartridge, extra lighting is often unnecessary.

Shooting Reminders. Even though the automatic features of most cameras have made a camera-setting checklist generally unnecessary, there are a few basic points to keep in mind:

(1) Focus affects picture sharpness at different distances. Close-ups have a shallower depth of field than long shots. Preset cameras have a fixed focus and should be used at distances of six feet or more.

(2) Lens aperture is the main control over the amount of

light reaching the film. The lowest f/number is the largest opening, the highest f/number is the smallest opening. Too much light (overexposure) causes washed-out colors; too little light (underexposure) causes dark pictures.

(3) Camera speed governs whether the filmed motion will appear normal or slowed-down or extra fast. Speeds other than normal affect the amount of light reaching the film; faster camera speeds admit less light, and slower speeds more light.

MOVIE SHOWMANSHIP

The activities you have photographed are returned to you from the processor in individual reels, just as you shot them. If you have photographed the activities in the order in which you intend to show them, you may run the film through your projector and decide it needs no more editing than a few splices, especially if the pictures are intended solely to please family and fond relatives. If less personal footage is to be shown to friends or club members, it should be edited into a movie of more general interest.

Splicing. Defective frames, such as overexposed, underexposed, blurred, or dull pictures, which may mar your movie, can be cut out of the film and the remaining pieces joined end to end. Shortening any scenes which seem to drag will improve the pace of your movie. There are splicers to do the job quickly and neatly, either by joining the cut ends with pressure-sensitive splicing tape or by welding them with splicing cement. Tapes are newer and generally preferred, particularly for quick repairs when a film breaks during projection. Those without a commercial splicer but with time and ingenuity can find, in various home-movie books, simple do-it-yourself guides for making splicer and rewind substitutes.

Titling. The easiest titling, like editing, is done as an integral part of the movie you are filming, using the single-frame release to photograph place names, recognizable landmarks, and whatever informative signs will add to your story. For impromptu lettering you can use chalk on a sidewalk, lipstick on a car window, or a finger in the sand of a beach. You can make a batch of titles

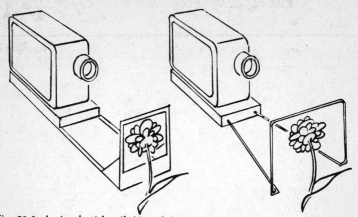

Fig. 21.3. A simple titler (*left*) and focal frame (*right*) for use in close-ups

separately, to be spliced in, by using a titler or a simple focal frame (see figure 21.3) and techniques similar to those described in the section on making title slides in chapter 17. Some of the materials mentioned there are included in movie-titling kits available in photographic stores.

Editing Methods. Combining sections of old or new films into a ten- or fifteen-minute movie may require considerable planning and patient work. The more interested and methodical you are about editing, the more rewarding your finished movie can be. You may be able to edit your own movies satisfactorily by simply projecting them two or three times, making written or mental notations of what you wish to cut, splicing the films accordingly, and then rewinding them onto a larger reel. For more extensive revisions there are complete editing kits with splicer and tapes, a pair of rewinds, and an *editor*, which is a miniature viewing screen-and-projector for conveniently studying the movie material. The kits vary in size and price, but the basic setup is similar to the diagram shown in figure 21.4.

To use the editing setup for an all-out rearrangement of many films, have a package of small index cards handy and, as you critically view each scene, make whatever brief notations will identify the scene later, using a separate card for each scene so that you can shuffle and reshuffle them into a final order. Nick the edge of the film you are editing at the beginning and end of

a scene or sequence you wish to keep, and cut out the unwanted sections.

The Commentary. Your completed movie can be shown as a silent film, accompanied simply by your occasional comments, or you may prefer to have a musical background, suiting it to your pictures and your equipment, as discussed earlier in this chapter.

Any narration or comments, whether spoken during projection or incorporated in a sound track, should be planned as thoughtfully as a musical accompaniment. Subordinate what is said to what is being seen, give the pictures a chance to speak for themselves, and supplement them with as few words as clarity requires. Refrain from editorializing: if an action is breathtaking and suspenseful, or a fiesta colorful and gay, let your pictures say so.

An effective commentary should also maintain a consistent viewpoint. If you start with a third-person documentary style, don't suddenly switch to first-person phrases or shift tenses. Present-tense narration, as a rule, is preferable to saying something "was" or "happened"; try to make it seem as if the action on the screen is occurring while your audience is looking at the movie.

Show Business. As far as possible, the business of setting up your show should be done before your audience arrives. The projector should be threaded and focused, the screen in place, and room lights ready to be switched off efficiently. Try to see

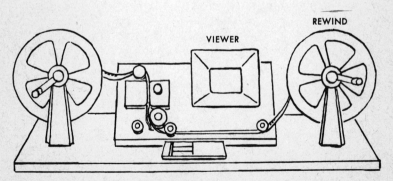

SPLICER
Fig. 21.4. Components of a basic editing outfit

that the projector cord is placed so that it will not be tripped over; as an extra precaution, you can wind it several times around the leg of the projector table to keep the projector from being pulled off. If you have a sound accompaniment, test it and adjust the volume. If you are showing separate reels of film and must rethread the projector during the show, don't keep the audience waiting while you rewind the first reel: do that later. Finally, don't make your show so long that the audience becomes restless—and the projector overheated.

General Maintenance. When you switch the projector lamp off at the end of the show, it is good practice to keep the motor running for three or four minutes so the cooling fan can lower the temperature of the equipment. Some projectors and movie cameras require lubricating, while others are self-lubricating and could be damaged by oiling; consult your instruction booklet about this and also about cleaning the gate and lenses.

All films should be protected from excessive heat and humidity, and exposed films should be sent out for processing without undue delay. If your movie films are worth editing and worth keeping, store the reels in proper cans and label them for future shows.

More Than a Hobby

Photography for many people is a pleasant hobby, engaged in only occasionally by some and more wholeheartedly by others. But quite often it is also an effective teaching tool and even a method of therapy. For students and serious amateurs it can also be a source of limited and unpredictable income, or a preliminary training ground for a professional career.

In more and more classrooms throughout the country photography is being taught as a regular part of the curriculum. The subject seems to take in practically all ages, spreading through high schools and secondary schools down into grade levels and up into college courses. Additionally, photography is offered in countless adult-education courses, in specialized private schools, and in workshops by individual photographers.

Photographic Markets. The principal "market" for photographs of the hobby variety consists of the numerous contests offered periodically by newspapers, magazines, and business concerns. Some are limited to persons of school ages or to a specific theme; some are open to all. Usually very few restrictions are placed on subject matter, in order to encourage the originality that makes a prize winner. Look for details of such contests in photography and general magazines as well as in local publications. Only a few entrants can win, of course, but acceptances without prize money can be a source of stimulation and gratification.

Nonprofessional photographs are occasionally purchased for publication if they are interesting, timely, and technically adequate, and if they meet the needs of the individual picture editor.

Generally it is preferable to send a written inquiry, with a brief description of your material, before submitting the photographs. Calendar and postcard publishers may be interested in exceptional color pictures, particularly if they are color negatives or transparencies larger than 35mm. Don't tackle the nationally famous magazines right off, but browse through some of the hundreds of little known periodicals to see what kinds of pictures they are using.

There are a number of books which catalogue the specific requirements of many photographic markets; however, it is difficult to keep such lists currently accurate, so you should double-check on the particular markets in which you might be interested.

Spot news pictures have been taken by amateurs who happened to be on hand at the right time—with a ready camera. If you photograph a holdup or a fire or a crash, don't stop to develop your film: phone the picture editor of your newspaper, describe what you have, and find out whether he is interested. If he is, he will want you to rush your undeveloped film to him. Insurance companies are sometimes glad to get an eye-witness photograph of an accident. If you take such a picture, get the names and addresses of the people involved, and write them later to let them know what pictures are available. Real-estate agents often like to be saved the bother of taking their own pictures of listed property; inquire first about their interest and about any features they would like emphasized.

If you do succeed in selling some photographs, you will find that most publications and other organizations have standard rates of payment. These prices do vary, but don't expect big money! A trade publication or a house organ, for instance, may pay only five to ten dollars for an 8 x 10 black-and-white glossy print, and only a little more for a color slide. *Do not submit unsolicited prints or slides;* always check a publication's requirements first, then send a letter of inquiry to the editor.

Legal Aspects. Pictures can be taken in most public places without restrictions; however, museums, libraries, private parks, theaters, and other places can forbid the use of cameras on the premises as they see fit. Taking candid snapshots of people in the street, in transportation terminals, and in other public areas for your own private enjoyment does not require written con-

sent. But selling candids for trade purposes does require a formal release; otherwise, such use of the pictures may be considered an invasion of privacy.

Publications or reputable businesses to whom you might sell amateur photographs will probably give you the necessary information. If in doubt, you can consult a book entitled *Photography and the Law*, written by Chernoff and Sarbin.

Cameras as Teaching Aids. For the past few years special programs in some of the public schools of large cities have been using photography as an effective tool in teaching disadvantaged youngsters to read. These started when a perceptive teacher theorized that, since most of the learning at first- and second-grade levels was by "looking at pictures" on a television screen, another kind of picture box, the camera, could be used to channel the learning process outside of TV channels. Small groups furnished with cameras are taken out on trips in the school neighborhood and encouraged to photograph subjects at random. In this way they learn to see and describe—and, hopefully, to better understand—their environment.

In at least one instance in a noncity locale, a "Head Start" program for preschool American Indian children, who knew practically no English and were suspicious of any teacher from outside the tribal village, used photography to break the language barrier. With some donated Polaroid cameras the children learned on field trips to take pictures of familiar subjects: horse, man, house, tree, cloud, and so on. Each print was promptly mounted on a card and discussed. Combinations developed: little horse = colt, little man = boy. After several months, the by then eager pupils had acquired a fifty-word vocabulary and were expressing themselves in simple sentences.

Photography as a Therapy. For more than thirty years photography has been adopted as a therapeutic technique in a number of hospitals, rehabilitation institutes, and youth centers through a volunteer service program in New York City. There are similar if smaller programs in other cities. Equipment is usually donated to the program, and photographers who are willing to donate a few hours each week are trained to assist small groups, under hospital or welfare supervision, to use cameras and to learn the mysteries of developing and printing. This popular hobby has in many cases proved to be "just what the doctor ordered," pro-

viding people with a genuine interest and a feeling of accomplishment. You may wish to share your own photographic skills and enthusiasm by organizing such a service program in your area.

Careers in Photography. If you are a beginner now but are seriously considering photography as a profession, it is worthwhile to channel as much shooting as you can in the general direction of the photographic field in which you are primarily interested. If you look forward to training as a photojournalist, for example, practice at as many small events as possible— family outings, school sports, local awards—anything that will help you develop an alert eye and accurate timing skill. If you expect to become a portrait specialist, concentrate on people and lighting.

If you decide to take up photography as a career, you must learn to work with larger cameras and more complex equipment, and you will either attend a commercial photography school or become apprenticed to a professional. Besides technical and general photographic instruction, large schools of photography offer a choice of courses designed to qualify students for work in advertising, illustration, fashion, and publicity; industrial, scientific, and medical photography; studio and home portraiture of children and adults, and bridal and social events; and retouching and darkroom techniques.

Some large companies retain a full- or part-time staff photographer. This job may involve travel to different domestic branches; with concerns having foreign branches, such as the international oil companies, it may mean travel to many different parts of the world. Either way, such a job may also afford an opportunity to collect interesting free-lance photographs for personal use.

Apprentice photographers are traditionally assigned to the darkroom lab, which has always been excellent basic experience for other assignments, particularly in the opportunity it affords the observant worker to profit from the photographic mistakes of others. But more and more, today's lab technician is a creative artist, imparting to the finished print some wanted quality which the camera has failed to capture.

It's Up to You. One of the characteristics of a successful photographer, amateur or professional, is a genuine enthusiasm for

his work. If you really enjoy making pictures, you will keep learning from them and will acquire new techniques as needed in new phases. When there is a choice between subject matter or technique, subordinate the technical concern to the subject; go by how you feel about it rather than by how someone else claims it ought to be done.

The essence of a good photograph is that it comes alive by what you have contributed to it. In the final analysis it is you, the photographer, who must teach yourself.

Index